THE ART OF
PLEIN AIR
PAINTING

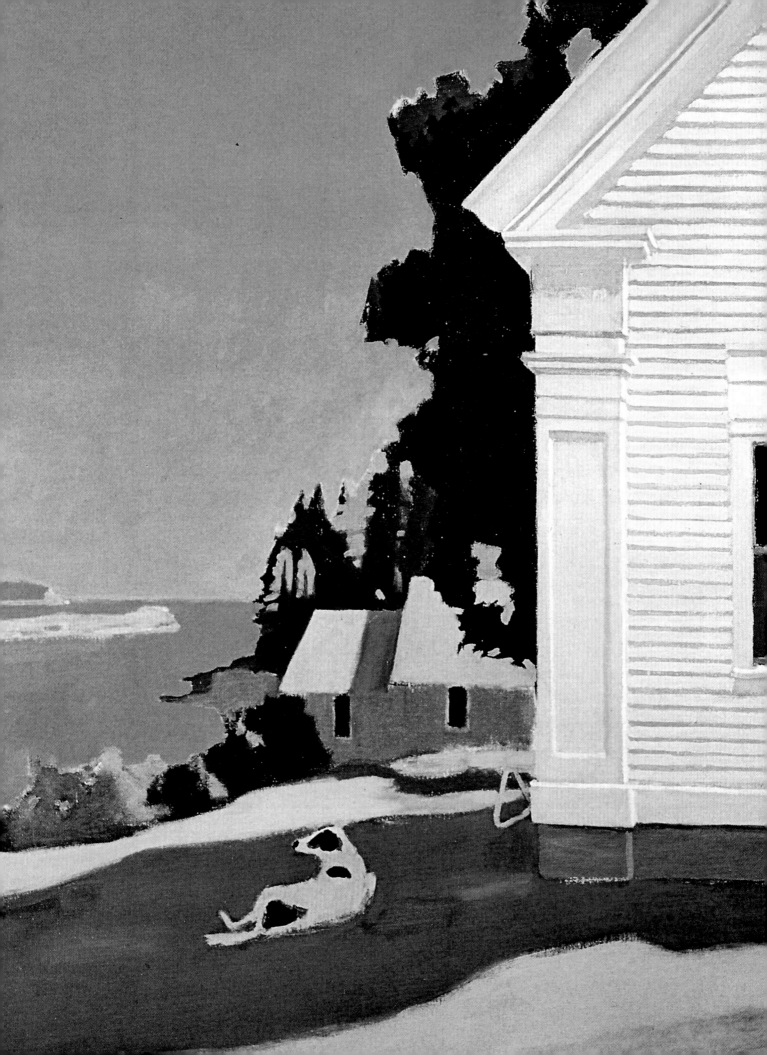

M. Stephen Doherty

THE ART OF PLEIN AIR PAINTING

An Essential Guide to Materials, Concepts,
and Techniques for Painting Outdoors

𝓜 MONACELLI STUDIO

Published in the United States by MONACELLI
STUDIO, an imprint of THE MONACELLI PRESS

Library of Congress Cataloging-in-Publication Data
Names: Doherty, M. Stephen, author
Title: The art of plein air painting : an essential guide
 to materials, concepts, and techniques for paint-
 ing outdoors / M. Stephen Doherty.
Description: New York : The Monacelli Press, 2017.
Identifiers: LCCN 2016026699 | ISBN
 9781580934480 (paperback)
Subjects: LCSH: Landscape painting—Technique.
 | Plein air painting—Technique. | BISAC: ART /
 Techniques / Painting. | ART /
Subjects & Themes / Landscapes. |
 NATURE / General.
Classification: LCC ND1342 .D64 2017 | DDC
 758/.1—dc23
LC record available at https://lccn.loc.gov/
 2016026699

ISBN 978-1-58093-448-0
Printed in China

DESIGN BY Jennifer K. Beal Davis
COVER DESIGN BY Jennifer K. Beal Davis
COVER IMAGES BY (front) M. Stephen Doherty;
(back, clockwise from top left) Marcia Burtt, Marc
Dalessio, Mark Boedges, and Jeremy Sams.

Illustration rights are retained by the individual
artists.

10 9 8 7 6 5 4 3 2

MONACELLI STUDIO
The Monacelli Press
6 West 18th Street
New York, New York 10011

www.monacellipress.com

PAGE 2: Fairfield Porter, *Island Farmhouse* (detail),
1969, oil on canvas, 79⅞ × 79½ inches (202.9 × 201.9
cm). Private collection.

PAGES 3–4: John P. Lasater IV, *Ephraim View*, 2015,
oil on panel, 11 × 14 inches (27.9 × 35.6 cm). Private
collection.

PAGE 6: M. Stephen Doherty, *Skies above Rockfish
Gap*, 2014, oil on canvas, 10 × 8 inches (25.4 × 20.3
cm). Collection of the artist.

This book is dedicated to my family and to the friends I have met on my journey as an artist and editor.

ACKNOWLEDGMENTS

I thank the many artists who have allowed me to share their artwork and ideas in this book; my wife, Sara, for her support; and the editors at Monacelli Studio, Victoria Craven and James Waller, for their professional guidance.

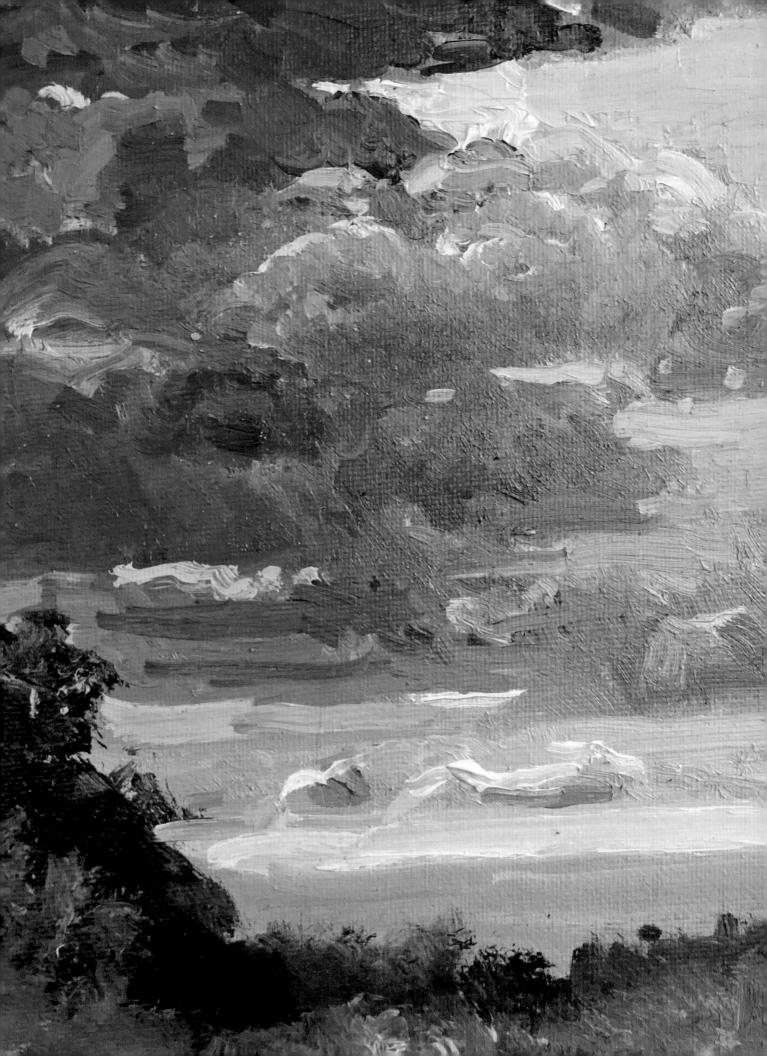

CONTENTS

ABOUT THIS BOOK 8

CHAPTER 1:
WHY PAINT OUTDOORS? 11

How Much of the Work Must Be
Done Outdoors? 15

Sketches versus Finished Works 18

Figures in the Landscape 20

Rural versus Urban Scenes 21

Oil Paints versus Non-Oil Media 23

*Contemporary Plein Air Master:
Clive R. Tyler* 26

CHAPTER 2:
A HISTORY OF PLEIN AIR
PAINTING 31

John Constable: Master of Loose
Brushwork 33

The American Hudson River
School 36

The French Barbizon School and
the Impressionists 40

American Impressionists and
Twentieth-Century Outdoor
Painters 44

*Contemporary Plein Air Master:
Clyde Aspevig* 47

CHAPTER 3:
THE LEARNING
PROCESS 53

Focusing Your First Efforts 55

Attending Demonstrations and
Workshops 57

Developing a Personal Style 59

*Contemporary Plein Air Master:
Joseph McGurl* 62

CHAPTER 4:
GETTING STARTED 67

Choosing a Location 68

Finding the Best Spot 70

Simplifying Your Subject and Ap-
proach 80

*Contemporary Plein Air Master:
Kathryn Stats* 84

CHAPTER 5:
MATERIALS, TOOLS,
AND EQUIPMENT 89

Surfaces and Surface Preparation
90

Media for Plein Air Painting 95

Additive Mediums 111

Brushes 114

Palette Knives 114

Portable Easels 118

*Contemporary Plein Air Master:
Michael Godfrey* 122

CHAPTER 6:
TECHNIQUES 125

Using a Viewfinder 126

Making Preparatory Sketches and
Color Studies 127

Toning a Surface 130

Blocking-in Big Shapes 136

Alla Prima Painting 136

Indirect Painting 142

Sight-Sizing 144

Painting Urban Landscapes 146

Abstracting from Reality 152

Using Photographs 155

*Contemporary Plein Air Master:
Mark Boedges* 156

CHAPTER 7:
PLEIN AIR EVENTS 161

Open Events with Last-Minute
Sign-Ups 162

Member and Invitational Events
163

Juried Shows 164

Publicity Events: Quick Draws,
Nocturnes, Landmarks 166

Selling Plein Air Paintings 168

Drawbacks of Plein Air Events 171

RESOURCES 172
INDEX 174
PUBLICATION CREDITS 176

ABOUT THIS BOOK

Long before the term *plein air* came into common use, artists placed a high value on working directly from nature. That's because they knew there is no better source of visual information—and no better measure of one's skills—than a human model or a landscape. Everyone who sees a drawing or painting of those subjects knows whether or not the image is true to life. That's why it's always important for artists to spend time studying nature and learning to quickly transcribe what they observe about light, color, and form. Even if their studio work relies heavily on imagination, ideas, or memory, nature will still exert an influence on their creations.

This book offers some particular ways of working from nature to create landscape paintings, ones that immediately capture honest perceptions. To help explain that process, I selected artists and artwork that illuminate this process of working from nature. I have relied on my years of interviewing and writing about practicing artists. What I offer here is a summary of that information.

When I began working as an art magazine editor, the first publisher I worked for was an exceptionally wise man who put things into the larger context of how such a magazine should be positioned. One of his key observations was that magazines as well as books, blogs, and lectures are never as effective in teaching painting as receiving one-on-one instruction with brush in hand. "Painting is active pursuit, not a passive one," he would say. "Printed magazines and books will never be as helpful as demonstrations, workshops, videos, and classroom activities, but we can approximate that active experience by offering step-by-step demonstrations, practical tips, lists of supplies, photographs of artists at work, and critiques of paintings." I considered his sage advice when developing articles for the magazine, and I kept it in mind as I developed the contents of this book. I work from an understanding that while I may be able to pass along advice from experts in the field, you will ultimately have to put that advice into practice for it to have any real meaning for you as a painter.

OPPOSITE: Author M. Stephen Doherty painting in Virginia.

CHAPTER 1

WHY PAINT OUTDOORS?

To someone who hasn't painted outdoors, plein air painting may seem labor intensive and unnecessary. After all, painting outdoors means having to tolerate bad weather (heat, humidity, cold, rain) and, sometimes, bugs. It is a lot more comfortable to work indoors with music playing and hot coffee brewing, and the materials and procedures are basically the same as those used in the studio. So why go through the bother of learning to paint *en plein air*?

The first time people actually try to paint outdoors, they do find it hard, but they also quickly discover there is a great deal to appreciate about being out in nature and responding directly to its beauty, variety, and drama. It's great physical and mental exercise; it may yield information that can enrich the studio experience; and it can put an isolated studio painter out in the company of other painters. Most skeptics go through an initial struggle to make adjustments from studio to field, but they soon respond to the challenges of being properly equipped and mentally prepared for executing a respectable work of art outdoors in less than three hours. And plein air painters learn to like adding physical challenges to the already difficult process of developing works of art.

Among the strongest reasons for painting outdoors are the essential processes of making accurate observations and presenting informed interpretations. Your observations will be more direct and honest when made right in front of the subject, and your interpretations will happen without a lot of intellectualizing. The results are likely to be more spontaneous, economical, and passionate because you have to confront the ways forms, values, colors, and spaces that actually appear in nature.

OPPOSITE: Clive R. Tyler, *Summer Aspens*, 2013, pastel, 10 × 8 inches (25.4 × 20.32 cm). Private collection.

But while observation is a critical part of the plein air process, so too is the need to edit information. Without a camera to define your field of vision, you have to consider whether to eliminate trees, shrubs, buildings, people, or other things your eye sees. And you have to deal with the changes that happen as the sun moves across the sky.

Plein air can complement studio painting, but it is a completely different creative process. There may not be enough time to work through a series of preparatory drawings, pull elements from photographs, or apply color in glazes of slow-drying paints. Decisions have to be made quickly, and actions have to be deliberate and sequential. Unless you return to the same location at a time when the light and atmosphere are similar, you will usually have to define your image within the first 90 minutes of painting.

> The term *plein air* comes from the French phrase *en plein air*, meaning "in the open air." *Plein air* is often pronounced "plen-AIR," but some Americans prefer to say "plain air."

ABOVE: L. Diane Johnson, founding editor of *PleinAir* magazine, painting outdoors.

OPPOSITE: When trying to paint a view of downtown Waynesboro, Virginia, I had to work around construction vehicles, barrier cones, and safety flags. It's not uncommon for plein air painters to adjust their working procedures to accommodate workers and equipment.

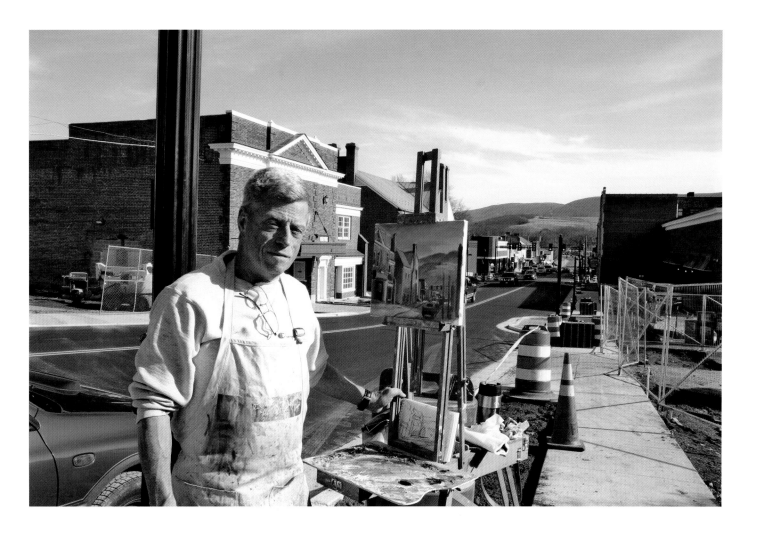

Nature is rich and varied, sometimes changing appearance in an instant—and certainly over the course of a day, a week, or a year. Plein air painting offers an effective way of dealing with all those variables and unexpected delights. While photography freezes nature's appearance and thereby limits the amount of visual information you receive, plein air challenges you to consider all the angles of shapes, the whole pattern of lights and darks, and the momentary effects that occur. Outdoor painting is at once totally confusing and harmoniously expressive.

Outdoor painting is appealing to many artists not only because it challenges them to understand and synthesize their observations, but also because it taps into people's need to be active and engaged in the open air. Many people who are involved in plein air groups grew up camping, fishing, hiking, and participating in outdoor sports. Now they can combine their love of art with their lifelong love of outdoor activities. They feel a great sense of fulfillment being engaged in an enterprise that is both physical and creative.

It isn't necessary to hike miles into a forest to discover paintable subjects. In fact, that kind of exploration can sometimes be a waste of painting time and may set up an expectation of finding the absolutely ideal arrangement of natural formations. You can spend hours hiking or driving to find a perfect alignment of pictorial elements, but in all

Capturing a Changing Scene

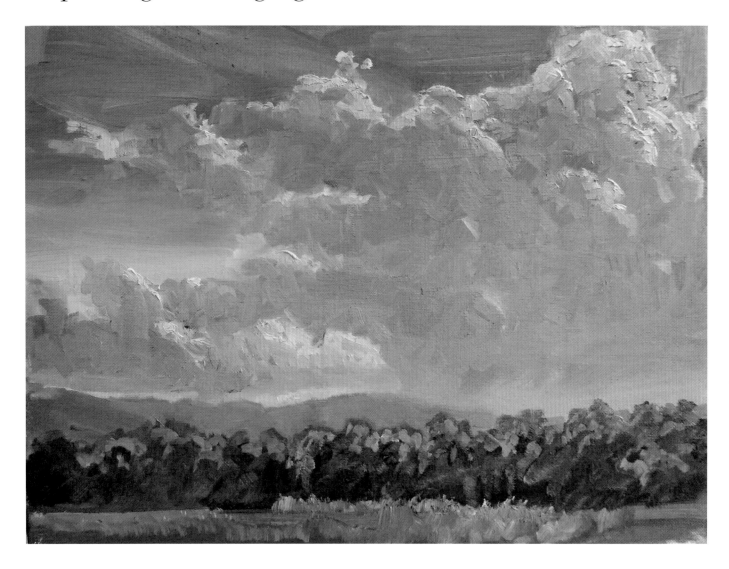

Some subjects change so dramatically every few minutes that a plein air artist has to either commit to the initial pattern of light and shadow or adjust it to incorporate colors and values that are more intriguing than those first observed. In the cloud painting here, I adjusted the purple shadow color of the clouds to bring out the red tones because those were more interesting than the darker colors I used first.

Sometimes the only way to capture the fleeting appearance of a subject is to study it thoroughly, make mental notes about the momentary value patterns and colors, and then paint the overall effect from the mental image, adding details from direct observation.

ABOVE: M. Stephen Doherty, *Clouds at Sunset*, 2016, oil on panel, 12 × 16 inches (30.5 × 40.6 cm). Collection of the artist.

likelihood that perfection doesn't exist. Instead, you must discover perfection in locations that might not seem promising until you spend time observing, thinking about, and evaluating what is happening in front of you.

So while plein air painting is not essential to creating a work of art, it can benefit the artistic process by providing you with a direct, exhilarating, and physical experience that can result in a finished painting or in studies that you can use later, in the studio.

Steve Allison being resourceful so he can complete his plein air painting.

HOW MUCH OF THE WORK MUST BE DONE OUTDOORS?

Questions are often raised about what constitutes a plein air painting. Such issues typically arise at festivals, where organizers need to level the competitive playing field by establishing eligibility for prizes, rules for painting, and expectations of participants. For example, to certify that all the juried paintings were created over the days of an event, organizers may stamp the backs of canvases and panels to certify that they were blank on the first day. They may also restrict artists to painting within a specific geographic area so that people attending the event can find them while they are working.

But the larger question about what a plein air painting is occupies online community forums, art clubs, and collectors. Unfortunately, there is no definitive answer to the question, except that *some amount* of the drawing and painting for a work has to be done directly from nature and that it cannot

be based completely on photographs, sketches, or imagination. The debate about this definition becomes complicated when you consider how many artists now use their smartphones and tablets to photograph scenes or make videos of them.

Can part of the work be done in a studio or from photographs? If so, how much? Can still lifes be included? And how about figures, if painted from live models? Among the editors of *PleinAir* magazine, there is agreement that artists need to be given the widest possible latitude for creative exploration, so we don't measure the amount of time an artist spends painting outdoors, nor do we place restrictions on what or where they may paint. We are more interested in promoting the spirit of outdoor painting and the fresh, immediate quality of paintings created during a relatively short period of time. It is simply impossible to judge a small

painting created completely outdoors in 90 minutes against a 40 × 60 work begun *en plein air* but then developed over weeks or months in a studio. Both may be great works of art, but it is difficult to make meaningful comparisons.

The prospectuses of many plein air festivals contain rules about when and where the work can be done—for example, that it must be done during the days of the event and within a certain geographic area. These defined areas are often changed from day to day to give artists a variety of subjects and, hopefully, to grab the attention of passersby who might become interested in buying paintings. If the event schedule includes a timed painting session—often called a *quick draw competition*—the area is likely to be quite small so the public can easily find the artists and watch them work.

ABOVE: A Tennessee artist painting close to the edge of the cliff above a waterfall.

When galleries and art centers organize exhibitions of plein air paintings, they often define the term very precisely because they can't control the painting activity or assume that every artist is following the same set of standards. In such cases, the prospectus for the show might say that paintings have to be created "mostly" *en plein air,* or it might go so far as to rule that 70 to 80 percent of the work has to have been done outdoors.

Repainting in the Studio

Sometimes, you have no choice but to repaint when you get back to the studio—*in order to capture what you saw at the painting site.* I changed this plein air painting quite significantly in my studio. Once I was indoors, I discovered that the bright morning light had affected my vision so severely that I'd miscalculated all the values and the composition of shapes. What seemed well designed at the site turned out to be completely inaccurate.

ABOVE: M. Stephen Doherty, *Distant Sunlight*, 2016, oil on panel, 12 × 16 inches (30.5 × 40.6 cm). Collection of the artist.

SKETCHES VERSUS FINISHED WORKS

Many artists—especially those who participate in festivals that culminate in juried exhibitions—consider their plein air paintings to be finished works of art. But there are also a great many who refer to their outdoor paintings as "sketches" or "studies" and who are unlikely to exhibit or sell their plein air paintings, either because they want to keep the reference material readily available or because they want to be known for their polished studio paintings, not their rough sketches.

The French painter Theodore Rousseau (1812–1867), a founder of the Barbizon School and one of the most influential outdoor painters of the nineteenth century, was very reluctant to exhibit his outdoor drawings and oil sketches because, like most of

ABOVE: John P. Lasater IV, *Ephraim View*, 2015, oil on panel, 11 × 14 inches (27.9 × 35.6 cm). Private collection. **))** This painting has all the loose, generalized qualities of a sketch, yet it won the first-place prize in the 2015 Door County Plein Air Festival in Fish Creek, Wisconsin.

his contemporaries, he wanted to build his reputation on studio paintings. When he launched his career in the 1830s, landscape paintings were considered far less important than allegorical tableaux based on stories from mythology or the Bible, so the idea of showing sketches did not seem like a viable marketing strategy. But Rousseau was so desperate for money that he began to exhibit his plein air paintings, and to his surprise and pleasure they were quickly bought by members of the rising middle class, who found them pleasant, understandable, and affordable. Many of Rousseau's contemporaries followed his example, and by the end of the century galleries in America, England, France, and Italy were exhibiting and selling plein air paintings by Barbizon and Impressionist artists as well as Italian painters of the Macchiaioli group.

Although those artists established the validity of plein air painting more than a hundred years ago, some painters and collectors still consider such work preliminary and incomplete. This attitude can free artists to work without the pressure to exhibit or sell their paintings, and it gives collectors the opportunity to understand an artist's creative process more clearly. The evidence of the initial decision-making process is right there on the surface of the plein air painting, and small plein air works reveal the thought process and ultimate intentions of the artist in ways that may not be obvious in a polished, highly detailed studio painting.

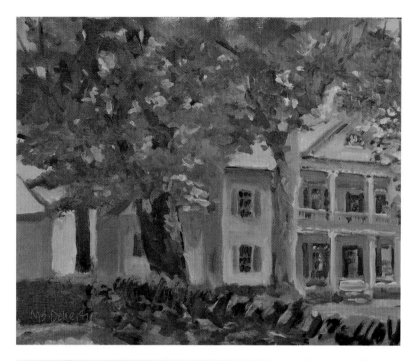

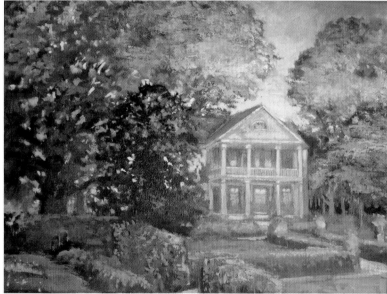

TOP: M. Stephen Doherty, *Rose Hill Manor*, 2015, oil on panel, 11 × 14 inches (27.9 × 35.6 cm). Collection of the artist.

BOTTOM: M. Stephen Doherty, *Southern Grace*, 2016, oil on canvas, 18 × 24 inches (45.7 × 61 cm). Collection of the artist. ❯❯
At top is a plein air sketch I did during the Easels in Frederick plein air festival in Frederick County, Maryland; at bottom is the studio painting I did based on my sketch of the historic building. I didn't complete the sketch on location because I wanted to use it as a reference for a larger, better-composed studio work. In the studio painting, I remained faithful to the architecture but completely transformed the scene by adding trees and shrubs native to the southern United States and by using the raking light of morning to illuminate the scene.

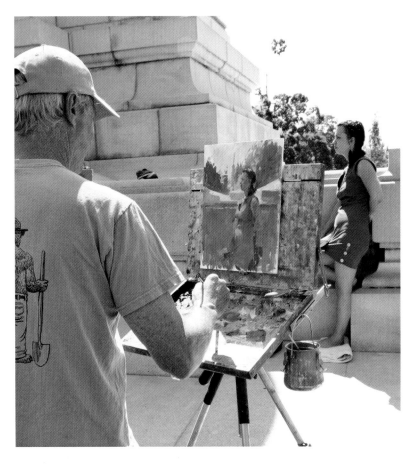

FIGURES IN THE LANDSCAPE

While pure landscapes are clearly the favorite subject of plein air painters, some artists like to include figures posing within the scenes they paint. That may be because they are primarily figure and portrait painters and feel most comfortable incorporating a posed model, or because they are looking for a way to distinguish their work in a crowded exhibition of local landscapes, or because they are simply tired of painting the same local scenes on the list provided by the organizers of a plein air event.

For the most part, painting figures within a landscape is a matter of painting shapes in sunlight. It is natural, however, for the viewer of such a painting to assume that the incorporated figures are the subjects of the work. Moreover, if the figures' faces express discernible emotions, those emotions will affect the entire painting. That's why many artists will show the painted figures with their heads turned, so their faces are not visible, or will render the figures' forms with gestured strokes of paint that don't provide details.

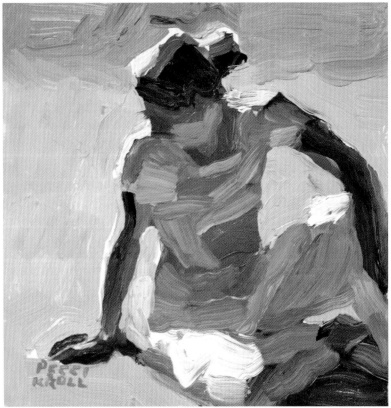

TOP: Larry Moore painting a posed model outdoors.

BOTTOM: Peggy Kroll Roberts, *Yellow Shirt*, 2012, oil on panel, 10 × 8 inches (25.4 × 20.32 cm). Collection of the artist.

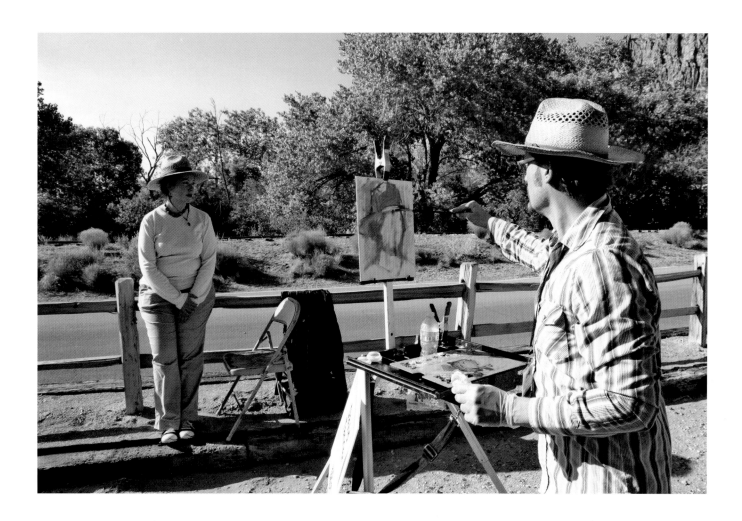

RURAL VERSUS URBAN SCENES

Most plein air paintings exhibited during festivals or presented in commercial galleries are rural landscapes in which barns, bridges, or houses establish a focal point. The concentration on rural landscapes results from many plein air artists' desire to be at one with nature in an open field, along a gravel road, or up on a mountain trail. It is also a response to collectors' wanting to have pleasant, nostalgic, or picturesque artwork on display in their homes and offices.

There are quite a few outdoor painters who like to paint urban scenes, however. Some of them are sociable people who like setting up their easels in locations where they can interact with passersby.

They have no problem working in the midst of a gathering of other sociable folks, and they often discover that casual observers become collectors after gaining an understanding of what plein air painting involves. Many people are turned off by a lot of contemporary art and appreciate discovering that there are a great many artists creating work they can understand, appreciate, and own.

Another motivation for painting urban scenes is that it can distinguish an artist from the vast

ABOVE: Virginia artist David Tanner painting a model posing outdoors.

number of landscape painters who compete in plein air events. The work of an urban painter stands out on a wall crowded with pictures of rural landscapes or boating scenes, mountain views, and seascapes. Just count the number of boat paintings in the Plein Air Easton festival in Maryland or the number of mountain scenes in a Jackson Hole, Wyoming, gallery and you will understand why some artists prefer to paint cars, trucks, and storefronts instead.

Several artists have achieved enviable success with paintings of buildings, street scenes, cafes, and restaurants—especially when the scenes are of collectors' hometowns. As every plein air painter knows, buyers often look for paintings of places they know

and love, and their interest increases when they watch a painting being created. That gives them a story to tell friends and family—a pleasure that goes beyond being able to identify the painting site.

Painting urban scenes requires a high level of drawing skill and a lot more preliminary planning than does pure landscape. Structures have to appear in accurate perspective and people, if they appear in the painting, have to be of the correct scale and proportion.

ABOVE: John P. Lasater IV, *Transformed by a Downpour*, 2015, oil on panel, 11 × 14 inches (27.9 × 35.6 cm). Collection of the artist.

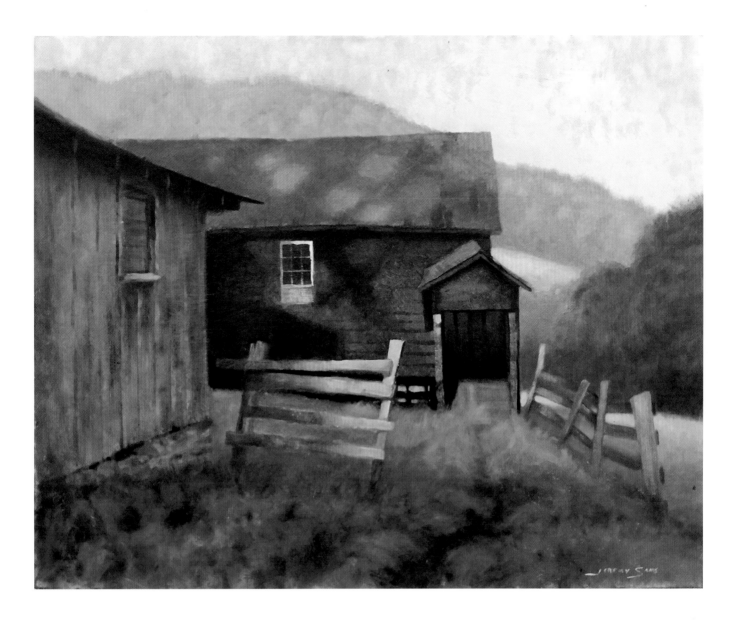

OIL PAINTS VERSUS NON-OIL MEDIA

Artists who paint with watercolors, acrylics, and pastels often complain that most plein air events are dominated by oil painters. There are, however, several reasons for the disproportionate number of oil painters at such events. One is that among all painters there are many more working in oil or watercolor than in pastel or acrylic, and most watercolorists prefer painting in the studio, where they have greater control over the paint's fluidity and drying time.

Despite the fact that relatively few non-oil painters are interested in working outdoors,

watercolors and acrylics are actually very well suited to outdoor painting. Both mediums are water soluble, and neither requires much in the way of supplies or equipment—or no more than what's necessary for oil painting. Also, some newer acrylic paints dry more slowly than traditional acrylics, solving the problem of the colors drying too quickly and forming an impenetrable surface.

Since 2010, there has been a great increase in

ABOVE: Jeremy Sams, *Sunrise at the Oakley Barn*, 2016, acrylic on canvas, 16 × 20 inches (40.6 × 50.8 cm). Collection of the artist.

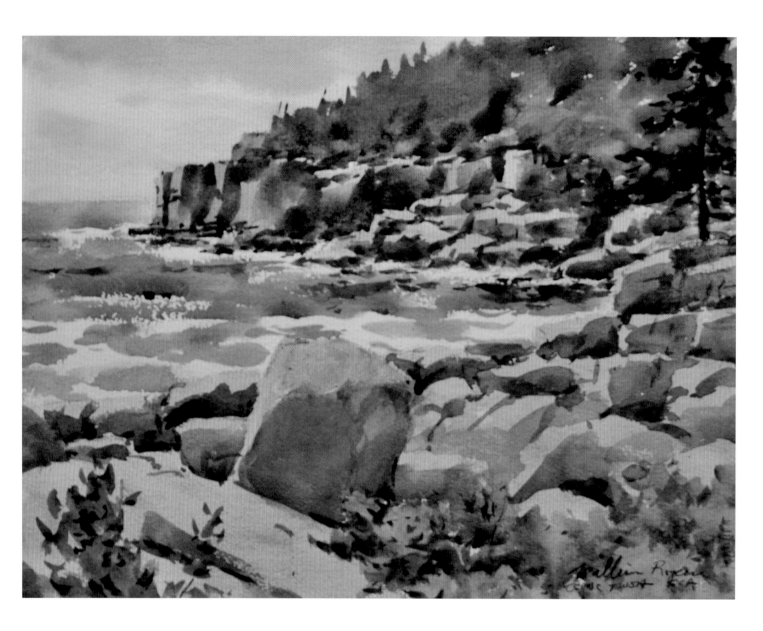

the number of non-oil painters competing in plein air events, in part because they want to share the excitement of outdoor painting and in part because many watercolor painters who do commercial illustrations have seen a steep decline in the number of clients willing to pay for original works of art rather than computer-generated images.

Despite this recent growth in interest, the vast majority of watercolorists who participate in competitions, workshops, and conventions still cling to painting techniques that are difficult to employ under the variable conditions that exist outdoors. Painters who want to build up separate transparent washes of color and allow each to dry thoroughly before applying the next will become frustrated if the air is excessively moist or, oppositely, if it is so hot and dry that the paint almost dries before it comes off the tip of the brush. Similarly, if they're accustomed to reserving the whites by blocking areas of the paper with the masking agent called frisket, they may find that high outdoor temperatures bake the frisket into the fibers of the paper. For these and other reasons, artists who enjoy using

ABOVE: William Rogers, *Otter Cliffs*, 2011, watercolor on paper, 10¹⁄₂ × 14 inches (26.7 × 35.6 cm). Collection of the artist.

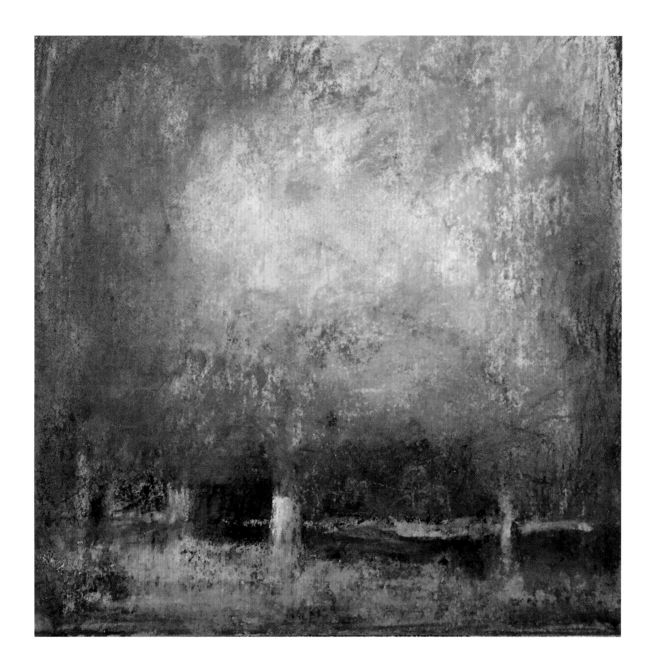

watercolors outdoors tend to work on a small scale and to use gestural brushstrokes rather than precise, highly detailed applications of color.

Pastel artists also find it difficult to transfer studio practices to the outdoors. In general, they like having dozens of pastels available in a full range of colors, values, and degrees of softness. But carrying 100-plus sticks of pastel to the top of a mountain or along a hiking trail is daunting, to say the least. To work outdoors successfully, they must learn to make do with a handful of carefully selected pastels and to simplify their technique. Forget the idea of trying to cram soft and hard pastels, pastel pencils, stumps, various sheets of paper, a hard backing board, clips, and denatured alcohol into a backpack with bug spray, sunblock, food, and water. Lots of pastel artists do work outdoors with amazing results, but they have had to radically adjust their studio techniques to work effectively on location.

ABOVE: Loriann Signori, *Rothko Trees*, 2014, pastel on paper, 8 × 8 inches (20.3 × 20.3 cm). Collection of the artist.

CLIVE R. TYLER

Colorado painter Clive R. Tyler frequently works on location, yet he considers the resulting pastel paintings to be explorations in problem-solving and note taking and not finished works of art unless they are created during a paint-out or a plein air festival. "My primary motivation is to try out compositions, gather information, and develop a sketch that can be used as reference material in the studio," he says. "I do think of them as independent works of art, but they are so useful to me in the studio that I don't want to part with many of them. I sometimes call them pages in a textbook I am writing on the subject of problem-solving.

"I value plein air painting because it provides an opportunity to witness nature, light, humidity, weather, and all the prevailing conditions," Tyler says. "It gives me a chance to stare at and analyze a scene for hours in order to accurately capture the values and light effects, to memorize the image so I can easily remember it in the studio, and to recall color variations that aren't recorded in a photograph.

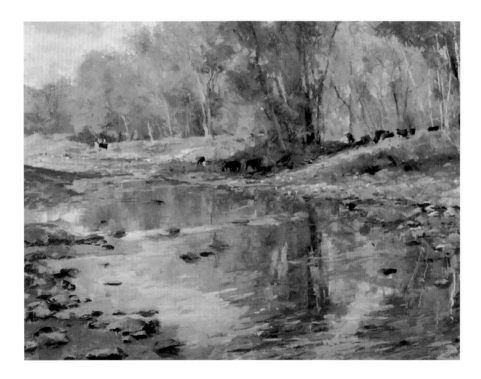

ABOVE: Clive R. Tyler, *Autumn*, 2014, pastel, 22 × 28 inches (55.9 × 71.1 cm). Private collection.

OPPOSITE: Clive R. Tyler, *Fall Poudre*, 2007, pastel 22 × 28 inches (55.88 × 71.12 cm). Private collection.

Studio painting proceeds more easily when I have already used and understood the rocks, river, trees, etc., and I can paint what I've observed. It's good for artists to work outdoors and nourish their souls.

"After spending time looking at and understanding nature, I make quick compositional ink drawings in a sketchbook, first with lines that establish the scale and placement of shapes, then with cross-hatching to suggest a composition of dark, middle, and light values," he explains. "When I am confident in my plan, I use pastel pencils to draw the outline of major shapes on a sheet of 800 grit UART sanded pastel paper. Then I establish an underpainting using Sennelier soft pastels exclusively—not the way an oil painter might tone canvas and not like other pastel painters might wash in color. For example, I might apply orange to the foreground, burgundy in shadow, etc., and then top those off with a complementary color of the same value. In another painting I might apply a lime green over orange and go back into those layers with ochers. I use the broad side of the sticks of pastel to get a kind of brush mark, movement, expression. In many cases, I paint cool colors under warm ones, warm colors under a cool blue sky, etc. All of that can bring more life to a painting. One layer sits side by side with or on top of another without being blended, creating broken color and an Impressionist style.

"I work with a somewhat limited palette of pastels on location," Tyler says. "I set up on an oil painter's plein air easel with about 100 sticks of pastels in a Tupperware container filled with rice flour that will keep the sticks clean. I have another set of pastels arranged from light to middle to dark values by color grouping. My goal is to express the fleeting light with independent strokes of color that come together when viewers stand back from the painting. It never bothers me when someone says that from a distance my paintings look like photographs. That may be one of the reasons I'm not automatically dismissed by people who assume my work is created with oils. Another reason might be that I frame the paintings with museum glass that doesn't have the glare of standard glass glazing. I'm delighted when people walk up close to one of my paintings and realize it was created with overlapping strokes of color that give it an abstract quality. At that point the medium becomes less important than the overall impact of the image."

OPPOSITE: OPPOSITE: Clive R. Tyler, *Winter Fall*, 2014, pastel, 22 × 28 inches (55.9 × 71.1 cm). Private collection.

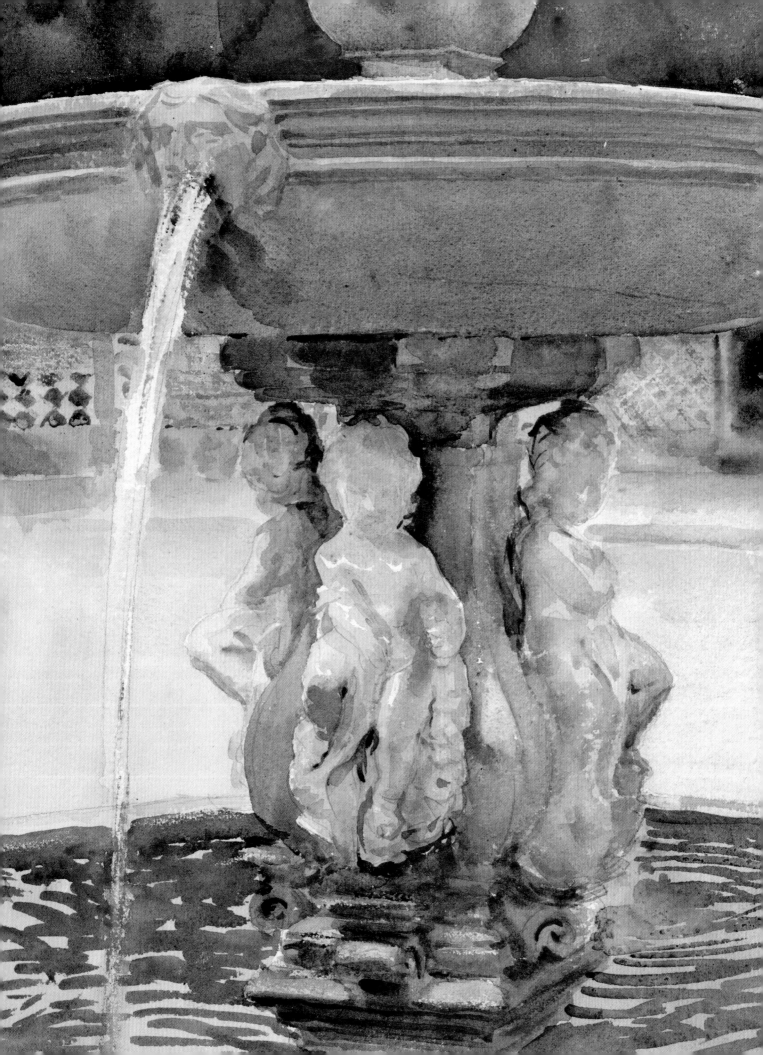

CHAPTER 2

A HISTORY
OF PLEIN AIR
PAINTING

by Daniel Grant and M. Stephen Doherty

There is no definite date when plein air painting began. The French artist Claude Lorrain (1600–1682) was renowned for his naturalistic landscapes, but his was not yet an era in which buyers wanted pure landscapes, so his outdoor scenes tended to feature seaports, towns, and figures from mythology. However, his sketchbooks are filled with drawings of fields, sea, and sky that he made on trips to Italy on his own or with fellow artist Nicolas Poussin (1594–1665). It wasn't until the latter part of the eighteenth century that landscape became an accepted subject for artists, led by Pierre-Henri de Valenciennes (1750–1819) in France and John Constable (1776–1837) in England. Both artists were zealots in the cause of getting artists to go outside to draw and paint. Valenciennes, who taught at the École des Beaux-Arts in Paris, encouraged his students to get a direct experience of nature, while Constable derided much of the painting of his time as "imitation." In 1802 he wrote to a fellow artist, "For the last two years I have been running after pictures, and seeking the truth at second hand."

Constable used quick, gestural strokes of paint that suggest short bursts of effort, but some other European artists who went outside to paint in the late eighteenth and early nineteenth centuries worked differently. For example, Camille Corot (1796–1875) and his fellow painters returned to the same painting site over the course of several days so they could refine their work.

OPPOSITE: John Singer Sargent, *Spanish Fountain*, 1912, watercolor and graphite on white wove paper, 21 × 13³/₄ inches (53.3 × 34.9 cm). Metropolitan Museum of Art, New York.

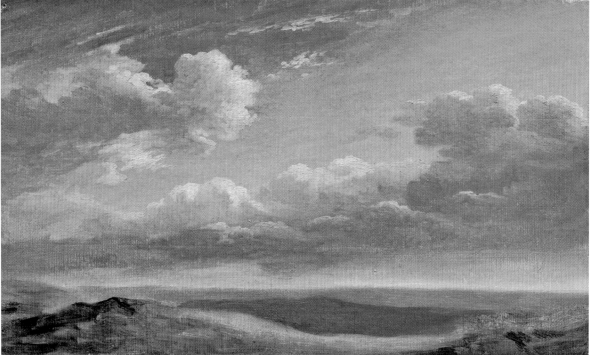

Sometimes, plein air artists did all their work outside; at other times, they refined their plein air sketches in their studios or used plein air drawings as the basis for studio oil paintings. Most plein air artists painted on heavy rag paper; the works were later attached to canvas or panels for durability.

TOP: Claude Lorrain (born Claude Gellée), *Artist Studying from Nature*, c. 1639, oil on canvas, 30³/₄ × 39³/₄ inches (78.1 × 101 cm). Cincinnati Art Museum, Cincinnati, Ohio.

BOTTOM: Pierre-Henri de Valenciennes, *Study of Clouds over the Roman Campagna*, c. 1782–1785, oil on paper on cardboard, 7¹/₂ × 12⁵/₈ inches (19 × 32 cm). National Gallery of Art, Washington, D.C.

In the opinion of many academically trained artists, Impressionism spelled the end of the oil sketch as a personal study tool (the *étude*) and the end of plein air painting as a fact-finding mission. The Impressionists redefined the plein air painting as a finished work of art (the *tableau*). Jennifer Tonkovich, drawings and prints curator at the New York City's Morgan Library, explains: "There was a change in tastes and in the market for art. The artists started to see these sketches not so much as their private visual diaries but as works for the market, things to show and sell at galleries."

JOHN CONSTABLE: MASTER OF LOOSE BRUSHWORK

Plein air watercolors and oils by the great British artist John Constable (1776–1837) have influenced generations of artists. Ironically, the qualities in these paintings that contemporary artists admire (including broad brushwork, suggested details, and dramatic patterns of light and dark values) are precisely the ones that critics in Constable's time disliked.

BELOW: John Constable, *The Hay Wain*, 1821, oil on canvas, 51 ³/₈ x 73 inches (130.6 × 185.4 cm). Collection National Gallery, London.

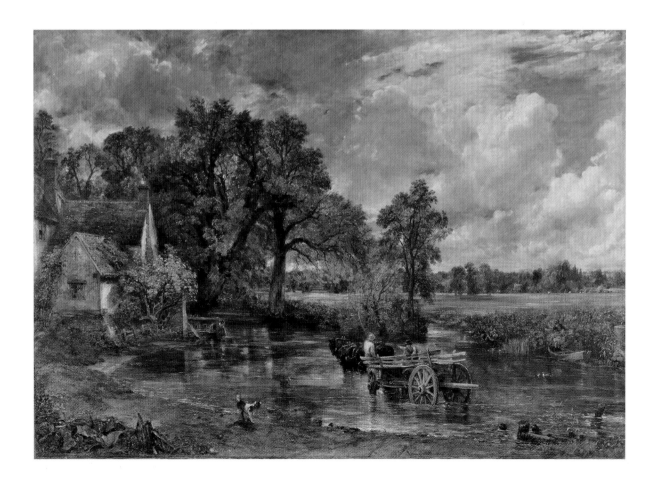

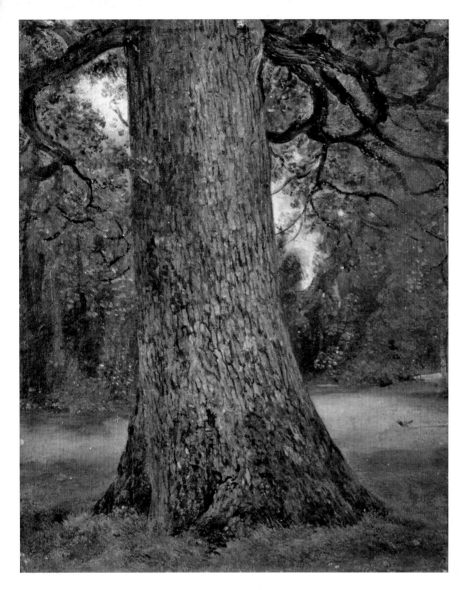

wanted to make a color study for his most famous painting, *The Hay Wain* (previous page), Constable redrew the lines of a preparatory drawing in ink on a sheet of glass. He then laid a piece of canvas over the glass drawing and illuminated it from below, redrew the lines he could see through the canvas, and then painted the transferred image on the canvas with oils. The resulting color study became source material for the painting of the English countryside. Those studies allowed Constable to compose and recompose the painting, often making radical revisions in his plans for *The Hay Wain*. One of those revisions involved changing the direction of light in such a way that the artist completely reversed the pattern of light and dark from what he had originally planned.

Constable was by no means the first or the most important artist to paint directly from nature, and he would certainly give credit to Claude Lorrain, whom he considered to be "the real student of Nature." Constable was inspired both by Lorrain's extraordinary paintings and by his dedication to plein air drawing and painting. Lorrain "devoted himself to study with an ardour and a patience perhaps never before equalled," Constable wrote. "He lived in the fields all day and drew at the Academy at night."

ABOVE: John Constable, *Study of Trunk of Elm Tree*, c. 1821, oil on canvas, 12 × 9¾ inches (30.5 × 24.8 cm). Victoria and Albert Museum, London.

Typical of artists who worked directly from nature, Constable did most of his painting on stiff, heavy sheets of cotton fiber paper. At various times, he also worked on panels, millboard, and canvas, and toward the end of his career he painted on sheets of a paper laminate he made himself by gluing together two sheets of paper and priming the surface with a colored ground. He made several large sheets at a time, cut them into manageable sizes, and took a number of different-size sheets with him so he could select the best format to record a particular scene.

Constable thought of his plein air sketches as studies for larger studio works, so he sometimes painted over completed oil sketches or over the lines of transferred drawings. For example, when he

Corot: An Early Outdoor Painter by Christopher Volpe

Jean-Baptiste-Camille Corot (1796–1875) has long been considered one of the greatest landscape painters of all times, and his influence has been so pervasive that a *Newsweek* magazine article in 1940 quipped that "of the 2,500 paintings Corot did in his lifetime, 8,500 are to be found in America."

In particular, the plein air paintings Corot created during several trips to Rome dramatically impacted the course of outdoor painting. The French Barbizon and Impressionist artists considered him a "true artist" (in the words of Delacroix), and today many painters have the mistaken belief that plein air painting began with Corot.

Even though he eventually gained this exalted status, Corot was dismissed by critics and collectors until he was almost fifty years old. It took a change in the political climate and the support of a few artist friends and collectors for him to gain respect and entry into the important Salon exhibitions.

TOP: Charles Desavary, *Portrait of Camille Corot Painting,* July 1873, albumen print, 5 ¼ × 4 inches (13.3 × 10.2 cm). George Eastman House, Rochester, New York; gift of Eastman Kodak Company.

BOTTOM: Jean-Baptiste-Camille Corot, *The Arch of Constantine and the Forum,* Rome, 1843, oil on paper mounted on canvas (lined), 10 ⅝ × 16 ½ inches (26.9 × 41.9 cm). The Frick Collection, New York.

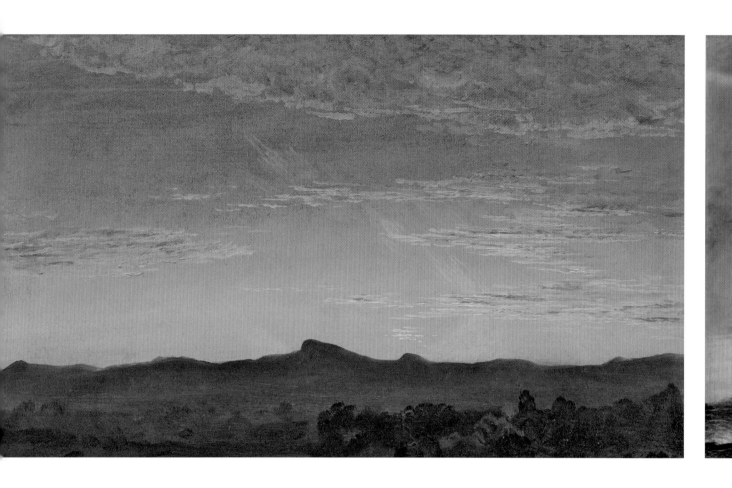

THE AMERICAN
HUDSON RIVER SCHOOL

In the first half of the nineteenth century, Thomas Cole initiated an approach to landscape painting that celebrated the beauty of the rivers and mountains north of New York City in highly detailed, romantically charged oil paintings. This approach was the foundation of the so-called Hudson River School of Art, the United States' first indigenous art movement. Members of the school and younger artists influenced by it included Thomas Moran, William Stanley Haseltine, Jasper Francis Cropsey, Albert Bierstadt, and Frederic Edwin Church.

In 1857, Frederic Church (1826–1900) unveiled his 40 x 90 painting of Niagara Falls, opposite. Publicity about the painting attracted more than 100,000 people, each of whom paid twenty-five cents to see the colossal masterwork. That enthusiastic public response was not accidental or unexpected. From the very beginning of his celebrated career, Church drew attention by creating blockbuster-size landscape paintings of exotic and captivatingly dramatic locations. Some of those depictions were reports of what the artist had

ABOVE: Thomas Cole, Study for *Catskill Creek*, c. 1844–1845, oil on wood, 12 × 18 inches (30.5 × 45.7 cm). National Gallery of Art, Washington, D.C.; Avalon Fund.

OPPOSITE: Frederic Edwin Church, *Niagara*, 1857, oil on canvas, 40 × 90½ inches (101.6 × 229.9 cm). Courtesy of the National Gallery of Art, Washington, D.C.; Corcoran Collection.

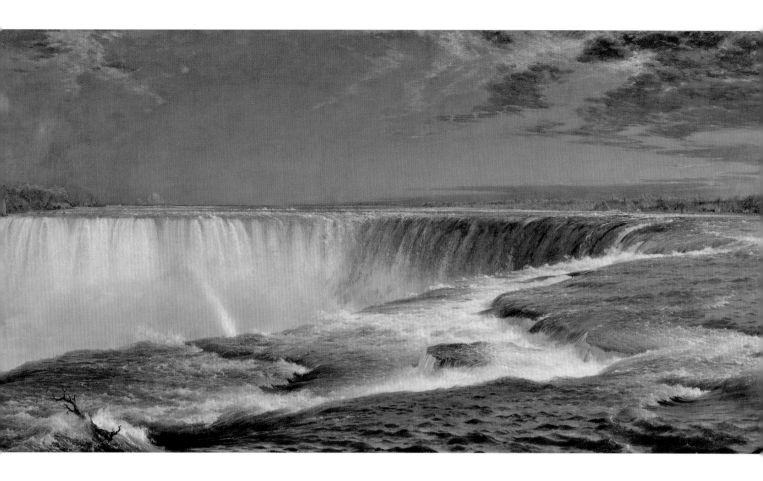

actually discovered on location; others were imaginative compilations of the plants, animals, volcanoes, rivers, waterfalls, and people the artist had sketched and painted when he made trips to Central and South America, Cuba, and Mexico. The physical and creative challenges he set for himself were monumental.

Church was not the only great American artist who built his career on attention-getting, large-scale paintings. Albert Bierstadt (1830–1902) filled massive canvases with dramatic storms, skyscraper-size waterfalls, and remote mountain landscapes. Some of the best wildlife artists of the twentieth century, including Carl Rungius (1869–1959), created large, curved backdrops for dioramas in natural history museums by referring to studies created on location in Africa, South America, Europe, and the United States.

Most Hudson River School painters trained in the academic tradition that emphasized skillfully recording subjects from direct observation, memory, and imagination. To accomplish that, they started by accurately drawing the skeletal structure of the human figure, adding the musculature, and then covering the form with skin. The underlying assumption of this course of study was that if artists could draw the human form with absolute accuracy, they could paint any subject—whether from direct observation, stored memories, or knowledge of anatomy, botany, geology, and meteorology. Those skills enabled Cole, Church, Bierstadt, and others to use their sketches, memory, and knowledge to create large studio paintings that were at once totally convincing and, at the same time, completely imaginative.

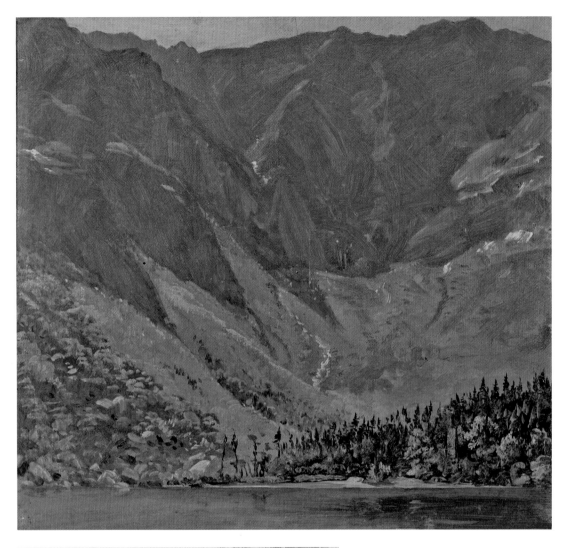

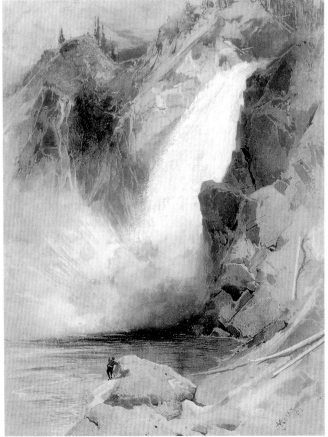

ABOVE: Frederic Edwin Church, *Great Basin, Mount Katahdin, Maine*, 1878, oil and traces of graphite on paperboard, 12 × 12¹⁵/₁₆ inches (30.5 × 32.8 cm). Cooper-Hewitt National Design Museum, Smithsonian Institution, New York.

LEFT: Thomas Moran, *Upper Falls, Yellowstone*, 1872, watercolor and body color (opaque watercolor) on paper, 11 × 8¹/₂ inches (27.9 × 21.6 cm). Collection of Yellowstone National Park, National Park Service, U.S. Department of the Interior.

Drawing from Nature

Although this book deals primarily with painting outdoors, it should be mentioned that many great artists, past and present, have created drawings directly from nature. Some of those artists thought of their drawings as preparatory sketches or detailed studies to potentially be used in developing studio paintings, while others considered their drawings to be independent works of art. The great American artist Asher B. Durand (1796–1886) was one such draftsman. In the plein air drawing reproduced here, you can see that Durand drew on toned paper, sometimes using pen and ink and sometimes starting with graphite and charcoal and later enhancing the image with white chalk.

RIGHT: Asher B. Durand, *Study of Trees, Shandaken, New York*, 1849, graphite, white gouache, white lead pigment on gray-green paper, 13 7/8 × 10 inches (35.2 × 25.4 cm). Collection of the New-York Historical Society.

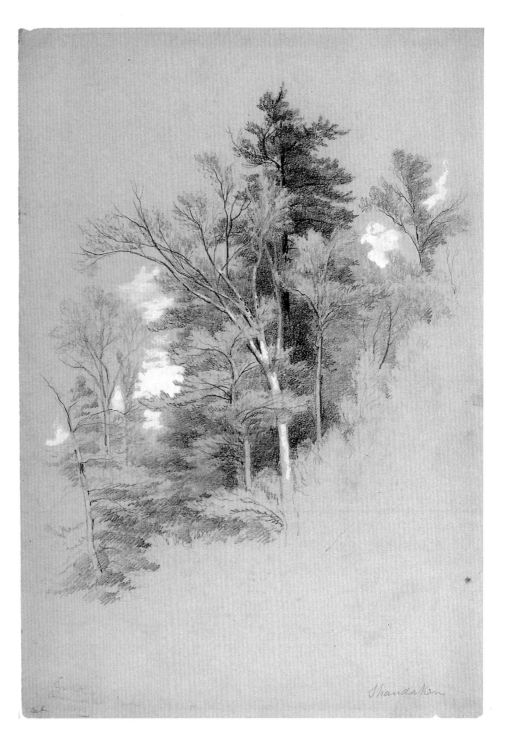

THE FRENCH BARBIZON SCHOOL AND THE IMPRESSIONISTS

From 1830 to 1870, French artists belonging to the so-called Barbizon School carried their painting equipment to royal parks outside Paris and to locations farther out in the countryside. Among the most popular destinations was the Forest of Fontainebleau, a 42,000-acre, densely wooded area that was accessible to members of the growing French leisure class, who could now reach the forest by train. (The nearby village of Barbizon gave the school its name.) The wide variety of tree specimens, open meadows, farming communities, and quaint villages was a great attraction for landscape painters, especially Théodore Rousseau (1812–1867), Jean-François Millet (1814–1875), and Charles-François Daubigny (1817–1878). By 1870, however, younger artists were moving west out of Paris along the Seine River to find new subjects suitable to the brighter, more colorful style of painting that came to be known as Impressionism.

The French Impressionist painters had a lasting influence on the worldwide interest in outdoor painting. Sometimes working side by side, artists like Claude Monet, Camille Pissarro, Auguste Renoir, and Mary Cassatt advanced the idea of using broken strokes of color to represent their direct observations. In 1872, Monet moved to Argenteuil, France, on the Seine River just a short train ride from Paris, and he bought a small boat and turned it into a floating studio. He sat inside and on the bow of the boat while it was anchored offshore so he could create plein air paintings of the shoreline and the reflections of boats, buildings, and trees in the water. Later, Monet moved to a sumptuous home and garden in Giverny, which became a magnet for European and American artists, including John Singer Sargent, Willard Metcalf, and Theodore Wendel.

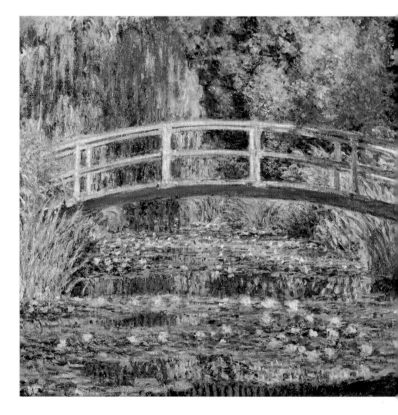

ABOVE: Claude Monet, *Water Lillies and Japanese Bridge*, 1899, 35⅝ × 35⁵/₁₆ inches (90.5 × 89.7 cm). Collection of The Art Museum, Princeton University.

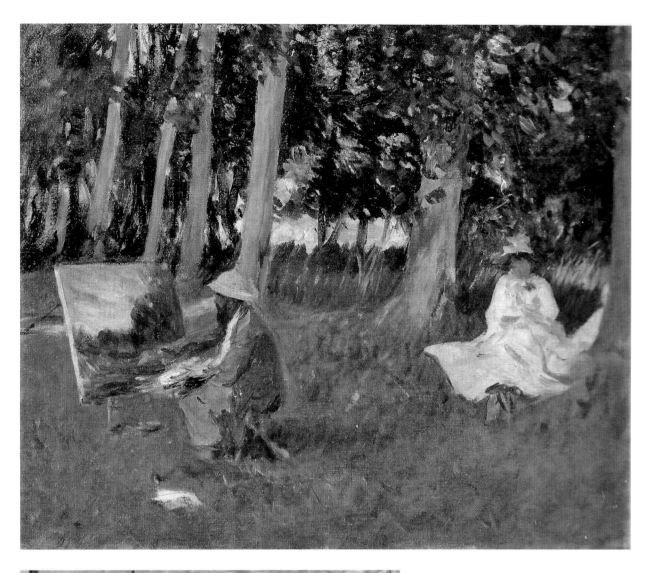

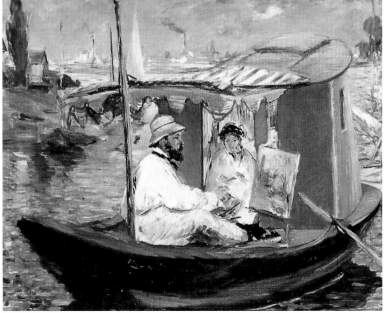

ABOVE: John Singer Sargent, *Claude Monet
Painting at the Edge of a Wood*, 1885, oil on
canvas, 21 × 25¼ inches (53.3 × 64.1 cm).
Tate Gallery, London.

LEFT: Édouard Manet, *Monet in His Studio
Boat*, 1874, oil on canvas, 39½ × 32½ inches
(100.5 × 82.5 cm). Neue Pinakothek, Munich,
Germany.

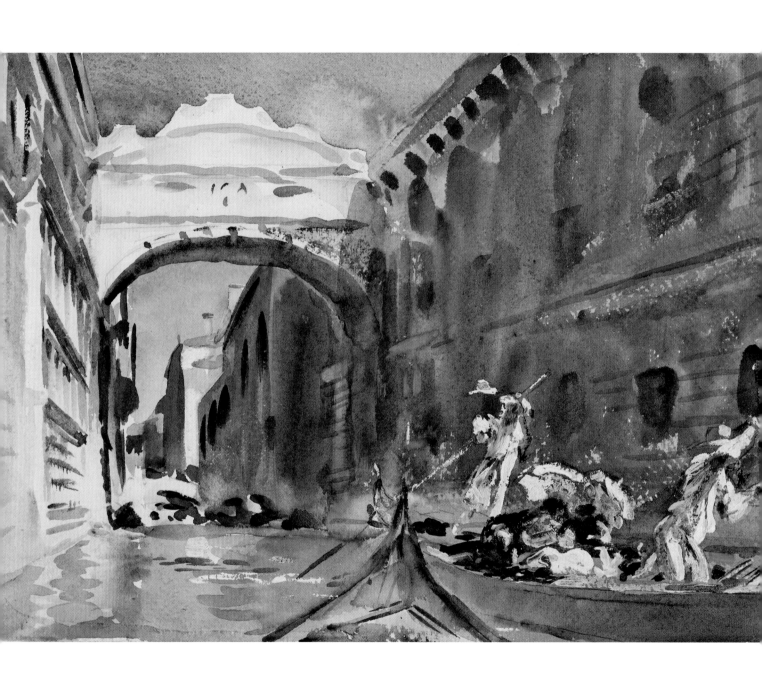

ABOVE: John Singer Sargent, *Bridge of Sighs*, 1904, watercolor on paper, 25²/₅ × 35³/₅ inches (64.5 × 90.4 cm). Brooklyn Museum of Art, New York.

Impressionism and Contemporary Plein Air Painting

French and American Impressionist artists of the nineteenth century validated plein air painting as a legitimate style of expression, and contemporary artists embrace many of their ideas. Although art historians define Impressionism in very narrow terms, today's painters apply the term to a wide range of approaches that employ broken brushwork, visual interaction between colors, and the suggestion of details through independent strokes of color. Like the Impressionists, painters today also use plein air sketches as studies for studio paintings. In fact, it is hard to imagine contemporary painters following the older academic approach—which could involve hauling a backpack full of supplies to the top of a mountain, working through a careful drawing, developing a monochromatic grisaille underpainting, and then glazing transparent color over a completely dry painting surface.

Artists achieve an Impressionist look in their outdoor paintings by working quickly with thick strokes of opaque colors, using relatively big bristle brushes, adding very little medium to their paints, and premixing the colors that dominate the scene they intend to paint. All these techniques help them to record their observations quickly and to capture both the look and the mood of their subjects.

In my painting at right, you can see how dabs of color can come together to create an "impression" of a landscape. The finished painting is composed of thick, unblended strokes of oil colors laid down with a stiff bristle brush. My intention was to convey the powerful presence of the large tree hovering over the creek, the sunlight filtering through its leaves, and sparkle of light touching the flowing water and scattered rocks. I did not blend the edges of the marks, so there are no soft transitions between patches of color.

ABOVE: M. Stephen Doherty, *Back Creek Maple*, 2016, oil on canvas, 14 × 11 inches (35.6 × 27.9 cm). Collection of the artist.

AMERICAN IMPRESSIONISTS AND TWENTIETH-CENTURY OUTDOOR PAINTERS

During the late nineteenth century, wealthy patrons paid for American artists' study in Europe, where they came under the influence of the Impressionists. The Americans were excited about painting outdoors with bright, unblended oil colors, but they had their own way of using the Impressionist style of painting. Returning home, some American Impressionists set up artists' colonies in Indiana, Connecticut, Illinois, New York, and California, teaching students outdoors. Their students went on to promote plein air painting in other locations. In the early decades of the twentieth century, groups of plein air painters were working in almost every region of the country. J. Alden Weir hosted painters at his home in Ridgefield, Connecticut; William Merritt Chase ran a school in Shinnecock Hills, New York; Guy Rose painted with friends in Carmel-by-the-Sea, California; T. C. Steele invited members of the Hoosier Group to paint at his home in Brown County, Indiana; and six artists formed the Taos Society of Artists in New Mexico.

The postwar growth of the American middle class brought an increase in the number of people interested in making art, many of whom joined workshops and classes focused on plein air painting. Artists like Andrew Wyeth (1917–2009), Fairfield Porter (1907–1975), and Isabel Bishop (1902–1988) set up their easels in the field or on the street. Some thought of their plein air paintings as studies

for studio paintings, but others completed their pictures outdoors without making adjustments in the studio.

During the latter part of the twentieth century, some artists shifted their attention from bucolic scenes to ones that reflected a world of rapid change, painting poor communities, industrial scenes, and military installations. That was

ABOVE: Unknown photographer, photograph of William Merritt Chase painting outdoors, c. 1900, approx. 3 9/16 × 3 9/16 inches (approx. 9.0 × 9.0 cm). Collection of the Archives of American Art, Smithsonian Institution, Rockwell Kent papers.

OPPOSITE: Fairfield Porter, *Island Farmhouse*, 1969, oil on canvas, 79 7/8 × 79 1/2 inches (202.9 × 201.9 cm). Private collection.

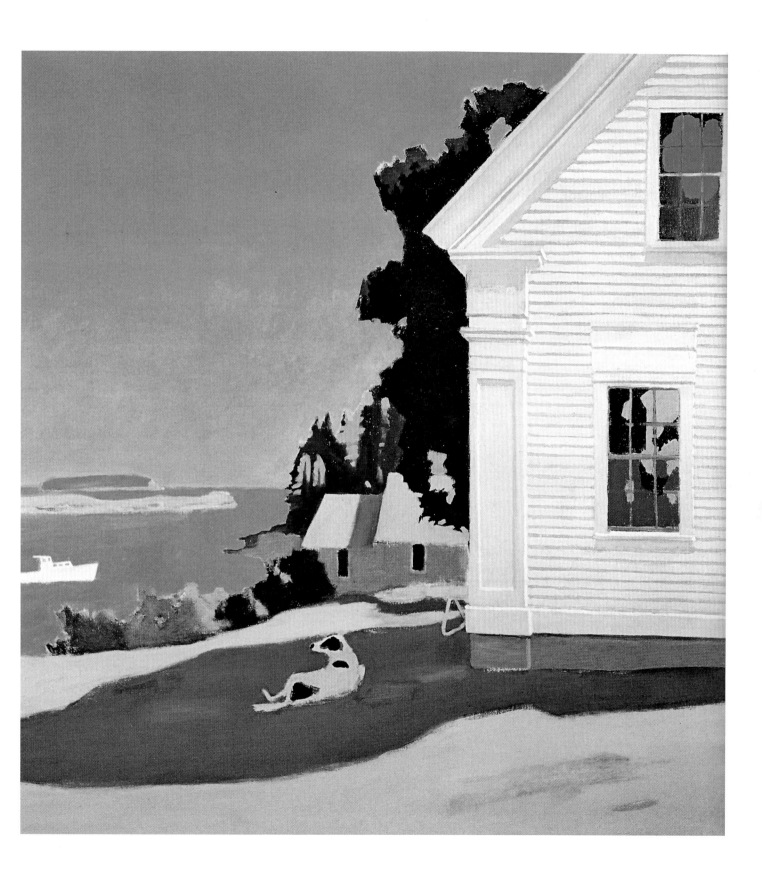

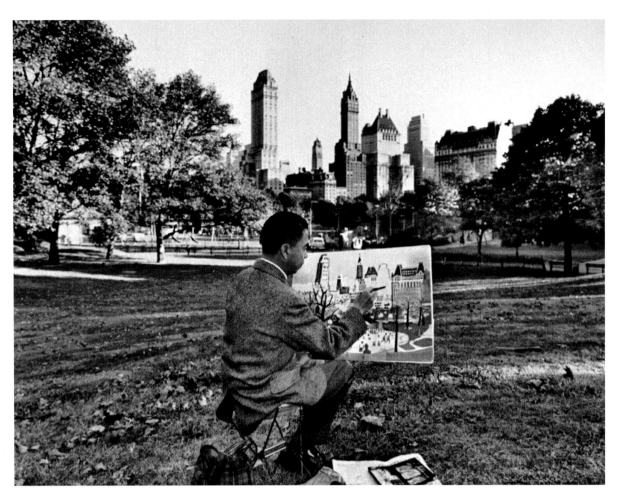

especially true of watercolorists like Californians Dong Kingman (1911–2000) and Ken Potter (1926–2011), who painted the reality that surrounded them. Kingman, who also worked as an illustrator in Hollywood, eventually settled in Brooklyn, New York, and taught at Columbia University and Hunter College. Potter was renowned for his scenes of San Francisco, including depictions of the many changes the city was undergoing in the mid-twentieth century.

ABOVE: Watercolorist Dong Kingman painting in Central Park, 1959. Photo courtesy of CaliforniaWatercolor.com.

LEFT: Ken Potter painting outdoors with watercolors in San Francisco, 1963. Photo courtesy of CaliforniaWatercolor.com.

CLYDE ASPEVIG

ABOVE: Clyde Aspevig, *Junkyard Pump,* 2015, oil on linen, 10 × 12 inches (25.4 × 30.5 cm). Private collection.

Montana artist Clyde Aspevig has long been a leading force among plein air painters, although he now focuses more attention on creating large studio paintings and on supporting organizations that preserve the subjects he paints. Aspevig was influenced by Denis Dutton's 2009 book *The Art Instinct: Beauty, Pleasure, and Human Evolution,* which explores the premise that our ability to appreciate and create art is as integral to the human condition as language or social relationships, as well as by Daniel Levitan's 2006 book *This Is Your Brain on Music: The Science of a Human Obsession,* which investigates the reasons every culture has created music and some form of representational art. Says Aspevig: "I've been intrigued by all these ideas, as well as the related 'savanna hypothesis,' which postulates that we are automatically predisposed to look for protective living areas—fenced backyards, shelters, and trees and other places that offer 'prospect and refuge.' According to anthropologists, those landscapes take us away from chaos yet afford views of potential threats.

"I think about these ideas when I'm working in the studio, and I am less dependent on the identification of one specific place," Aspevig says. "When I'm staring out from behind my pochade box in the field, I'm trying to respond to one moment in time at one particular location. Field studies are like feelers for locating good ideas, considering a direction, or visualizing how a painting might take shape. Conversely,

when I'm in the studio I'm harnessing impulses and ideas from a variety of sources, including the field studies, my memories, and the ideas I have been considering."

One significant source of Aspevig's painting ideas is music, about which he writes eloquently in his 2010 book *Visual Music*. "When you organize a painting in musical terms, you make it easier for people to understand and appreciate because there are rhythms that help them travel through that painting. Again, we all seem to have an instinctive way of relating to music and art." Aspevig makes reference to those basic instincts when writing, for example, about aspen trees dividing a horizontal landscape into a rhythmic pattern, ocean waves rising and falling like the sounds from an orchestra moving toward a shoreline and then pulling back with the undertow, or warm and cool colors acting like contrasting sounds. He points out that in each case the sense of mood and movement is similar in both music and art.

"I found that offering a lecture and a demonstration was as effective a way of helping other artists and collectors as teaching a week-long workshop, so I began turning down invitations to spend ten or fourteen days away from my studio," Aspevig explains. "I also became more involved in supporting nonprofit organizations such as the American Prairie Reserve and the Montana art-education group Arts Without Boundaries because I believe conservation and education are the foundation for the future."

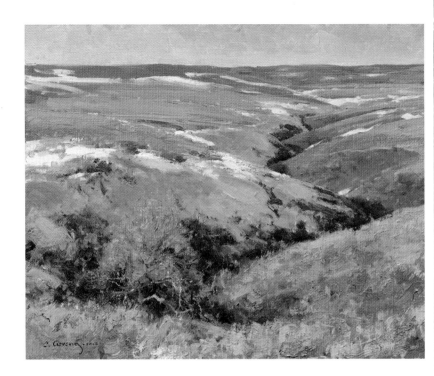

ABOVE: Clyde Aspevig, *Snow Capture*, 2015, oil on linen, 10 × 12 inches (25.4 × 30.5 cm). Private collection.

OPPOSITE: Clyde Aspevig, *Sargent Point*, 2014, oil on linen, 40 × 50 inches (101.6 × 127 cm). Private collection.

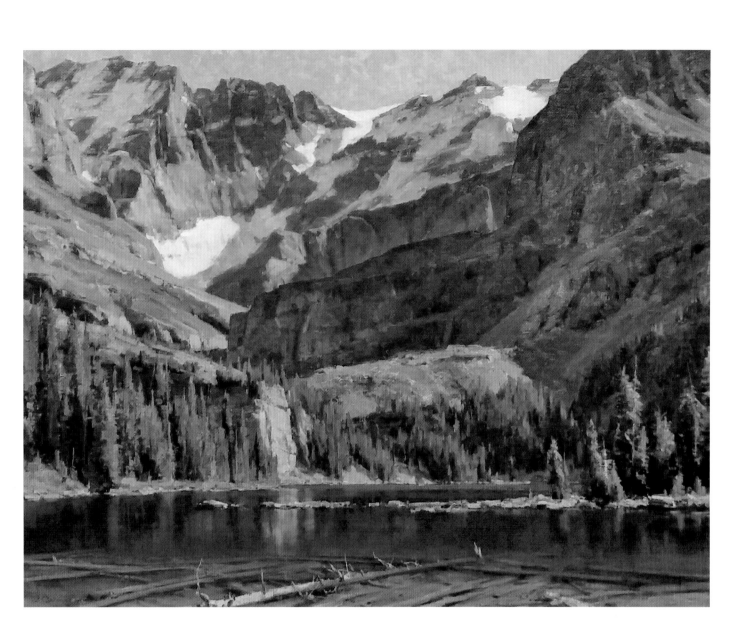

RIGHT: Clyde Aspevig, *Boulder River*, 2015, oil on linen, 10 × 12 inches (25.4 × 30.5 cm). Private collection.

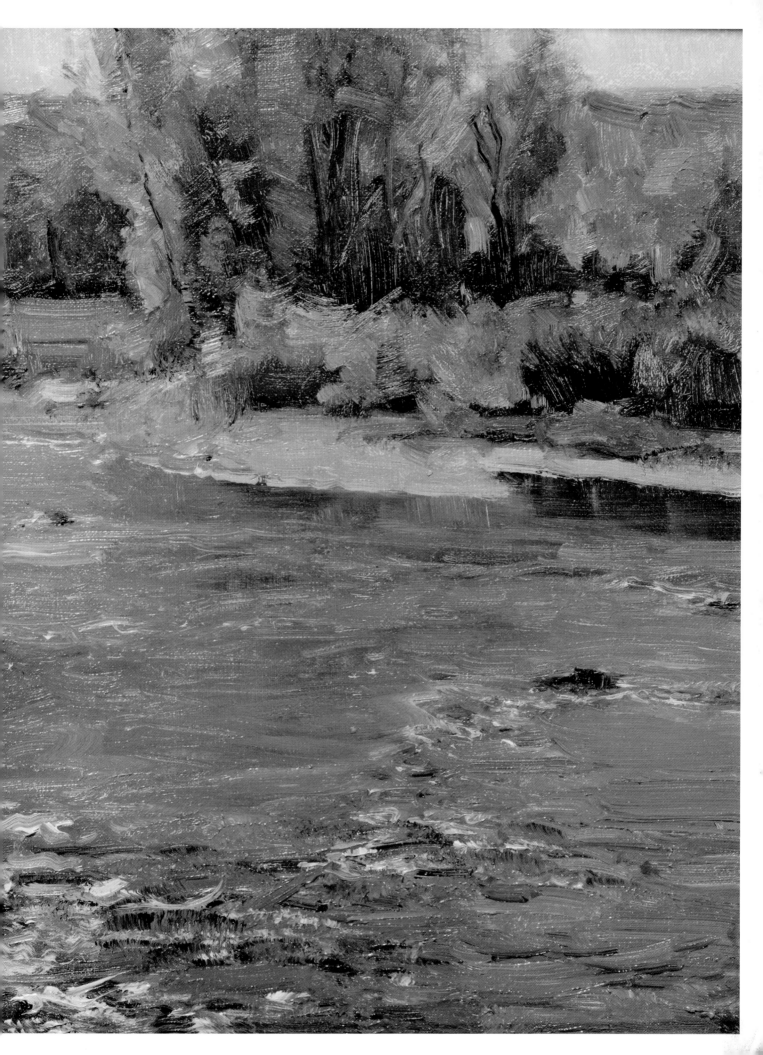

CHAPTER 3

THE LEARNING
PROCESS

Learning to paint *en plein air* means overcoming a number of challenges. For example, most of us have a tendency to draw and paint what we *know* rather than what we actually *observe*. Our preconceived ideas are that grass is green, skies are blue, and brick buildings red. We hold firmly to those ideas even though the ground might actually appear to be ocher or tan, the sky might be orange and pink at sunset, and a shadow might turn a red brick building purple.

Our observations are influenced by weather, atmosphere, seasonal characteristics, and changes of light. Once you learn to go beyond what you *expect* and to objectively evaluate what you *see*, you can put aside your assumptions and begin painting convincing plein air paintings. This is the first step in becoming a skilled outdoor painter.

The second challenge is to become thoroughly familiar with a selected group of artists' pigments that *approximate* the colors in nature. Painters usually work with four to sixteen tube colors and not the infinite number of colors in the visual world. Moreover, each synthetic or natural pigment in a paint (whether oil, watercolor, or acrylic) has properties that influence the way paints intermix and overlay. Some are opaque while others are transparent; some are cool while others are warm in temperature. Also, some paints dry quickly and to a matte finish while others dry slowly and have a lustrous finish.

OPPOSITE: M. Stephen Doherty, *Private Garden in Spring*, 2013, oil on panel, 11 × 14 inches (27.9 × 35.6 cm). Collection of the artist.

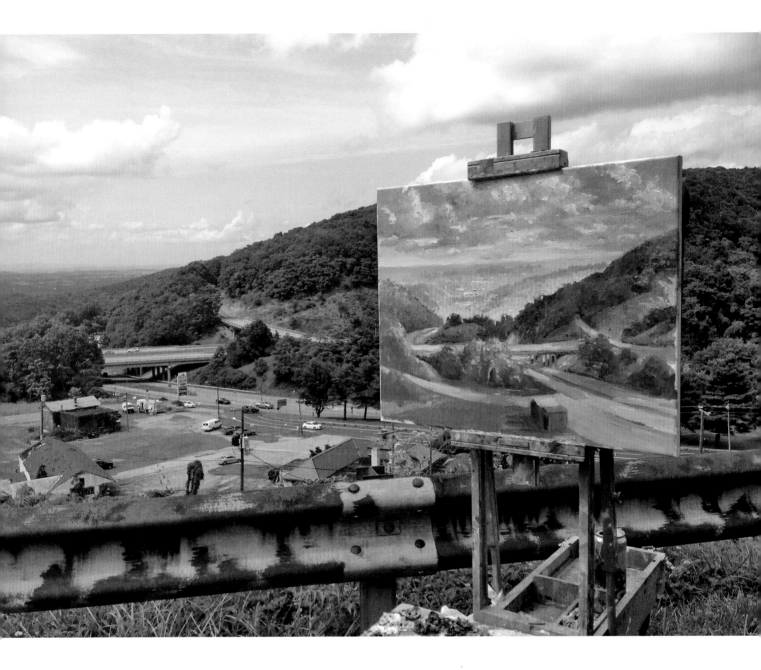

Finally, your education in plein air painting has to include instruction in working quickly to capture the fleeting pattern of sunlight and shadow and to maintain your energy and focus. A studio painter may take naps, coffee breaks, and phone calls, but a plein air painter has to remain committed to recording as much information as possible within a limited amount of time.

Unfortunately, some artists progress through these stages but still cling to the idea that they must paint every branch of a tree, every brick in a wall, and every color they see. Workshops are sometimes filled with "experienced" painters who

have never put aside their habits, expectations, and assumptions, and their plein air paintings remain stiff, stilted, and unnatural. The difficult challenge that workshop instructors face is to convince those students that their attitude can present as much of a challenge as the knowledge and varied experiences they need to acquire.

ABOVE: M. Stephen Doherty, *View from Rockfish Gap*, 2014, oil on canvas, 16 × 20 inches (40.6 × 50.8 cm). Collection of the artist. **))** Because of the complexity of this wide-angle view and the great depth between the foreground and background, I had to hold on to the initial pattern of light and dark throughout the painting process.

FOCUSING YOUR FIRST EFFORTS

The most effective art teachers take students through a series of exercises that break down the painting process into the basic issues of design, relative value, relative color temperature, color mixtures, and edge control. One exercise is to have students paint with only burnt umber plus white (or black plus white) so that they have to pay attention to the key design issues. Another is to limit the students' palette to three primary colors and white so that they have to explore mixing a complete range of colors. Yet another has the students paint from photographs turned upside down so that the relationships between shapes and values become more important than the images recorded by the camera.

In my own workshops, I like to spend the first day indoors talking to students about photographs of subjects they are interested in painting. I find out why they are attracted to certain images, because that will determine what to emphasize or eliminate from a scene while painting. Then I suggest steps to take the students through the painting process successfully, tailoring my suggestions to the medium they want to use. My purpose is to get the workshop participants to spend time thinking, seeing, and planning before they pick up a paintbrush. I want them to consider how to get the most out of their time outdoors.

All workshops are tailored to the medium the participating artists have chosen to use. That's because the stages of painting with oils are

TOP: Texas artist Ron Rencher doing a demonstration during a workshop he taught.

BOTTOM: Georgia artist James Richards teaching a workshop.

completely different from those followed with watercolor, pastels, or acrylics. Adjustments have to be made in the planning and execution of paintings. Oils are opaque and dry slowly; watercolors are transparent and dry quickly; acrylics are opaque and dry quickly to a permanent film; and pastels are a dry medium that can be smudged.

The most common way to begin a plein air painting is to draw the outlines of the major shapes with a thin mixture of an oil color. The photo shows the site being depicted: Wigwam Falls, in Rockbridge County, Virginia.

STEP 1

Roughly outline the basic forms to establish their scale and placement and to determine the compositional flow of spaces within the picture.

STEP 2

Now establish the sense of space and light by defining the separation between the warm, sunlit shapes and the cool, shadow colors.

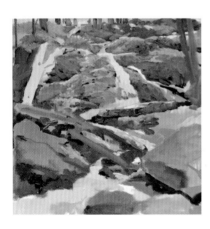

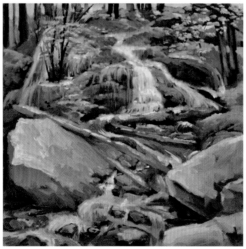

STEP 3

Paying attention to the initial statements about shapes, color, and values, proceed to block in smaller shapes.

STEP 4

Over several hours of painting on location, you can add details to further define the character of the rocks and trees as well as the light flowing from the background to the foreground. The finished painting is pictured.

ABOVE: M. Stephen Doherty, *Wigwam Falls*, 2013, oil on canvas, 20 × 20 inches (50.8 × 50.8 cm). Collection of the artist.

ATTENDING DEMONSTRATIONS AND WORKSHOPS

One way to turn passive study into active painting is to attend demonstrations and workshops. Demonstrations usually take place during regular meetings of art organizations, and are sometimes conducted in art-supplies vendors' booths during conventions. Workshops, on the other hand, are three- to fourteen-day-long educational programs. Often, participants have to travel some distance to attend and must stay in a motel or school dorm. For example, the six-day-long Kanuga Watermedia Workshops are held at an Episcopal Church retreat camp in Henderson, North Carolina. Eight to ten classes take place simultaneously in various buildings on the extensive grounds, and students are housed in cottages, guesthouses, and a nearby hotel.

Different workshops are structured differently and provide varying levels of learning and satisfaction depending on the instructors' experience and responsiveness. In a typical format, the workshop begins with demonstrations by the teacher, followed by an opportunity for the students to paint and the teacher to comment on the work being done. There may also be a time at the end of the workshop when the instructor offers a critique of all the paintings that have been created; sometimes this can be a very stressful activity for students.

Unfortunately, not everyone who offers workshops is well organized, has strong communication skills, is empathetic, or encourages students with

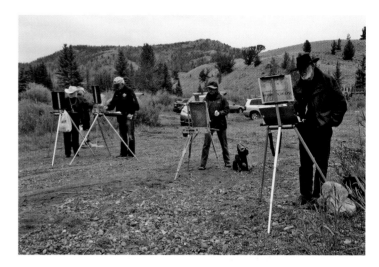

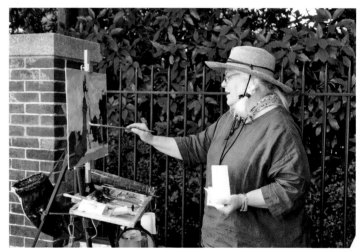

TOP: Hodges Soileau teaching as he develops a plein air painting

BOTTOM: Dawn Whitelaw painting during Plein Air Richmond, in Virginia.

positive comments. One nationally known artist was known to be so harsh in his criticisms that students were reduced to tears. Another spent most of his time painting and expected students simply to watch silently. My point in mentioning this is to recommend that before you sign up for a workshop and commit your money and time, you should find

out as much as you can about how the class will be run and decide whether you really like the instructor's artwork. You might also want to talk to your artist friends or people who have recently studied with the artist to learn more about his or her personality and teaching method.

One of the best things about any workshop is the chance to meet informally with other students and make friends with people who share your interest in art. You'll pick up a lot of helpful tips about painting and professional activities, and you'll be comforted by the fact that just about everyone else feels the same anxieties, confusions, and joy as you. As one workshop participant said to me, it is like studying a language for years and finally being in the country where it is spoken.

DEMONSTRATION: STARTING WITH WASHES

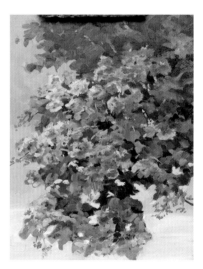

For a painting of crepe myrtle blossoms cascading from a fence, my challenge was to capture the flow of shapes, not necessarily the exact scale of the forms or their spatial relationships.

STEP 1
First, I covered the panel with a wash of thinned yellow ocher oil color, then wiped out the lightest values with paper towels and added middle values with red iron oxide paint.

STEP 2
Using a broader palette of thick oil colors, I then blocked in the leaves and blossoms without completely covering the underlying warm tones. The finished painting is pictured.

ABOVE: M. Stephen Doherty, *Maryland Crepe Myrtle*, 2015, oil on canvas, 14 × 11 inches (35.6 × 27.9 cm). Collection of the artist.

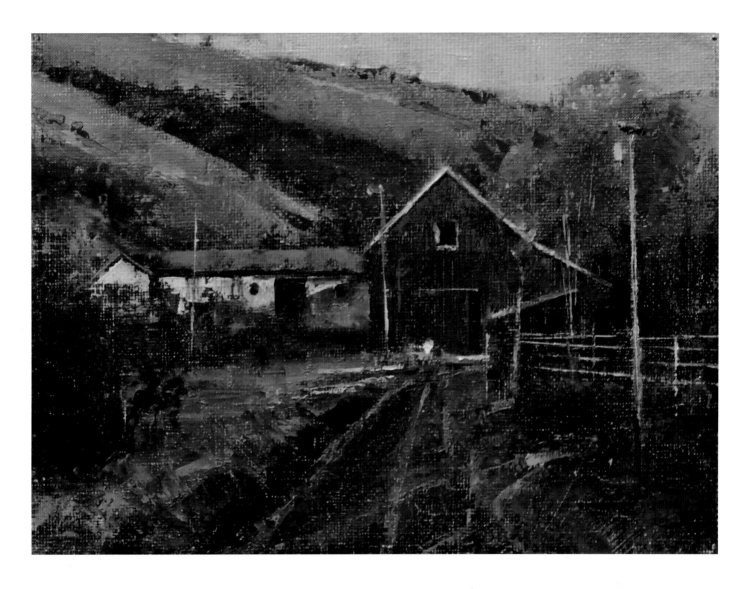

DEVELOPING A PERSONAL STYLE

When the editors at an art book company conducted a survey to determine the subjects they should cover in upcoming publications, one of the top requests was for a book that provided specific guidance in establishing a distinctive, personal style. The respondents were looking for help in bringing an identifiable look to their paintings, one that would help make their paintings easier to identify and appreciate and more attractive to potential buyers. When the editors searched for someone who could develop such a book, however, they couldn't find an author capable of giving dependable advice and concrete examples of such an individual, personal quality.

Style may be both the most important and the most elusive aspect of painting. It requires mastering the fundamentals—drawing, shapes, values, edges, perspective, scale, balance, harmony, and surface development—but also searching for what will express the artist's individual response to a subject as well as his or her ability to communicate that expression to people who view the work. Most artists begin their

ABOVE: Brent Cotton, *Turquoise Roof*, 2015, oil on canvas, 6 × 8 inches (15.2 × 20.3 cm). Private collection.

careers exploring variations on their teachers' styles, or they imitate the style of a well-known artist. As they experiment with materials and ideas over time, they change their palette of colors, procedures, and the subject matter.

Developing an identifiable personal style of painting seems to be very important to artists who've only recently begun painting outdoors. Unless an artist has a great deal of experience painting in a studio, however, the issue of style needs to be put aside until he or she has spent a few years painting in the field. In most cases, a definite style will evolve without conscious effort. It just seems to happen as you make decisions about your favorite places to paint, the colors you prefer to use, the manner in which you apply paint to a substrate, and the amount of detail you want to include in a painted image.

Some of the artists who were consulted by the book editors mentioned previously said much the same thing, explaining that a style evolves naturally during the process of painting a large body of work. There is no way to predict what distinctive elements of design, color, subject matter, or pattern might constitute a style. Speculation about what might contribute most to the development of a style would be like forecasting the weather six months in advance. Past experience might be a guide, but it wouldn't be a firm indicator.

If you ask a number of painters how they arrived at their style, they will often mention the influence of images seen early in their lives, especially those reproduced on posters or prints or in books or magazines. They might even recall one specific moment then they saw a painting in a gallery or museum that motivated them to say to themselves, "Someday I want to be able to paint like that." Those early impressions and ambitions usually linger in the mind, taking artists on a journey to find their own method for painting in the manner of Rembrandt, Wyeth, de Kooning, or Cézanne. In the end, their ultimate professional style of painting is founded in those early visions. Knowing this, a person can make a conscious and deliberate attempt to eventually "paint like that" with his or her own variation on the master's signature style.

Painter and teacher David A. Leffel has often talked about the need to base paintings on a "concept," or a quality that has little to do with the identity of the subject being presented. The most obvious concept that can guide a plein air artist toward an identifiable style is the light within the landscape. Few contemporary artists use light as dramatically as Brent Cotton. Using a palette knife, he adds bright oil colors to dark, uniformly toned scenes to represent the raking light that might cross the landscape in the first or last moments of the day.

OPPOSITE: Brent Cotton, *Twilight Camp*, 2014, oil on canvas, 6 × 8 inches (15.2 × 20.3 cm). Private collection.

JOSEPH MCGURL

Massachusetts artist Joseph McGurl has a Yankee sense of efficiency, labor, and intelligence. Like the sailors, farmers, and fishermen of New England, he doesn't waste words or time, nor does he shrink from working hard to achieve results that matter. In an age when celebrity is thought more important than content, it is refreshing to know that McGurl is achieving great success with his extraordinary paintings.

Two early experiences shaped McGurl's approach to painting: The first was working for his artist father, learning how to create the illusion of detail in large murals, stage backdrops, and display panels. The other was studying the work of nineteenth-century landscape painters to find out how they achieved such a high level of mastery and distinction. He understood that great artists like Frederic E. Church, Fritz Henry Lane, and others faced as much competition as his father did. McGurl had to create paintings that were exceptional if he wanted to avoid the syndrome of the starving artist.

Over thirty years, McGurl has experimented with materials and techniques, always with the aim of working more efficiently and achieving better results. At one point, he covered the surface of his panels with sun-thickened linseed oil to speed the drying time of the oils he applied over that medium; at another time, he added alkyd medium to his oil colors to achieve the same result; later, he relied on Winsor & Newton Underpainting White to increase the oils' opacity and shorten their drying time. In addition, he has tried different tools to apply paint or modify the painting's surface: stiff bristle brushes, palette knives, and stumpy brushes that sculpt the painting's surface. In one series of paintings, he waited until the thick oil paint was partly dry and then scraped over it with a palette knife to get a different textural effect. In his studio work he developed an underlying value composition and textured surface with mixtures of burnt umber and titanium white.

Joseph McGurl, *Late Summer*, 2009, oil on panel, 9 × 12 inches (22.9 × 30.5 cm). Private collection.

McGurl has written eloquently and forcefully about the importance of working directly from nature without depending on photographs, and yet he develops a level of contrast and detail in his paintings that owes much to the way photography has shaped our vision of the world. That is, while he insists on working from life, his work has photographic quality to give it a heightened sense of believability. He may not be a realist in the manner of Courbet, but he presents a level of

ABOVE: Joseph McGurl, *Drifting Clouds*, 2011, oil on panel, 24 × 48 inches (61 × 121.9 cm). Private collection.

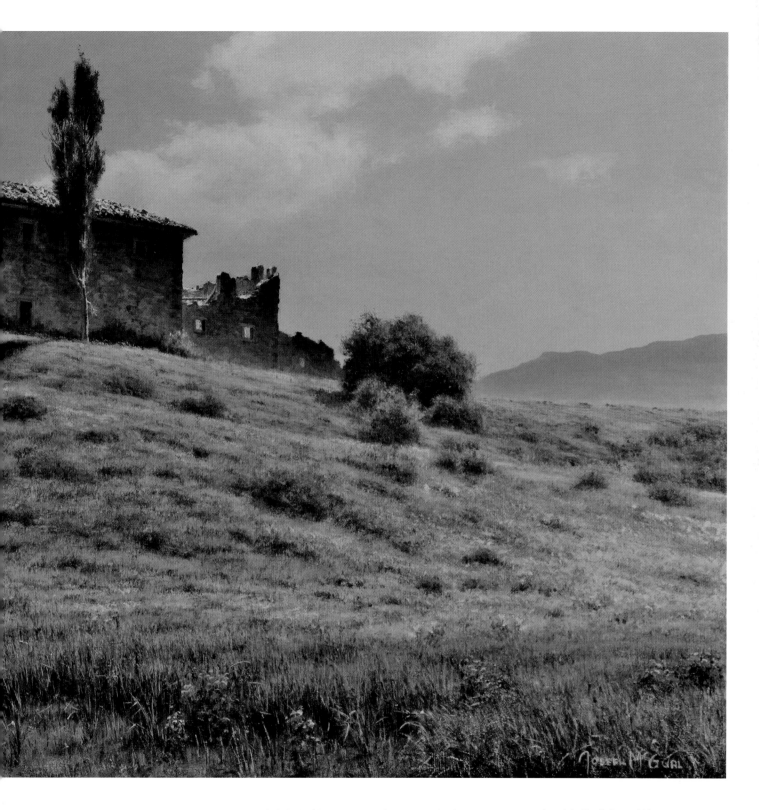

certainty in his paintings that suggests he is painting reality. McGurl doesn't let weather, fatigue, or inertia distract him from his work, and he understands the basics of painting and marketing so well that he cuts through the nonsense and concentrates on what really matters.

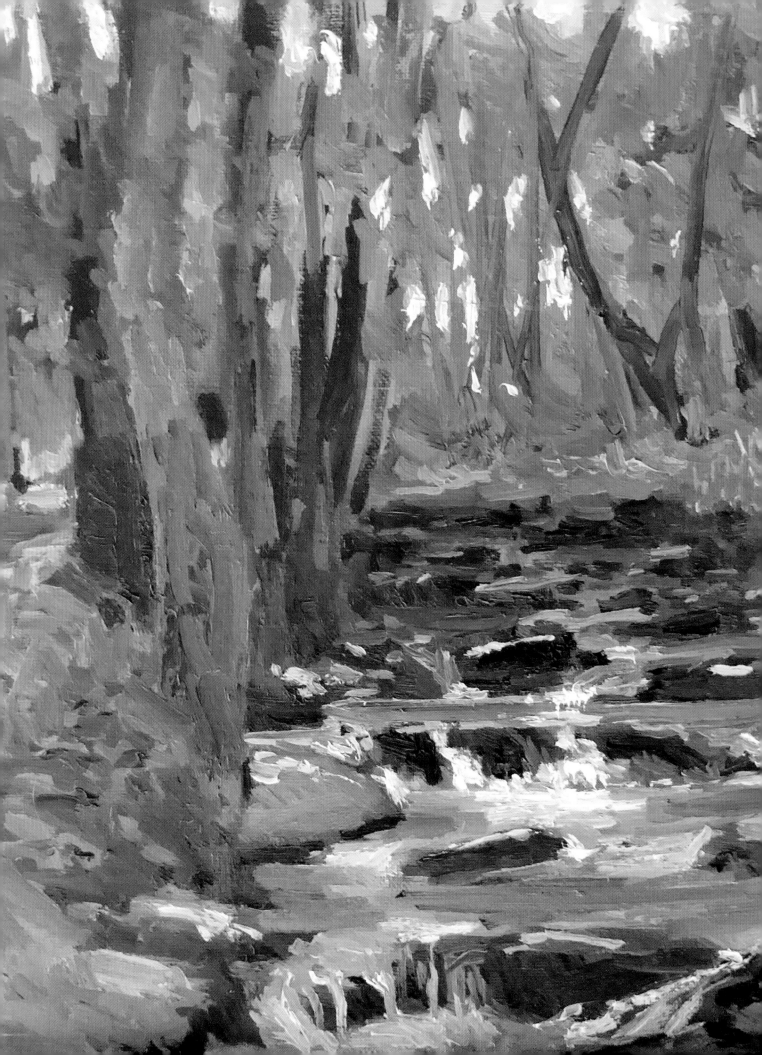

GETTING STARTED

The first big question you must ask yourself as a plein air painter is what and where you will paint. Sometimes the answer is provided by the organizers of an event that limits the geographic area in which you may paint. Sometimes it's determined by the members of a plein air group that are traveling together. But absent such limitations, the choices depend on your own preferences. Some artists like to keep painting in a familiar location that has personal significance and that they explore again and again. More adventurous artists like to hike or climb to a vantage point that gives them access to a special view—and some physical exercise. Many, though, keep themselves open to any scene that inspires them, whether because of the pattern of sunlight and shadows, light and dark shapes, bright and muted colors, or deep and shallow space.

One factor you might use in determining where and how to paint is the potential opinion of someone who might consider purchasing the finished painting or of a festival judge who might consider if for an award. Of course, you can dismiss those opinions as irrelevant to your personal agenda or to the ultimate purpose of your art, but artists who compete in plein air festivals, exhibit in commercial galleries, and market their paintings online have to give some thought to what collectors might want to buy and how judges will evaluate their plein air paintings.

OPPOSITE: M. Stephen Doherty, *Bath County (Virginia) Cascade* (detail), 2016, oil on canvas, 11 × 14 inches (27.9 × 55.6 cm). Collection of the artist.

CHOOSING A LOCATION

Being out in nature means that the physical appearance of any subject, whether familiar or not, will depend entirely on the light, atmosphere, season, weather, and time of day. Strong midday light will wash out any sense of dimension, fog will reduce the depth of field, high wind will make it treacherous to stand in its path, and frost will kill off colorful flowers. Knowing these things, it makes sense to search out locations that are likely to be interesting and comfortable at a particular day and time.

When I look outside and think about where I might paint, I evaluate the quality and direction of the light, look at the weather predictions for the next three to four hours, and think about what kind of painting I want to paint. One day I might want to find a sheltered location and an intimate scene, while on another I may have an urge to go to the top of the Blue Ridge Mountains to paint the view. I tend to prefer facing into the light so that shapes are silhouetted by backlighting and there is more contrast in values, but on an overcast day I have to think about locations that are not defined by the sunlight and shadows.

Living in rural Virginia, I seldom have trouble finding a place to park my car and set up my easel in a location where landowners or the police won't chase me away. When I lived in a suburb of New York, however, I was unable to paint some spectacular views because all the land surrounding the best vantage points was privately owned. More often than not, I had to work in public parks or parking lots or on property owned by friends. I got to know which churches, schools, and shopping centers had paintable views from their parking areas—and which days the lots were likely not to be crowded.

The point is that you have to plan ahead to wind up in a location with the conditions and access you need for a few hours of painting. No amount of planning will guarantee that there will be something worth recording on that day and time, but the preliminary planning will at least send you in a promising direction. Once you get to the parking lot, driveway, hiking trail, or riverbank you will have to spend time observing, feeling, and thinking about how the elements might be composed into a painting.

Over the years, I have heard artists offer pithy statements about what, where, and how a plein air artist should work. One of my personal mentors, Thomas S. Buechner (1926–2010), made statements I often quote when giving talks on outdoor painting. Buechner once said, "Artists should paint what they *want to see*, not necessarily what they *do see*." His point was that plein air artists should not paint a photographic representation of what's in front of them but, rather, an interpretation of that location filtered through their ideas and feelings. That contrasts with the method known as sight-sizing (see page 144), in which the artist strives to paint exactly what he or she sees when the landscape is viewed from a measured distance away from an easel. These conflicting ideas show that you have options you can choose from as you paint.

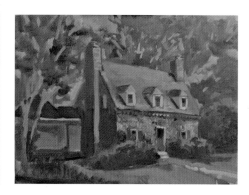

The house in the photo above is one block away from where I live in Virginia, so it was easy for me to decide in which season and lighting situation it would look best. I determined that morning light in winter would show off the brick facade to its best advantage.

STEP 1

After covering the surface of the canvas with a thin wash of yellow ocher oil color, I wiped off the paint in the sky and foreground to quickly establish the scale and placement of the building and to give a sense of warm morning light on the home.

STEP 2

Using warm mixtures of ultramarine blue and cadmium yellow medium, I blocked in the main elements of the scene. I didn't concern myself with architectural accuracy at this point because it would be easier to straighten edges and locate architectural features after the initial layers of paint dried.

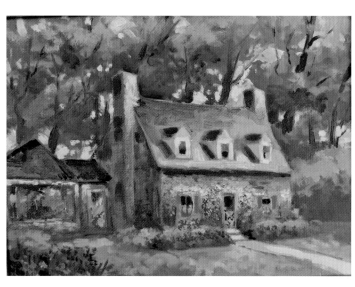

STEP 3

Here's the completed painting: *Tinny's House*. I waited until the surface was completely dry before adding the finishing touches so that additional layers of paint wouldn't blend into wet paint. I used greens thinned with linseed oil to paint the ivy on the front facade and transparent glazes of blue to give the appearance of screening over the large window on the side porch.

ABOVE: M. Stephen Doherty, *Tinny's House*, 2016, oil on canvas, 12 × 16 inches (30.5 × 40.6 cm). Private collection.

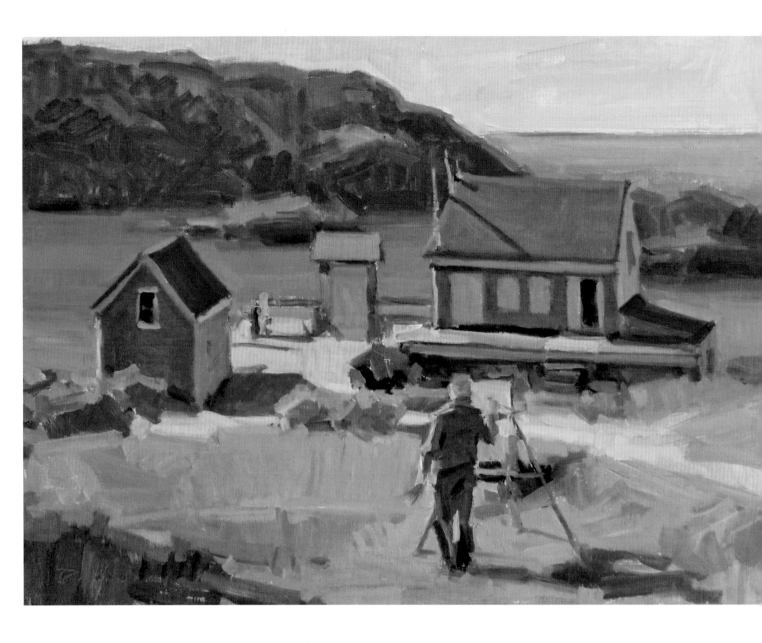

FINDING THE BEST SPOT

The decision about where to set up an easel is as much a function of an artist's personality and stamina as it is about the attractiveness of the location. Artists may not be able to resist the urge for adventure and risk—or, for that matter, comfort—but they can become more efficient in using their painting time to maximum advantage.

I've traveled with plein air painters whose sense of adventure or competition wouldn't allow them to stop until they hiked to the top of a mountain to paint an almost inaccessible view. I've also spent hours driving around with artists who couldn't make up their minds about the absolute best location. And I've interviewed painters who would never venture more than six feet from a public restroom or from the van in which they transport their equipment.

ABOVE: Ken DeWaard, *Brett Weaver Painting the Wharf*, 2010, oil on panel, 12 × 16 inches (30.5 × 40.6 cm). Private collection.

KNOWING YOUR BEST SUBJECTS AND CONDITIONS

Most successful plein air artists evaluate painting sites in the same way they review the choices listed in a restaurant menu. They know exactly what kinds of subjects and painting conditions most satisfy them, and they avoid situations that might give them artistic indigestion.

Some top plein air painters make a point of painting scenes of trash cans, back alleys, highway underpasses, decaying barns, and other subjects that are not pretty. The point is to find beauty in the mundane or the neglected and to emphasize the more formal, abstract aspects of painting relationships. That approach certainly appeals to judges of plein air competitions, but it often leaves the average collector cold. The evidence of that divide is that a competition's top award-winner paintings often remain unsold—at least until the ribbons go up and buyers are tempted to take home an award winner.

Of course, at some plein air events, artists are asked to paint in private yards, botanical gardens, or historic homes. Everything in sight is carefully planted, clean, and manicured. There isn't a rusty car or dumpster in sight. Then the participating artists have no choice but to deal with greeting-card scenes!

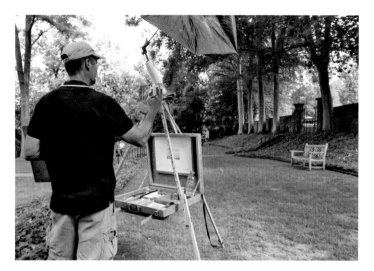

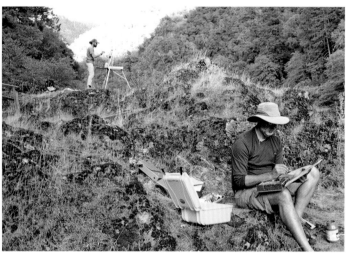

TOP: Ken DeWaard paints at a historic home in Virginia.

BOTTOM: Thomas Jefferson Kitts (foreground) never hesitates to paint where there are stunning views.

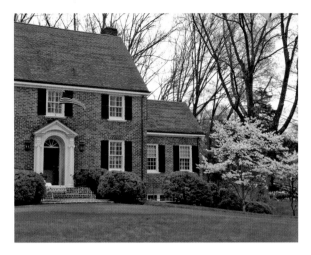

I did a painting of the home pictured above as part of a plein air event timed to coincide with the Garden Club of Virginia's Historic Garden Week. I was invited to paint in a private garden, and my challenge was to create an image the homeowner might want while offering something more than could be recorded in a digital photograph. I decided to make the dogwood tree in the front yard the real subject of the painting, with the home and plantings playing minor roles in the drama.

STEP 1

After applying thin washes of yellow ocher, red iron oxide, and green, I refined the perspective drawing by wiping around the big shapes and judging their accuracy. I lifted all the paint away from the dogwood tree blossoms so that they became bright shapes against an overall gray background.

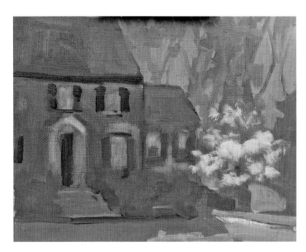

STEP 2

Using a flat bristle brush, I sharpened the edges of the roof, windows, door, and trees. Then I piled light green on top of the shrubs to suggest the light hitting those forms. I used smaller brushes to refine the 11 × 14 painting.

STEP 3

I next added strokes of thick titanium white paint tinted with yellow ocher and light cadmium yellow, then added a variety of reds and browns to the brick walls to make them richer and more realistic.

ABOVE: M. Stephen Doherty, *Bath County (Virginia) Cascade*, 2016, oil on canvas, 11 × 14 inches (27.9 × 55.6 cm). Collection of the artist.

SCOUTING LOCATIONS IN ADVANCE

Whenever I've traveled with top plein air painters, I've noticed that they generally find the places where they want to paint by the second or third day—places where the sunlight is likely to be best in the morning or afternoon, where they can find shelter from the rain or wind, and where they can develop several good pictures. As they drive around on the first day, they make mental notes about places worth checking on subsequent days to see whether conditions worsen. Not all painters look for good daytime spots. Baltimore artist Tim Kelly often drives around at night looking for scenes that come alive under artificial lights.

ABOVE: Tim Kelly, *Christ Church, Philadelphia*, 2015, oil on canvas, 12 × 14 inches (30.5 × 35.6 cm). Private collection.

RETURNING TO FAVORITE SPOTS

Many workshop instructors advise students to "paint what you know," meaning that artists are more likely to have success when returning to places where they are already familiar with the prevalent colors, patterns, shapes, and light. South Carolina artist Mark Kelvin Horton does just that, often setting up his easel in the same general area along the Atlantic shoreline because he knows that the scene, though always changing, is always equally dramatic.

TOP: Mark Kelvin Horton, *Shoreline*, 2015, oil on panel, 8 × 16 inches (20.3 × 40.6 cm). Courtesy of Horton-Hayes Fine Art, Charleston, South Carolina.

BOTTOM: Mark Kelvin Horton, *Waves Crashing*, 2015, oil on panel, 8 × 16 inches (20.3 × 40.6 cm). Courtesy of Horton-Hayes Fine Art, Charleston, South Carolina.

I have driven along one particular road in Nelson County, Virginia, dozens of times and have set up to paint in various locations near a horse farm there.

STEP 1
After setting up on the side of the road, I painted thin lines of transparent red earth oil color to indicate the major divisions of space.

STEP 2
Using a medium and a dark gray, I then blocked in the major value shapes to create the sense of space and light within the scene.

STEP 3
Continuing with a more extensive palette of colors, I filled in the areas of the landscape. Toward the end of the painting process I mixed cold wax medium with the oil colors and used a palette knife to build up textures in the foreground area. The completed painting appears at right.

ABOVE: M. Stephen Doherty, *Nelson County View*, 2014, oil on canvas, 12 × 12 inches (30.5 × 30.5 cm). Collection of the artist.

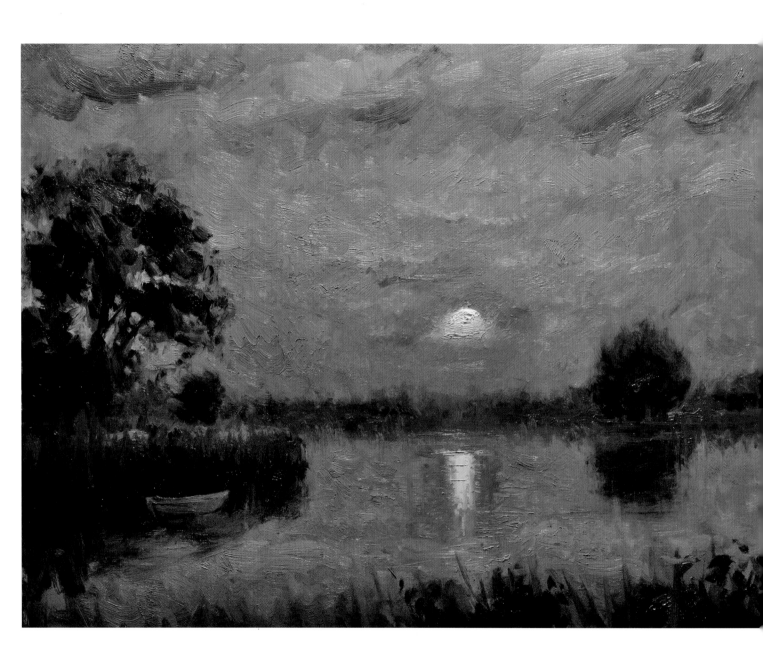

DOING MORE THAN ONE PAINTING IN THE SAME LOCATION

Several artists I know have a routine of leaving their easels in the same location when they complete one painting, turning as the sunlight shifts, and then painting the view to the left or right. "Chances are there is enough there for more than one painting if you adjust for the changing pattern of light and shadow," says Virginia painter André Lucero, two of whose sunset paintings are shown here. "Instead of wasting time packing up and moving to another location, I always consider making another painting from the same general location. If the sun sets and

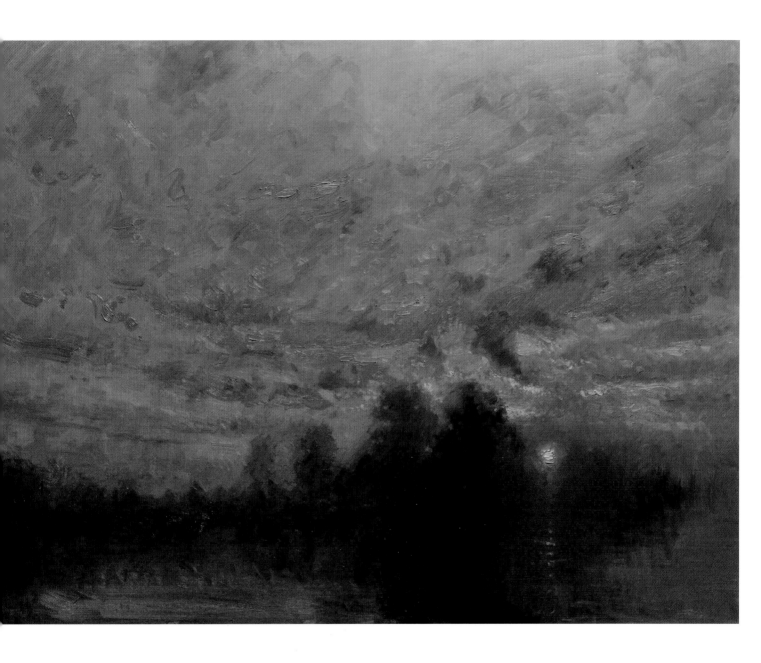

I can't continue, I consider returning to the same location another evening with the expectation there will be another dramatic sky."

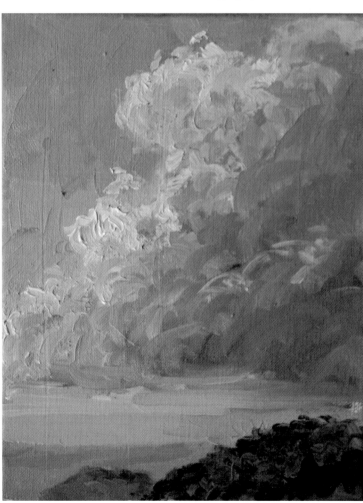

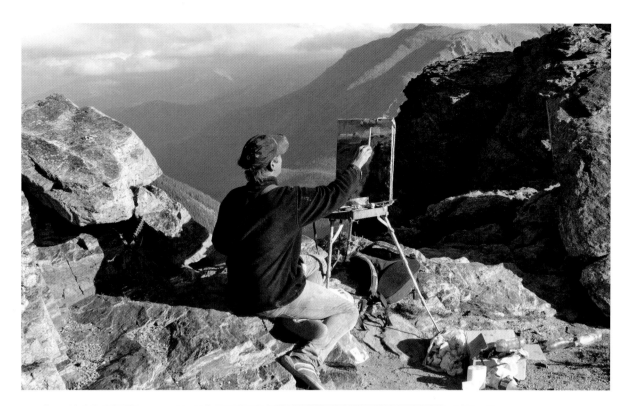

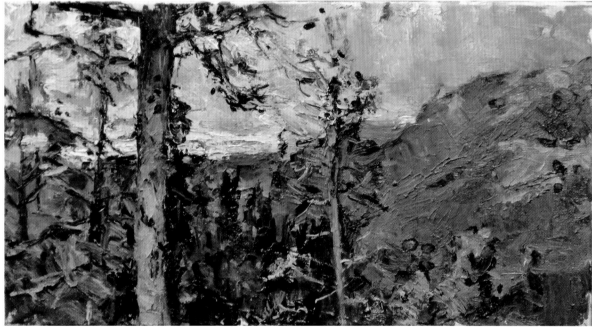

KNOWING YOUR PHYSICAL LIMITS

It's wonderful that a young guy like Ulrich Gleiter can climb high into the Rocky Mountains to paint from the edge of a cliff, but most of the rest of us have to recognize our physical limitations and stay in lower elevations, limit the amount of gear we carry, and paint in the shade. As my mentor, Thomas S. Buechner, once said to me: "The older I get, the more attractive the subject matter becomes that is closest to the bathroom."

OPPOSITE: I painted this group of 9 × 12 oil sketches of clouds while set up in a motel parking lot on a hill above my hometown.

ABOVE: Ulrich Gleiter painting in the Rocky Mountains.

BELOW: Ulrich Gleiter, *View from Fairview Curve*, 2012, oil on panel, 12 × 18 inches (30.5 × 45.7 cm). Private collection.

SIMPLIFYING YOUR SUBJECT AND APPROACH

Artists often say that they are not interested in presenting a completely realistic view of the world

but rather a personal interpretation that emphasizes what they feel is most important about a location at a particular time. To get at that essence of reality, they take steps to both simplify and exaggerate their subjects. That is, they eliminate extraneous bushes, houses, power lines, and cars to get down to the most important elements of a scene. It's like writing a story—you have to avoid overloading it with so many details that the underlying message gets lost.

Many of the best plein air painters trained as illustrators and once held high-paying jobs with advertising agencies and design firms. That training and experience made them aware that the message conveyed in a commercial, advertisement, or editorial illustration has to be instantly understood and must convey a positive impression of the product or service. In many ways, the same can be said of paintings in general and plein air paintings in particular. The goal is often to have viewers immediately recognize the depicted location and feel that the place is engaging and pleasing.

TOP: Stewart White did these quick water-color sketches to freeze the poses of the workers and to determine how to simplify an otherwise complicated scene.

BOTTOM: Stewart White, *St. John's Church, Richmond*, 2014, watercolor on paper, 11 × 14 inches (27.9 × 35.6 cm). Private collection.

DEMONSTRATION: SIMPLIFICATION

When painting Poplar Forest, the smaller version of Monticello that Thomas Jefferson designed for a farm near Lynchburg, Virginia, I faced the challenge of having to simplify an octagonal building. There was little room for interpretation or alteration because I wanted to respect Jefferson's use of Palladian ideas about proportion, symmetry, and scale, and yet I had to generalize the complicated architecture in order to document it within a two-hour time period.

STEP 1
Because of the perspective consideration, I first drew lines defining the building using a thin mixture of red iron oxide.

STEP 2
It started to rain when I got to this point in the painting process, so I left the background trees and the lawns loosely defined, but I did add thick mixtures of titanium white and cadmium lemon yellow to suggest sunlight raking across the lawn toward the back of Jefferson's building.

STEP 3
Continuing to work with a flat bristle brush, which made it easier to paint sharp edges, I resolved the 11 × 14 plein air painting well enough to be able to use it as a study for a larger studio painting. The finished painting is pictured.

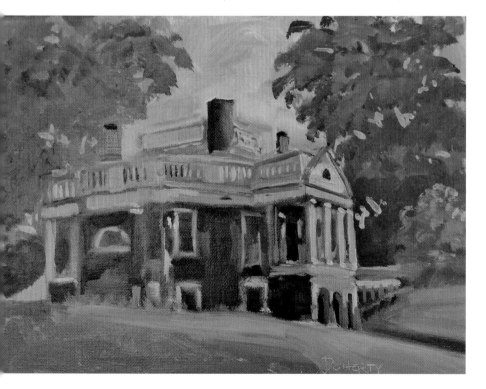

LEFT: M. Stephen Doherty, *Poplar Forest*, 2016, oil on canvas, 11 × 14 inches (27.9 × 35.6 cm). Collection of the artist.

Achieving the proper level of simplicity is not as easy as you might think. Just as storytellers have a tendency to stray from the central premise of their message, so, too, do painters have trouble remaining focused on their original intentions. The light keeps changing, new aspects of the scene become interesting, and details start to confuse the overall composition. That's why some artists work from a plan, going through specific steps before and during the painting process. They often start by making thumbnail sketches or black-and-white drawings, or they might take a few moments to visualize how they want the finished painting to look. Some even title the painting before it is actually started so they remain mindful of the original impetus for the picture. Many artists occasionally step back from their easels while painting to evaluate how the image is taking shape.

Many artists use "tricks" that give them a fresh look at developing paintings. For example, Joseph McGurl has a mirror across from his easel so he can frequently look at the reversed reflection to see the image in an unexpected context. That change gives him a more objective view of the paintings' compositions. Others turn their paintings upside down or face them to the studio wall to help problems or identify ways to finish the paintings.

Thomas S. Buechner had a moulding ledge around his studio so he could look at his finished work while painting. He also used that ledge for an annual review of his paintings. That review would often make him aware of a tendency to place the focal point in the same position within each composition, to allow a slow increase in the amount of contrast between values, or a shift toward more detailed portraits.

TOP: Oregon artist Marla Baggetta made this quick compositional sketch to establish the scale and placement of landscape elements.

BOTTOM: Marla Baggetta, *Simple Pleasure*, 2017, pastel on paper, 12 × 12 inches (30.5 × 30.5 cm). Collection of the artist.

Bill Cramer on Hiking and Painting

Because he often hikes and climbs to painting spots, Arizona artist Bill Cramer makes sure all his supplies fit into a backpack. "I can carry several panels up to 20 by 24 inches, either in a panel carrier or strapped to my backpack." explains the artist. "I carry the following tubes of oil colors: two reds (cadmium red light, alizarin crimson), two yellows (cadmium yellow light, cadmium lemon), three blues (ultramarine, cobalt, cerulean), and titanium white." He also packs bristle flat brushes, several softer brushes for adjusting edges, and a few small rounds, as well as two small palette knives. "I also have a rubber-tipped tool for lifting out paint or striking a shape line for branches, grasses, cactus needles, etc. The tool is beveled at one end and pointed at the other, good for putting stars in nocturnes and making highlights. I also use paper towels to soften edges or to remove sections, but the rubber-tipped tool gives me more control over the mark-making process."

After nailing the value pattern of darks, Cramer paints the lightest-value shapes to key the rest of the painting, then he lets those darks and lights lead into the mid-tones. He often mixes M. Graham Walnut/Alkyd Medium into his oil colors to improve the flow and speed the drying time of his paints. Here are the steps he followed for his 2014 oil painting *Morning Salute*:

STEP 1

Cramer began by toning the surface of the canvas with a wash of a warm color and then loosely blocked in the big shadow shapes of the composition.

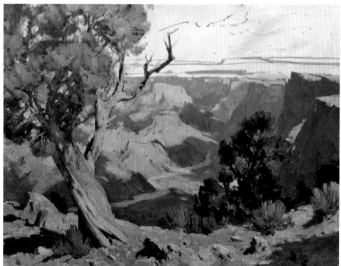

STEP 2

After nailing the pattern of darks, Cramer painted the lightest lights to key the painting. He then let the lights and darks lead into the mid-tones.

STEP 3

The artist filled in the medium-value mountain shapes in the middle of the canvas and then brushed a light sky color into the upper register of the canvas.

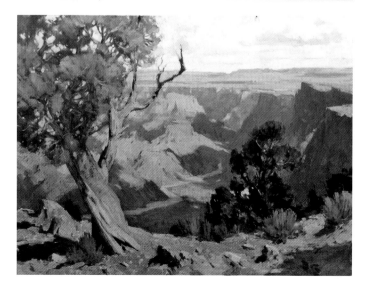

Bill Cramer; *Morning Salute*, 2014, oil on canvas, 20 x 24 inches (50.8 x 61 cm). Collection of the artist.

KATHRYN STATS

Utah artist Kathryn Stats offers specific advice to plein air painters to help them improve their work. For example, she recommends changing brushes as you paint to avoid overworking a painting with detail; she suggests toning the surface of your canvas to keep your composition from being too light or too dark in value; and she strongly urges you to put a troubled painting aside until you know how to finish it.

"When I first started painting, I didn't know how important grays are, but Ted Goerschner's book *Oil Painting: The Workshop Experience* taught me how to mix four 'mother grays' and have them on my palette to temper color mixtures," she says. "One is made from a combination of ultramarine blue and cadmium orange or burnt sienna, tinted with white. An effective blue gray can be made by combining titanium white, cobalt blue, and ivory black; and a useful violet gray is one I create by mixing titanium white, cobalt blue, and either manganese violet or quinacridone violet. Finally, a standard warm gray can be made with mixtures of titanium white, cadmium orange, cadmium red light, burnt sienna, and ultramarine blue.

"For example, the turquoise color in an ocean wave can be too harsh if you don't knock it down in intensity," Stats explains. "The goal is to maximize the impact of color without having it shout at the viewer. Without grays, a painting is likely to scream at a deafening pitch. There are usually three dominant colors in the ocean in Southern California: Prussian blue, raw umber, and yellow ocher. Those can be grayed very nicely with a combination of cobalt blue and quinacridone or manganese violet.

"I have a basic palette of tube colors that includes ultramarine blue, cobalt blue, cerulean blue, titanium white, lemon yellow, cadmium yellow light, cadmium yellow deep, yellow ocher, cadmium orange, cadmium red light, permanent red, alizarin crimson, Indian red, burnt sienna, and transparent red oxide; then I have a few guilty colors I add occasionally, like quinacridone red, cadmium red light, and naphthol red," Stats says. "I have some deep passages in my brain that I wander through when I feel the need to experiment with new colors and odd color combinations.

RIGHT: Kathryn Stats, *Zion Shadows*, 2011, oil on canvas, 16 × 20 inches (40.6 × 50.8 cm). Private collection.

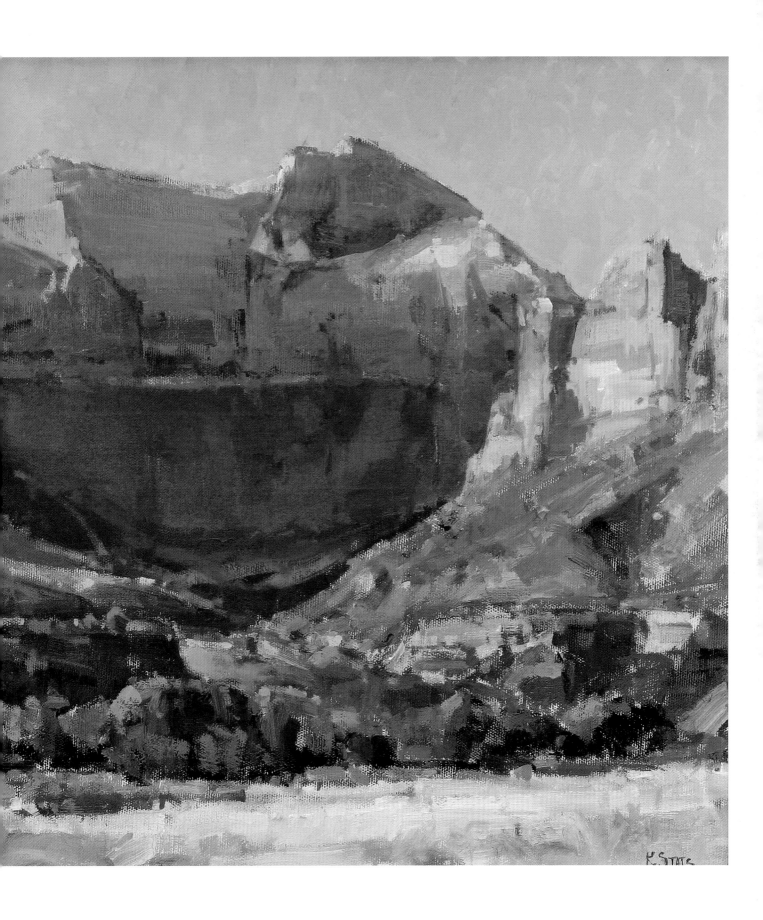

"I always make small compositional sketches before I start painting because if I don't I'm likely to regret the omission later on when it's difficult to make radical changes in the arrangement of shapes, values, colors, or spatial relationships," Stats cautions. "I make three or four sketches with a black permanent marker to determine which composition will have the most impact, and then I paint a quick three-tone gray value study on the canvas to test my idea on the full-size painting. I warn my students that their brains can't handle too many choices, so they need to deal with spatial composition first, value relationships next, and then color.

"I follow the recommended method of painting from lean to fat, meaning that I start by applying very little paint (rather than adding solvent to the paint) for the initial masses of colors—especially the darks—and then work with heavier applications of oil color as I build toward the lightest values," Stats explains. "When I'm painting on location, I try very hard not to build up the thickness of the paint too quickly because it can become too slick to accept the last aspects of dark and light values. I also make a point of saving the bright highlights until the very last stage of the painting process because, in my experience, too many painters rush into painting the light values and wind up with no place to go.

"I'm a firm believer in the value of working outdoors from nature, and I'm not shy about saying one simply can't be a good studio painter unless he or she paints directly from nature outdoors. That said, I seldom finish a painting on location," she says. "I take digital photographs of the subject when I start painting, and then I enlarge those on a computer monitor to help me complete the painting in the studio. If the plein air piece is promising enough, I will use it as the basis of a larger studio painting, again using my digital photographs to guide me through the initial stages of painting the larger composition. Of course, there is always a point where the photographs and references need to be put away and one must simply do right by the painting."

OPPOSITE, TOP: Kathryn Stats, *Changing Seasons*, 2011, oil on canvas, 30 × 40 inches (76.2 × 101.6 cm). Private collection.

OPPOSITE, BOTTOM: Kathryn Stats, *Time Travel*, 2011, oil on canvas, 16 × 20 inches (40.6 × 50.8 cm). Private collection.

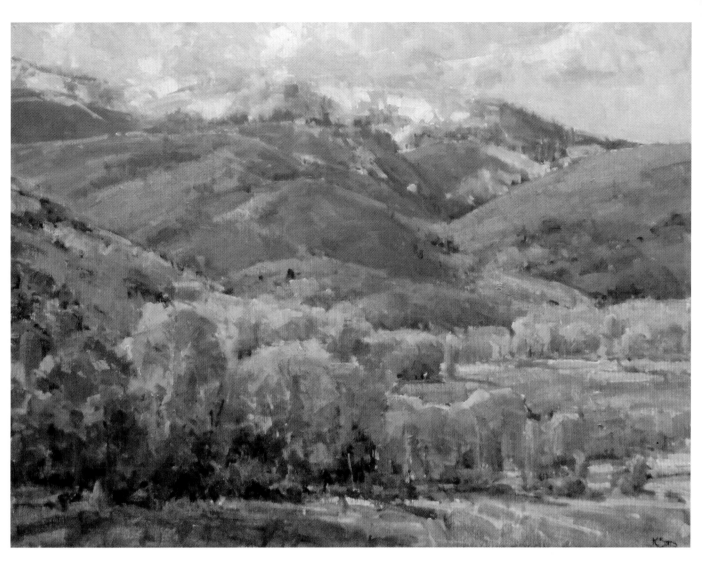

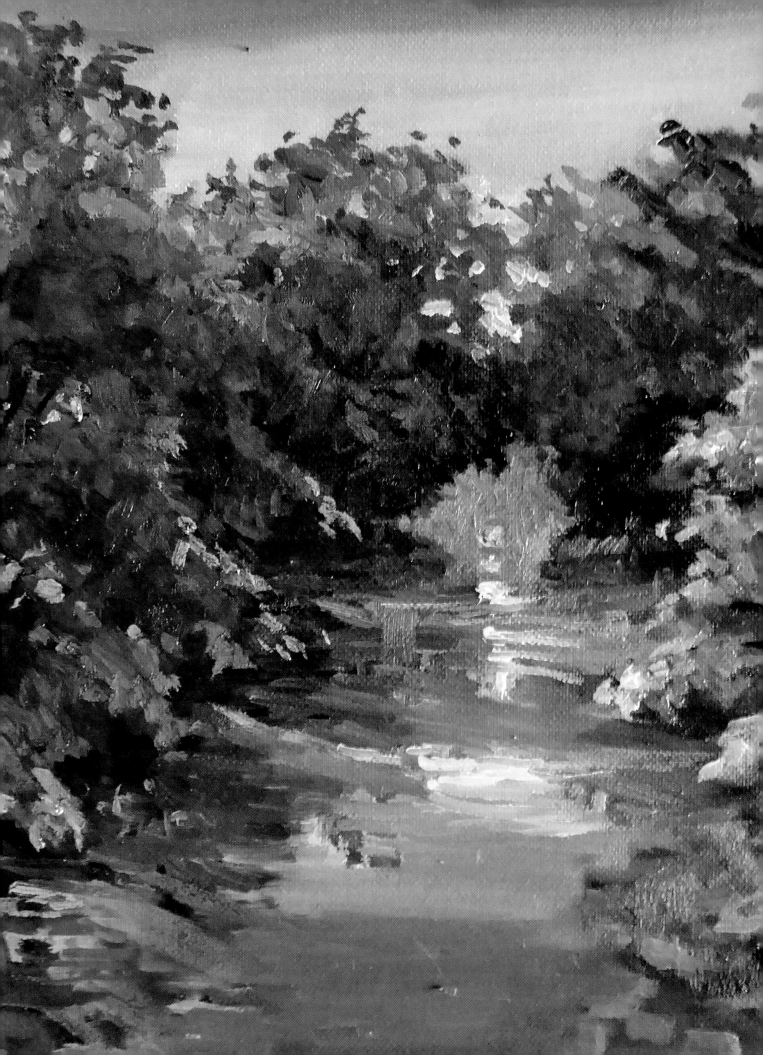

MATERIALS, TOOLS, AND EQUIPMENT

Most artists who paint outdoors want to be well organized and efficient so they make the most of their limited time painting a rapidly changing subject. They therefore buy art supplies made specifically to meet their needs. Most of the equipment is compact, portable, lightweight, and adaptable, and they limit their supplies to paints, brushes, mediums, and surfaces that are essential. These selections contrast dramatically with the wide range of supplies and equipment those artists might use in the controlled environment of a studio.

At first, studio painters may find it difficult to leave behind some of the supplies they depend on in the studio—especially watercolorists, who may be used to slowly building up layers of transparent color and using a hair dryer to speed the drying time of each layer. Pastel painters must also transition from having hundreds of hard and soft pastels near their studio easels to an outdoor situation where they must make the most of a couple dozen sticks.

What follows is an overview of products made specifically to meet the needs of plein air artists.

OPPOSITE: M. Stephen Doherty, *Morning Light on the Middle River* (detail), 2016, oil on canvas. Collection of the artist.

SURFACES AND SURFACE PREPARATION

The surface on which paints are applied is called a support, substrate, or ground. The selection and preparation of that support is determined by the kind of paint you intend to use. Watercolors, for example, have an impermanent binder, so they must be applied to an absorbent surface, usually paper. Pastels are held to the painting surface by becoming embedded in the textured surface of rigid paper, cloth, or board. Oils must be painted on a surface —flexible or rigid—that has been sealed so that the oil binder doesn't cause the deterioration of the substrate.

CANVAS—COTTON AND LINEN

The most commonly used surface for oil or acrylic paints is canvas (cotton or linen) that has been woven specifically for use by artists. It is the most popular for several reasons: the woven texture pulls paint off the brush; it is light enough to be stretched across very large frames, or stretchers; it can be glued to inflexible surfaces like wood or aluminum; and it is available in different weaves. Smooth weaves are suitable for portrait painting; rough surfaces are appropriate for an Impressionist style of painting.

Many artists insist on painting on linen canvas, believing it superior to cotton. Some conservators point out, however, that all cellulose-based materials are subject to changes in temperature and humidity and that both linen and cotton may deteriorate over

time. The most important consideration is how the brushstroke feels to your hand when you paint. If you prefer a smooth, slick surface, then a lead-primed linen canvas is best. If you want a surface that holds thick layers of paint and helps make each stroke of the brush visible, then a heavyweight cotton duck canvas may be best for you.

The biggest issues regarding the preservation of paintings are the effects of ultraviolet light, humidity, and temperature, as well as the conditions under which the artwork is exhibited, shipped, and stored. Even the most well-crafted painting will be damaged by excessive heat or cold, extreme dampness or dryness, or exposure to direct sunlight. Much of the conservation work done in museums is intended to reverse the damage caused by poor materials, unsuitable storage or display, or unskilled maintenance or restoration.

Art teachers often encourage students to buy top-quality materials, because poor materials can yield poor results. For example, lesser grades of canvas may be so rough and porous they impede the flow and coverage of paint. Their teachers' advice may be hard for students to accept, however, because the cost of professional-grade supplies can be substantially more than student grades. That's why many students buy colors made with cheaper pigments, canvases that aren't adequately sealed and primed, and brushes that can't stand up to normal wear and tear. But as their work gets better, so too must their supplies.

PAPER—SELECTING AND PREPARING

Many plein air artists prefer to paint on paper rather than board or stretched canvas because paper is lightweight, easily cut to different sizes and formats, and less expensive than other surfaces. There are papers on the market specifically made for artists who work in oil, pastel, or watercolor, but some artists develop their own methods for preparing paper for a particular painting medium. In general, papers for painting must be heavy enough to tolerate a lot of friction from a brush or stick of pastel and to remain flat after being dampened with paint.

Watercolors are usually applied to papers that have been heavily sized by the manufacturer. Sizing is similar to the starch used to stiffen fabric. It can either be added to the slurry that dries to form sheets of paper (referred to as internal sizing) or rolled onto the surface of paper (external sizing). Some artists size their papers themselves by applying layers of liquid sizing material. Pastels are best suited to papers that are milled to have a distinct texture, or "tooth," or that have been coated with a sealer containing grit to enhance the paper's ability to hold the chalk. The best papers for oils are sealed to prevent the linseed oil binder from damaging the fibers of the paper.

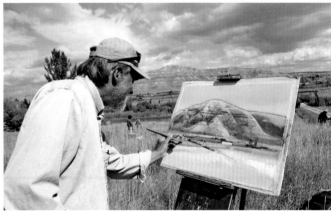

TOP: J. D. Wissler, *It Begins*, 2013, oil on paper, 10 × 9 inches (25.4 × 22.9 cm). Private collection. ❯❯ Pennsylvania artist J. D. Wissler often paints on sheets of prepared paper, which are less expensive than panels and easier to transport.

BOTTOM: Colorado artist Stephen Quiller painting with acrylics on a stretched and taped sheet of watercolor paper.

OTHER OPTIONS—METAL PANELS AND PLASTIC FABRICS

Because they are concerned about the potential for cellulose products to change shape or deteriorate over time, some artists choose to paint on sealed metal panels or on metal panels covered with linen canvas. Among the most common metals used are copper and Dibond aluminum. Artists have used copper as a painting surface for centuries, albeit for relatively small paintings, but it is expensive and soft. If it gets bent, the paint layers may crack and flake off. Another drawback is that the copper surface must be thoroughly cleaned of any oxidation or oil that might inhibit the adhesion of layers of resin, primer, or paint.

Dibond panels are composed of two sheets of aluminum with a solid polyethylene or honeycomb metal core. These are used primarily by sign makers, but artists can use them, too. Various products are available for preparing the aluminum surface to strengthen the bond between the layers of primer and oil color, but you can also glue cotton or linen to the aluminum to create a "traditional" painting surface—but one that will not be affected by humidity or temperature.

Artists can also choose from a number of relatively inexpensive nylon, polyester, and acrylic fiber fabrics that are unaffected by changes in humidity and only slightly by changes in temperature. Some professional artists are concerned, however, about how well layers of primer and paint adhere to these slick plastic surfaces, and scientists are not completely sure that chemicals in the plastic will not have an adverse effect on the paint applied to them, especially in light of recent research showing that plastic shopping and storage bags can transfer chemicals to the food inside.

ABOVE: Virginia artist André Lucero paints on panels covered with polyester fabric.

MEDIA FOR PLEIN AIR PAINTING

Following the requirement that plein air materials and techniques be efficient and portable, artists choose paints and mediums that meet those criteria. They take into account the drying time, opacity, and flexibility of the paints, and they determine what modifications might make the paints more suitable to the conditions of painting outdoors.

Every paint is a combination of pigment, binder, modifiers, and solvent. It's the binder that gives the paint its name: paints with an oil-based binder (linseed oil, walnut oil, sunflower oil, etc.) are called oil paints, and those with an acrylic plastic binder are called acrylic paints. Differences in paints' prices likely reflect differences in the quality of ingredients as well as in the type and amount of modifiers added. A "student grade" paint probably has a higher percentage of modifiers, whereas a "professional grade" paint has a higher percentage of quality pigments.

OILS—LIMITED OR EXPANDED PALETTES

The pigments used to make artists' colors differ in terms of opacity, drying time, and finish. Some, like zinc white, take longer to dry and yield a glossy finish. Others, like burnt umber, dry quickly and have a matte finish. In addition, colors mix with each other in different ways. That's one reason that many plein air artists use a *limited palette* of tube colors that have similar levels of opacity and can be intermixed to create a full spectrum of colors. They find it better to rely on five or six colors they know well rather than to juggle a cumbersome collection of twenty colors that have subtle differences that can confuse the painting process.

"There are theories about the way artists' colors can be used to capture what happens in nature, but the only way to really learn is to be out in nature observing and painting," says California painter Camille Przewodek. "I recommend that students begin painting a still life arrangement of brick-shaped blocks sitting in direct sunlight using permanent alizarin crimson, cadmium red light (or Winsor red), cadmium lemon, and titanium white." Once they are comfortable working with that limited

LEFT: Dawn Whitelaw using a limited color palette.

range of colors, they can expand their palettes to include more pigments. They can also tackle more difficult subjects such as live models posing outdoors. "It's very important to paint from life and not photographs," she says. "Artists have to first learn to understand the subtleties of color in nature before they can interpret the distorted images in photographs."

Tennessee artist Dawn Whitelaw is a big advocate of using only three tube colors plus white for painting outdoors or in a studio. Her choices are Blue Ridge oil paints in the following colors: titanium white and Flemish white, ultramarine blue, pyrrole red, and cadmium yellow deep. This is her everyday/every-painting palette. She premixes the secondary colors and paints mostly with the secondaries. Whitelaw does sometimes experiment with other colors, including chrome oxide green and Indian yellow, but she encourages beginners to stick with the primaries.

Working with the same colors day after day has helped Whitelaw achieve quick and reliable color mixing. "Almost every color we see in nature has all three of these colors in it," Whitelaw points out. "So it makes sense to start with a secondary, and then 'bend' it toward the proper primary. Bending a color simply means it is no longer in its original state, but has had something added to adjust it. As another important benefit, working with a three-colors-plus-white palette reduces the weight of the gear an artist carries outdoors."

New Hampshire artist Erik Koeppel also uses a limited palette, but his color choices are different from Whitelaw's. He works with burnt sienna, Venetian red, yellow ocher, Naples yellow, ultramarine blue, lamp black, burnt umber, and Gamblin Flake White Replacement mixed with a medium made from Utrecht stand oil and Gamsol solvent.

ABOVE: Erik Koeppel painting on location.

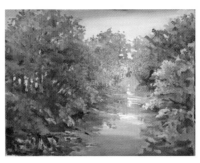

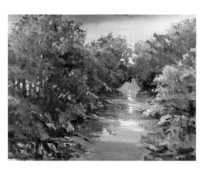

I crossed over Middle River around eleven o'clock one summer morning after completing a plein air painting at a nearby farm. It occurred to me that the bridge might offer a great vantage point from which to paint the morning light rising behind the trees. Moreover, I recognized that the variety of greens along the river would present an interesting challenge. The next morning, I set up my easel along the edge of the bridge and began painting the view shown in the photo above as soon as the sun rose above the trees and river.

Greens can be challenging colors to work with in landscape painting because their hue, value, and intensity depend so much on the prevailing light and surrounding colors. In this scene, the greens shifted toward a dark brown in the yellow-orange morning light.

STEP 1

Because the effects of the morning light would change quickly, I used thin washes of transparent red oxide to establish the big shapes on both sides of the river, light green to indicate the light filtering through the trees, blue/green to mark the cool shadow colors, and a light blue in the sky area.

STEP 2

I built up layers of greens from a bright yellow ocher, to a kelly green (ultramarine blue + cadmium yellow medium), to a dark green (burnt umber + cadmium yellow). I added a bit of quinacridone magenta to that dark green to establish a cool shadow color where branches bent down toward the water. The completed painting is below.

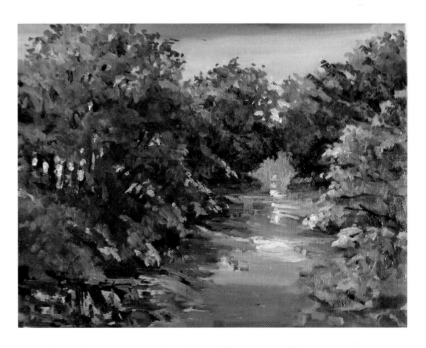

M. Stephen Doherty, *Morning Light on the Middle River*, 2016, oil on canvas, 12 × 16 inches (30.5 × 40.6 cm). Collection of the artist.

PRE-MIXING OIL COLORS

The technique of pre-mixing colors has many variations, but many are based on the teachings of the legendary Art Students League of New York instructor Frank Mason (1921–2009) and his teacher, Frank Vincent Dumond (1865–1951). Most artists who follow this method refer to it as a *prismatic palette*, meaning that it is based on the way colors appear when light passes through a prism.

Landscape painters often point out that the first three prismatic colors—red, orange, and yellow—are more prevalent in the foreground, whereas blue, indigo, and violet appear in the distance. Using more red, orange, and yellow when painting foreground shrubs, roads, fences, or trees and then painting the background mountains and hillsides with mixtures dominated by blue, indigo, and violet will create a more natural sense of depth and atmosphere.

Ohio painter Jack I. Liberman, one of Mason's students, uses a vertical palette filled with pre-mixed colors, which he refers to as a "paint tray organizer" or "vertical landscape palette box" to avoid confusing it with the horizontal palette that he reserves for mixing oil colors.

Many artists use a variation of the prismatic palette. New Jersey artist Lauren Andreach learned the technique while in art school and immediately grasped the concept of pre-mixing all her colors and numbering each mixture according to its relative value, from light values (numbers 1, 2, 3) to dark ones (numbers 7, 8, 9). Once that's been done,

Andreach can make a visual assessment of how light or dark a subject might be and then load a brush with that specific mixture. "I earned my college degree in computer science and worked in the field for fifteen years, so I found it easy to understand the system," she explains. "It is similar to computer science because it is organized by value numbers as well as the values in nature. It involves specific analysis of the upright plane and flat plane in the landscape and relating those to the colors on a pre-mixed palette."

Andreach adds, "The system is not totally rigid and mechanical, although students are trained to mix specific measured progressions for each color string. As with other activities, preparation can facilitate an expressive response to impulses, and in the case of plein air painting it allows me to have a lot of fun while I respond to the total experience of being in nature. I go to bed at night being thankful I can paint outdoors in a satisfying way."

Californian John Cosby developed a method for teaching plein air painting using pre-mixed "value pools," or about two to three tablespoons of each of the colors that dominate the landscape he is about to paint. The system of prepared value-pools performed so well that his own paintings got better and became even more appealing to collectors. And it also helps his students—even those who are perfectly satisfied with their current work—make significant improvements.

"Unless someone starts by creating a two-dimensional puzzle of values that read correctly in terms of pictorial space, they can't move forward,"

Cosby explains. "If you can't see a landscape as a pattern of relative values and have the ability to mix those values on your palette, it is less likely you will complete a painting successfully. The method I developed is to show students how to identify and describe the big value shapes and then mix three to five related value-pools of paint on the palette. I demonstrate how to pick out the biggest, strongest value changes in a scene, mix those values, and then tint and colorize the mixed pools of oil color.

"I emphasize that artists need to start a painting *on their palette* and not on the canvas, by which I mean the important judgments about value relationships should be made before the paint is applied to the canvas," Cosby emphasizes. "Once they get the value of each shape correct relative to both the adjacent shapes and the overall canvas, they can add the top planes over the big shapes."

TOP: Lauren Andreach painting on location.

BOTTOM: Californian John Cosby painting from a palette of pre-mixed colors.

WATERCOLOR

Although watercolor has become mostly a studio medium used by artists who slowly build up layers of transparent color, it is ideally suited to plein air painting. The equipment is compact, lightweight, and understood by airport security personnel, and only water is needed to dissolve and thin the paints. Moreover, watercolor can be used for creating a wide range of images from quick sketchbook studies to large, detailed paintings.

Arizona artist Raleigh Kinney talks about his approach to using watercolors for plein air painting: "Days before I head out to paint, I use acrylic gel medium to mount Fabriano Artistico watercolor paper on sheets of Masonite, and I grab a few small (8 x 10) loose sheets for sketching. When I get to a good painting site, I lay out my supplies and set up my easel and look through a viewfinder

mounted with a Plexiglas overlay with quadrant lines scratched into it in order to facilitate locating potential compositions. Then I do a careful mono-chromatic sketch of the scene, observing how the light and shadows fall to freeze those moments for later reference. Success with watercolor is all about thinking about the sequential applications of colors, and the sketch helps me work out a plan for a larger, full-color painting.

"If I'm satisfied I have a reasonably good plan, I put one of the prepared boards in my easel with the painting surface tilted at a 30- to 40-degree angle so the paint flows without running completely off the paper," Kinney says. "I transfer quadrant lines from my value sketch to the watercolor board, then I quickly sketch the major shapes in the composition with a graphite pencil, keeping in mind where the points of interest are within those four quadrants.

If those graphite lines are too heavy I might erase them, but most of the time I let them show through the finished paint so viewers might find evidence of how I created the watercolor."

From that point on, Kinney follows the traditional approach to watercolor, reserving the white of the paper for the brightest highlights and building up the layers of transparent color from the lightest to the darkest values. He uses a brush sometimes identified as an "aquarelle" brush, with a wide, flat, angled edge that allows him to paint sharp lines, broad washes, or marks that widen as he turns the brush in his fingers. "I first painted with a flat oil painting brush, but I switched to a wide two- or three-inch brush and manipulate that to make all the various marks I needed," Kinney explains. "I also have a clean palette knife I use for drawing thin lines and one round brush I use to sign my name."

Kinney continues: "I have two plastic John Pike watercolor palettes, one I take on location and the other I leave in my studio, and both are filled with the exact same pigments in the same locations. I dampen the entire surface of the paper and cover about 75 percent of the painting with a thin layer of transparent color (reserving the white for the highlights). That dries very quickly here in Arizona, so I can immediately follow up by painting the middle-value colors and middle-sized shapes incorporating an appropriate variety of edges: crisp, soft, ragged, and lost. Then apply needed details on the mid-sized shapes over the well-integrated background."

OPPOSITE: Raleigh Kinney painting on location with watercolors. A palette box rests at his feet.

ABOVE: Raleigh Kinney, *Crosslake Heritage*, 2016, watercolor, 16 × 20 inches (40.6 × 50.8 cm). Collection of the artist.

Cindy Baron on Keeping Watercolors Fresh and Transparent

When doing plein air watercolor paintings, Rhode Island artist Cindy Baron uses watercolor-paper blocks or sheets of Arches 300-pound, cold-pressed watercolor paper taped to lightweight Gator Board. Her equipment includes a plastic travel palette large enough for mixing generous amounts of paints. "It is much easier to transport than the heavy ceramic tray or the butcher trays I use in my studio," she explains. Baron works primarily in a standing position at her French easel with the back of the watercolor paper tipped up so that she can see the image better and the force of gravity will slowly pull the fluid paint down the paper toward her.

The palette of colors she uses on location includes Winsor red, Winsor yellow, ultramarine blue, cobalt blue, cerulean blue, Antwerp blue (to occasionally spice up a blue mixture), lamp black, and brown madder. Baron also carries zinc white gouache in case she needs opaque white highlights or milky mixtures of colors. She also keeps a bottle of Pebeo masking fluid available for use if she wants to preserve preliminary layers of color, and she carries several spray bottles with different sizes of nozzles so she can apply varying amounts of water mist on a painting. Perhaps her most critical tool is an old linen cloth that she uses to blot wet paint to control its flow or to lift dry paint off the watercolor paper.

The brushes Baron works with include a number of Lowe Cornell Ultra Round 7020 series brushes (sizes 1 to 14) that are made with synthetic hairs. They are durable, hold a generous amount of paint, and hold their shape with a great point. "At the beginning of the painting process, when I am literally throwing diluted pant, I use the largest brushes I have," says the artist. "On the last day of painting, when I am concentrating on refining the design and adding detail, I use the smaller brushes."

Baron works from preliminary drawings, some of which she does on location before laying out her paints and others that are added to a sketchbook as she goes about her daily routine. "I call my small thumbnail sketches—5 x 6 or 4 x 7—my 'little guys' that put an image and a plan in my head," she explains.

Using her sketches, Baron lightly draws the outlines of the important shapes on the stretched watercolor paper, and then mixes large quantities of primary colors to "throw" and brush on the white surface to establish an underlying statement about the atmosphere in the landscape. Sometimes she masks sections of her paintings, often after the initial wash of colors has dried thoroughly.

The steps on the next two pages show how Baron develops the images in the thumbnail sketches she calls her "little guys."

STEP 1

After taping off four small areas of the paper, Baron lightly draws lines to establish the horizon lines and the top edges of mountains, rocks, and trees.

STEP 2

Continuing with the same palette of primary colors, the artist defines the big shapes within each landscape.

STEP 3

In the final design stage of each painting, Baron uses smaller brushes to add the details to the foreground, middle ground, and background of each scene. These become great studies for bigger paintings in oil or watercolor.

PASTELS

Pastel painting appeals to a lot of artists because it is closer to drawing than to painting with a brush or palette knife. The sticks of pastel are held just like pieces of charcoal or graphite, and each new stroke sits on top of the colors that have already been applied rather than blending into wet paint. The painting process is direct and completely responsive to the artist's hand.

Because pastels don't mix when applied to a textured surface, you need to have a separate stick for each hue and value. That is, if you need a light blue, you have to select a specific light-blue stick because you can't combine a white with a dark blue as you can with oils or acrylics. In the studio, you can have a very wide selection of colors. The number of pastels you can carry to the top of a mountain or down to the shoreline will be quite limited, however. For that reason, plein air artists who work with pastels have to select just a few landscape colors that will allow them to record everything they see.

BELOW: Lisa K. Stauffer's pastels arranged on her half-size French easel as she creates a painting entitled *Winter Creek* in 2015.

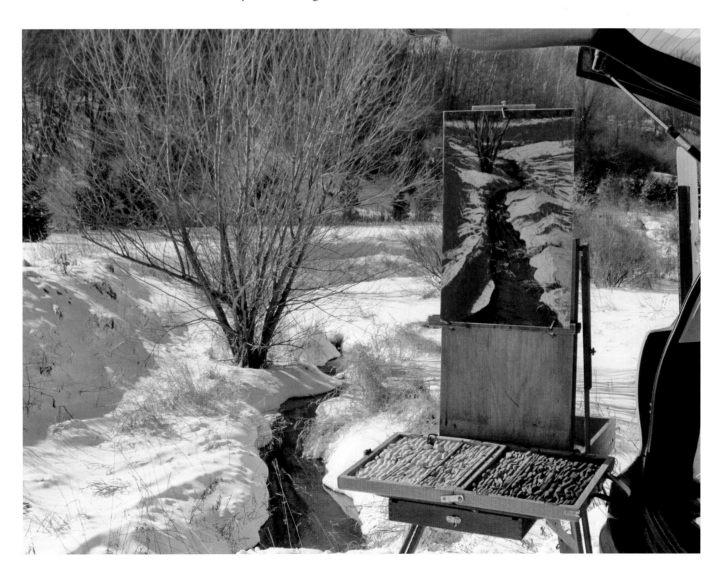

For her own plein air pastel painting, Minnesota artist Lisa Stauffer uses a variety of materials and techniques. She always keeps her car packed with the supplies she might need if time and opportunity allow her to stop and paint on location. "I have a Heilman box [designed to carry pastels] with about 150 or 200 small pieces of pastel arranged by value and color family, with the lightest values on the left-hand side graduating to darks on the right-hand side," the artist explains. "Of those pastels, about forty or forty-five are my 'best friends' because I use them most often. They include hard and soft pastels in a range of colors and values as well as a few intense darks I use for accents.

"I normally paint outside on sanded papers mounted to museum board," she says. "I often start by applying washes of watercolor as a way to quickly establish the big shapes in a design and to set up aerial perspective as well as texture in the underpainting. I can develop the image over those washes by layering strokes of hard and soft pastels."

Although Stauffer chooses subjects based on formal considerations, there was a period of time when she challenged herself to tackle specific themes she didn't immediately know how to paint: "Skill does come into play with any art medium, so I spent time working through the process of painting a wide variety of subjects, especially those I hadn't addressed before. It helped that I had strong drawing skills because I could use those to define the edges of shapes, the relative values, and the directional flow of forms on a two-dimensional surface. That gave me the confidence to break down any subject into its basic forms and represent it accurately with pastels, but I had to understand the range of possibilities so I could decide on the most appropriate way to paint in each new situation. Painting indoors allows me to experiment with underpainting techniques and revisit familiar painting concepts with more freedom."

Like most pastelists, Stauffer takes advantage of the fact that pastels are manufactured to be either hard, moderately soft, or very soft. These variations, which are achieved by using different binders to hold together the particles of pigment, allow artists to start with hard pastels that impart very little pigment to a textured surface, then switch to medium-soft pastels, and finish with very soft pastels that leave heavier deposits of pigment.

There is a limit to the amount of pastel that a substrate can hold, one determined by the substrate's texture. Smooth drawing paper will hold only a thin layer of pastel before the surface becomes so slick that it can't accept additional pigment, whereas a rough-surfaced board can accept many more layers of color within its crevices. For this reason, artists who paint delicately detailed portraits of children choose to work on relatively smooth paper while those who aim for large, impressionistic pictures prepare their own painting surfaces by coating boards with gesso mixed with pumice.

OPPOSITE: Lisa K. Stauffer, *Settled*, 2014, pastel, 12 × 12 inches (30.5 × 30.5 cm). Private collection.

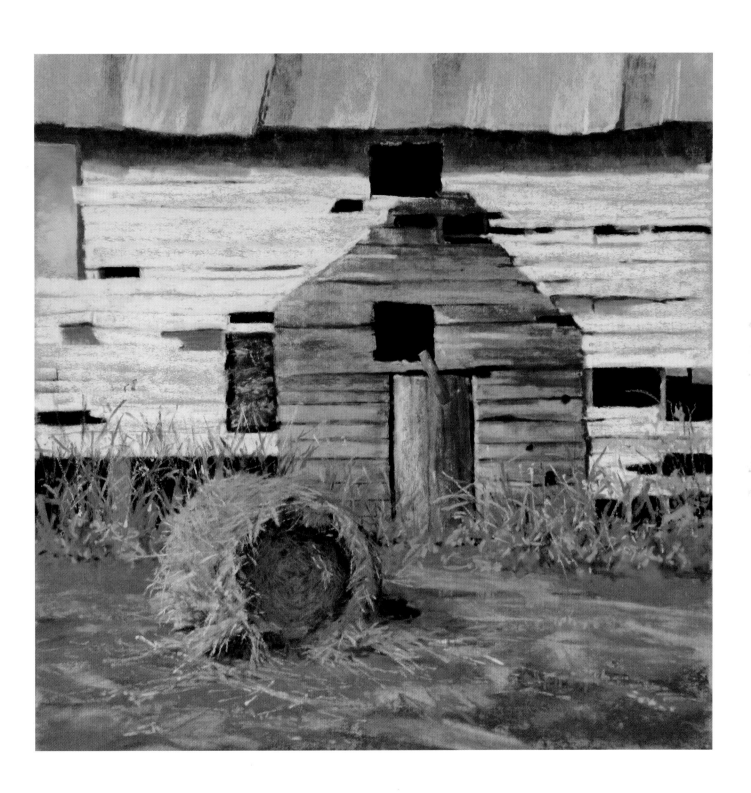

DEMONSTRATION: PLEIN AIR PASTELS OVER BRIGHT WASHES OF COLOR

Oregon artist Brenda Boylan's method is to start with a bright underpainting and gradually layer veils of color that create visual richness and luminosity in her paintings. She achieves this colorful dimension in her pastel landscapes through an intentional play of complementary or analogous colors beneath the top surface of the finished piece. Additionally, she considers the temperature of the colors she uses, such as the juxtaposition of a cool blue with a warm blue, to realize the kind of interplay that adds interest and sparkle to her work.

To prepare for painting outdoors, Boylan dry-mounts a sheet of white Wallis pastel paper to museum board. She then covers the Wallis paper with a protective sheet of glassine paper taped to the back of the mounted paper to safeguard the pastel once she has finished painting. Boylan carries her pastels and prepared boards in a modified Open Box M pochade box along with Turpenoid or denatured alcohol, barrier cream, a cheap foam brush, a sketchbook, and a few other standard painting supplies. Boylan jokingly refers to her setup as a "box of rocks." As she wrote in an April 2011 blog post, "The total weight of my setup is about fifteen pounds, and that can be an issue if I have to hike any distance."

Boylan uses a number of brands of buttery, soft pastels, including those made by Unison, Sennelier, and Terry Ludwig, as well as some of the hand-rolled pastels she herself creates with the leftover chips. "I seldom use hard pastels because they don't have the innate ability to layer softly, but I use them to lay in an initial sketch." she continues. "It's important to me that the underlying drawing be accurate, and I like having the ability to make changes using the softer pastels."

She begins painting a scene by blocking in the shapes with a limited number of pastels and then dissolving the pastels with a wash of Turpenoid or denatured alcohol. "When painting outdoors, I want the surface to dry quickly, so if there is a lot of moisture in the air I choose to dissolve the pastel with alcohol rather than the slower-drying Turpenoid," Boylan explains. "I prefer to have a warm underpainting of analogous colors to work over, so I almost always begin my painting with intense oranges, pinks, or reds. Once the underpainting is dry, I lightly block in layers of colors, establishing the darkest darks while juggling and comparing the values back and forth with each area until it all comes to a finish. I intentionally allow some of the underlying color to peek through the top layers to get an interplay of complements and color temperatures."

Opposite are the steps Boylan followed when creating her painting *Vineyard View*.

STEP 1

First, Boylan drew the major shapes and filled in the background colors of the landscape.

STEP 2

After drawing lines to indicate the general spatial divisions, she blocked-in bold, bright colors that would remain visible under the subsequent strokes of pastel.

STEP 3

Boylan then turned the first layers of pastel into washes of tone that she could work over after they were dry.

STEP 4

Boylan added broad strokes of warm and cool colors to establish the foreground, middle ground, and background of the landscape while allowing the underlying bright colors to show through those added strokes of pastel.

Brenda Boylan, *Vineyard View*, 2010, pastel on paper on board, 9 × 12 inches (22.9 × 30.5 cm). Collection of the artist.

ACRYLICS

In many ways, acrylics are the most flexible and adaptable of all paints, since you can change their properties to dramatically alter both their physical characteristics and drying time. They can be painted as thin, transparent washes that have the look of watercolors, applied as thickly as plaster with palette knives, painted on unsealed paper or hard planks of wood, shifted from a matte to a glossy finish, or modified so the paint surface remains wet for a longer period of time. Despite these varied characteristics and versatile applications, many artists reject acrylic paints because they falsely believe they always dry quickly and are therefore inappropriate for outdoor work.

Landscape and wildlife painter John D. Cogan, who works in acrylics, describes the paints and other supplies he carries when painting outdoors: "Most of the time, I use a French easel with a custom-made tempered-glass palette. Occasionally, I use one of my Open Box M pochade boxes, especially when I need to travel light. I use Golden's Open acrylics outside because they are formulated to dry more slowly than regular acrylics. I use the earth colors more than I used to, especially burnt sienna, burnt umber, and yellow ocher. I also use Golden's Van Dyke brown hue, red oxide, and carbon black (very sparingly).

"I can mix the full range of colors I need from the primaries, plus white and a couple of secondaries. On location, I usually work with titanium white, ultramarine blue, phthalo blue, quinacridone violet, pyrrole red, pyrrole orange, Hansa yellow opaque, and diarylide yellow. I do not take any toxic

ABOVE: Californian Marcia Burtt using a fishing tackle box as a palette to slow the drying time of her acrylic paints.

OPPOSITE: Marcia Burtt, *Breeze from the Southwest*, 2013, acrylic on canvas, 36 × 40 inches (91.4 × 101.6 cm). Private collection.

colors with me on location, such as the cadmium, chromium, or cobalt groups, because I want to avoid the chance of contaminating the environment.

"I store my wet paint in a plastic jewelry-sorting box with lid (about three dollars at a craft store). The depth is enough to protect the paint from the wind. I also use a water sprayer to mist the paint in the box and the paint on my glass palette. I usually use Trekell Legion synthetic mongoose brushes for thicker paint and Trekell's Golden Taklon brushes for smooth or thin passages and glazes. I prefer flats or brights but also use filberts. I use Golden Open gloss gel as a medium. If there are areas that I want to be built up, I may use regular gloss gel as a medium to allow for faster drying. I bring a small

plastic bottle of isopropyl alcohol to clean the paint out of my brushes when I am finished. I paint on RayMar and SourceTek panels, Fredrix watercolor canvas panels, or panels I make myself by gluing scraps of canvas to hardboard, birch plywood, or Gator Board."

ADDITIVE MEDIUMS

Artists' paints can be modified by adding mediums that change the paints' physical properties. Mediums can make acrylics thicker or thinner, make them dry slower or faster, and make their finishes iridescent, metallic, glossy, or matte. Oils, too, can be made to dry faster or slower, become thinner or

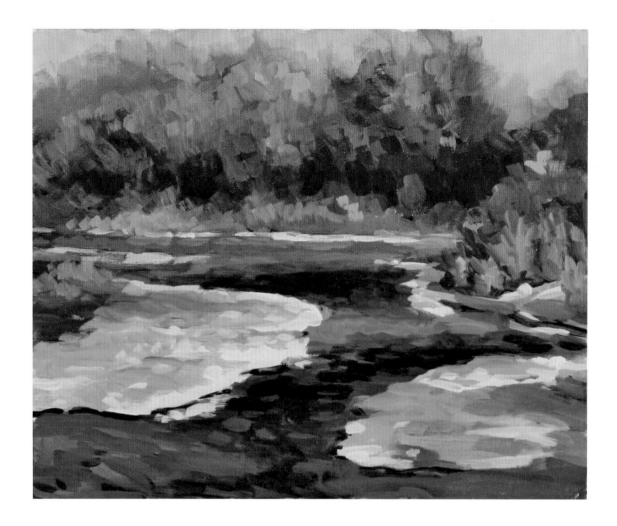

thicker, or take on a gloss or matte finish. Mediums can also make oils flow off a brush fluidly or in thick layers. Watercolors and watercolor papers can be modified to change how the paper accepts the colors or how the pigments granulate. None of these additives is necessary, but each offers artists the opportunity to achieve specific effects.

Some plein air painters prefer not to use anything to modify their paints because they don't want to carry something that isn't absolutely necessary. Many outdoor painters, however, see the benefit of having oil colors dry faster so they can overlay additional colors. They can either add an alkyd medium to the paints or substitute an alkyd-based white for an oil-based white (since artists generally use more white than any other color). Alkyds and oil are completely compatible with each other, so any combination of oil-based and alkyd-based materials will result in faster drying time.

Acrylic painters usually want the opposite—for their colors to dry more slowly. Standard acrylic paints dry too fast to allow the artist to blend colors and soften edges. Adding a medium called a retarder slows down the drying and gives artists the flexibility they want.

ABOVE: John D. Cogan, *Waiting for Spring*, 2012, acrylic on panel, 6 × 8 inches (15.2 × 20.3 cm). Collection of the artist.

DEMONSTRATION: USING ADDITIVE MEDIUMS

I regularly pass by the farm pictured above when traveling along an interstate highway and always note the way morning light rakes across the field. I finally used Google Maps to find out how to reach the farm from local roads so that I could set up my easel and paint.

STEP 1

Using very thin mixtures of oil color modified with fast-drying Gamblin Galkyd Gel, I quickly blocked in the big shapes in the landscape and the pattern of light and shadow that had attracted me to the site. The chevron shapes worked well in creating an illusion of deep space that will move the viewer's eye throughout the painting.

STEP 2

I then mixed Gamblin's Cold Wax Medium with my oil colors and applied them to the foreground using a palette knife. This allowed me to define the space quickly and add a textural richness to the painting.

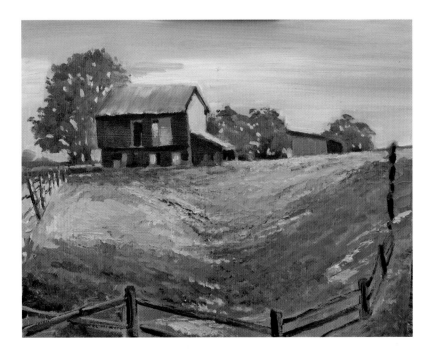

STEP 3

Continuing to use both a palette knife and a bristle brush, I refined the barn and the background trees as well as the fence posts to emphasize the rhythm of the spatial movement. The finished painting is pictured.

M. Stephen Doherty, *Morning Chevron*, 2016, oil on canvas, 16 × 20 inches (40.6 × 50.8 cm). Collection of the artist.

BRUSHES

Artists can choose from a wide variety of brushes of different shapes and made of different kinds of hairs, both natural and synthetic. Each type of brush is designed for a particular medium and style of paint application. Bristle brushes are generally less expensive and allow you to carry a lot of paint to the canvas or paper, while softer brushes made with animal hairs or synthetic fibers give you greater control over the brushstroke and are better suited to painting details.

Watercolorists need brushes that will hold and slowly release diluted watercolor paints, so soft natural- and synthetic-hair brushes are best for that medium. Acrylic paints can quickly gum up the fibers of a brush, so it makes more sense to use brushes with synthetic rather than natural hairs when painting with acrylics.

PALETTE KNIVES

Originally designed for mixing or scraping paint on a palette, palette knives are now used by artists to apply pure colors to a painting or to create somewhat random textural effects. Oil and acrylic colors often appear brighter and cleaner when slapped onto a canvas with a knife and not worked to the point that the colors become dull and dirty, and marks made with a knife loaded with paint can look more natural than well-controlled brushstrokes.

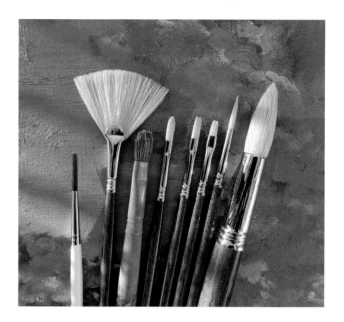

TOP: Shapes of oil-painting brushes. Left to right: no. 6 liner, no. 6 fan, no. 12 filbert (well used), no. 6 filbert, no. 6 flat. no. 6 bright, no. 6 round, and no. 20 round.

ABOVE: A display of five commonly used steel-bladed palette knives of varying lengths and shapes.

Brush Recommendations from James Gurney

James Gurney, a plein air painter and influential art blogger, uses bristle, sable, and white nylon brushes for oil painting. The bristle brushes, made from the bristles of Chinese hogs, are inexpensive. Stiffer than the other types, they are useful for blocking in big areas and manipulating thick paint. Bristle brushes are good for keeping paint application direct and simple and for creating soft edges. (Generally, the stiffer the brush, the softer the edges.)

Gurney likes using flats and filberts. White nylon flats are excellent for detailed painting of architecture and machinery. They're available in widths as narrow as a quarter of an inch. One-inch-wide flats are useful for laying in a transparent wash of thin paint. A flat brush should have a chisel tip, which you can use for either a wide stroke or a thin line. Most brush manufacturers make nylon brushes, and they're all pretty good. They're fairly inexpensive, but they don't last long.

For small detail work, Gurney uses Kolinsky sable rounds. The term *sable* is a misnomer: these brushes are made from the reddish tail hairs of a kind of weasel, not a sable (which is a kind of marten). Though intended for watercolor, they work equally well for oil. They are the most expensive brushes, but they respond very sensitively to detail work.

James Gurney painting outdoors.

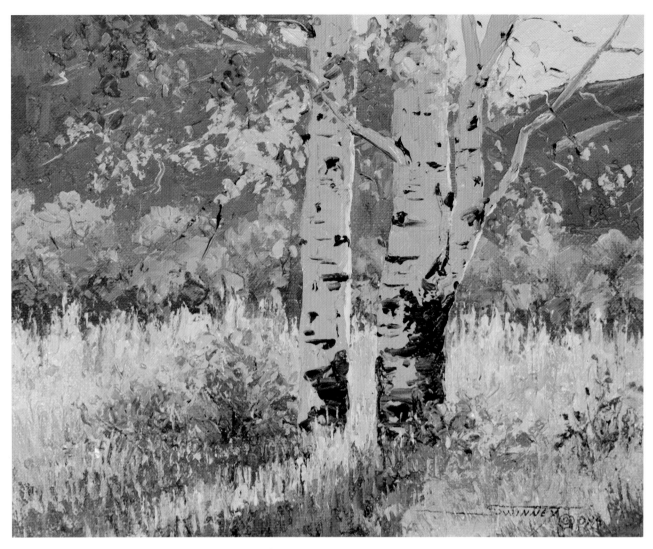

Knives with blades of different lengths and shapes are available; choice of a knife is based on the amount of canvas to be covered, the volume of paint to be applied, and the amount of control you want to have over the paint. A long, thin blade will facilitate painting sharp edges; a short, fat blade is best for adding dabs of color in a small area; a wide, trowel-shaped blade can be used to cover a large space like a sky, field, or ocean. Whatever its shape, a palette knife can be used to scrape, blend, or swirl wet paint depending on how you hold it and the amount of pressure you use when manipulating the paint.

TOP: Carol Swinney, *Aspen Light*, 2011, oil on panel, 8 × 10 inches (20.3 × 25.4 cm). Private collection.

BOTTOM: Carol Swinney using a palette knife to create a plein air painting.

DEMONSTRATION: MAKING THE MOST OF BRUSHES AND KNIVES

"Brushwork plays an important part in my oil paintings because it gives them a spontaneity and dimension," says Arizona artist Becky Joy. "I can create depth of field by adding a little texture in the background, and that makes a painting more exciting. Plus, I like adding playful brushwork in the foreground. I use a variety of flat and filbert brushes, plus a couple different sizes of palette knives. At times, I use brushes as if they were palette knives so I can create strong, thick strokes of oil color. I use techniques that lend variety to the brushwork to make a painting more exciting."

To help explain her procedure, Joy photographed the steps she followed when working in her studio on a 24 × 30 painting that was based on a small plein air sketch.

Here's the plein air sketch Joy used to create the studio painting.

STEP 1

Joy started by defining the dark shadow shape.

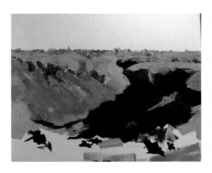

STEP 2

She kept the brushwork loose while blocking in big shapes.

STEP 3

She added purple to the horizon and resolved the foreground.

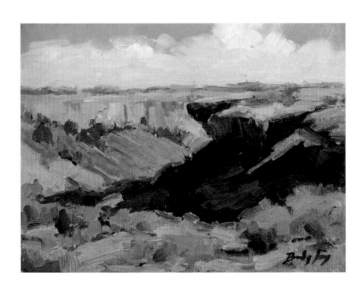

STEP 4

Finally, she suggested detail by adjusting the textures with a palette knife rather than using a small brush to add tiny strokes of paint. The finished painting is pictured.

Becky Joy, *Shadow Rock*, 2015, oil on canvas, 24 × 30 inches (61 × 76.2 cm). Collection of the artist.

PORTABLE EASELS

There are several different types of plein air easels on the market, all designed to be portable, durable, and relatively lightweight. They accommodate different sizes of panels and vary by weight, quality of the construction, and ease of use. Each has limitations. For example, easels that are more easily portable may not hold larger panels. Ultimately, you'll have to decide which kind best suits your working habits. If you like hiking to distant painting locations, you'll want the lightest and most durable easel available. If, on the other hand, you work out of the back of a van, then flexibility and price are more important considerations.

Most plein air easels can be tipped below a 90-degree angle for watercolor painting and can hold a box containing a large assortment of pastels. Attachments and extensions are available to hold brushes and solvents, provide a larger mixing area, or accommodate a vertical palette.

POCHADE BOXES

Pochade boxes hold painting panels, brushes, and tubes of paint. The boxes have a mount on the bottom so that you can add an adjustable tripod if you

TOP: Ken Karlik using a homemade easel laid flat while he paints with watercolors.

BOTTOM: Stephen Giannini using a pochade box while painting in Naples, Italy.

wish. They're perfect for taking on a trip or off into the wilderness because almost everything you need can be stored inside the box; you can even place wet panels inside to carry them safely away from the painting location. Some boxes are rugged and inexpensive, while others, made like fine furniture, are pricey and require more care. Among the pochade boxes worth considering are the Guerrilla Box, Open Box M, EASyL, Sienna by Craftech, MABEF, Alla Prima Pochade, SunEden, Artwork Essentials, Billups Pochade Box, and Edge PaintBook.

FRENCH EASELS

One of the oldest types of outdoor easel is the French easel. At one time French easels were finely handcrafted; now, they're mass produced. Full-size and half-size French easels are relatively cheap, but they tend to lose parts or break after just a few months of use. But they do fold neatly into a rectangular box that fits easily in the overhead compartment in an airplane or the trunk of a car. They hold lots of paints and brushes and can be adjusted to hold small panels or large canvases. And when you leave a painting location, you can strap a wet panel to the easel, making it easier to carry.

TOP: Tennessee artist Anne Blair Brown using an Open Box M palette/panel holder on location in Virginia.

BOTTOM: Gil Dellinger using pastels laid out on a French easel.

GLOUCESTER EASELS

The Gloucester easel has a simple design: a tripod consisting of three long notched sticks connected at the top and stabilized by crossbars. These easels can hold panels or canvases ranging from 6 × 8 up to 36 × 48. A paint box or palette can be set on the crossbars in the middle, and weights can be hung from the crossbars to keep large canvases from becoming sails in the wind. Gloucester easels can be expensive, and their long legs make them awkward to carry; also, all the other tools and supplies have to be carried separately.

MODERN METAL AND PLASTIC EASELS

A few artists who experienced problems with traditional plein air easels have designed and built innovative easels made from modern metals and plastics. Painter Jim Wilcox engineered the Soltek easel, which his sons now manufacture. Weighing nine pounds, it holds brushes, towels, and up to twenty-six tubes of paint, and it can support canvases up to 30 inches tall. The Soltek easel fits comfortably in a backpack. Bryan Mark Taylor designed the sleek Strada easel, which is made of sturdy aluminum and can hold panels in a range of sizes. The Strada can be heavy to carry in a backpack, however, and it doesn't hold any supplies. It works better with panels than with stretched canvases.

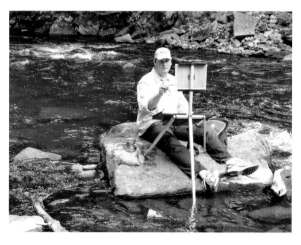

TOP: Maryland artist Steve Griffin using a version of the Gloucester easel.

MIDDLE: This view of a Gloucester easel shows how the crossbars between the legs can support a box of supplies, a palette, or other tools.

BOTTOM: Ryan S. Brown using a Soltek easel.

Traveling to Paint by Thomas Jefferson Kitts

When I prepare for a painting trip abroad, I reduce my gear to the bare essentials and decide what I should take in my carry-on luggage and what can be checked. For a trip to Spain and Morocco, I reduced my palette to titanium white, cadmium yellow medium, alizarin crimson, ultramarine blue, cerulean blue (hue), and viridian. I squeezed the contents of tubes of paint into plastic jars to avoid punctures. In the field, I combined the three darkest colors to make a black and mixed complementary hues together to create earth colors.

I packed six brushes, a palette knife, medium cup, six custom-cut 12 × 16 RayMar Feather Lite panels, and an Open Box M easel and tripod into my backpack. If something couldn't be replaced in Spain, it went into my carry-on backpack. Because airlines won't allow anyone to carry liquids, I Googled art stores in advance to locate places where I could buy solvent. I couldn't find any in Morocco, so I used olive oil and soap to clean my brushes and only had to squeeze out the excess to make that work. At the end of the trip, I left the extra oil behind for another artist—or a cook!

I consider the paintings I made to be quick field sketches that may be useful as color references when creating larger studio work. I say "may" because at heart I am a plein air painter filled with the urge to travel, and if given a choice I prefer to work from life. I love to respond directly to the light and colors of a place while experiencing the art and culture of a people firsthand.

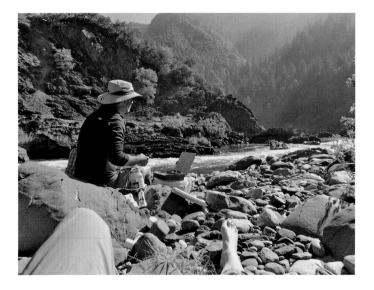

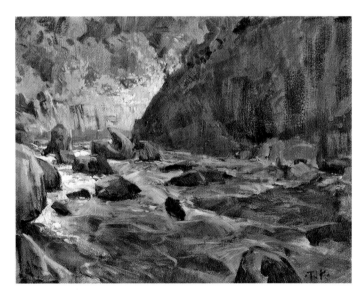

TOP: Thomas Jefferson Kitts painting while on a rafting trip.

BOTTOM: Thomas Jefferson Kitts, *Blossom Bar, Rogue River*, 2013, oil on panel, 9 × 12 inches (22.9 × 30.5 cm). Private collection.

MICHAEL GODFREY

Unless he is participating in a plein air competition and needs to work on larger canvases, Maryland artist Michael Godfrey prefers to work on 6 × 6 or 8 × 10 panels so he can quickly nail down the lighting effect in the landscape. "If I record the fleeting effects accurately, I can always add details later from my recollections or from photographs," he explains. "I learned early on when I began painting landscapes that photographs are useful for recording details, but they are inadequate references when it comes to really understanding how the light impacts the perception of shapes, colors, edges, distance, atmosphere, and the emotional impact of a landscape scene."

Godfrey creates most of his small plein air sketches not as finished paintings but with the intention of using them as reference material, so he focuses on making a study in 60 to 90 minutes. During a plein air event at which he hopes to sell his outdoor paintings, however, he has to work larger and bring the painting to a higher level of completion.

"I often use three or four different plein air sketches as references for one last studio painting," says Godfrey. "I might go back out to paint a specific location when I know the information I gather will be useful in the studio. Another thing I enjoy doing is reusing the same reference material to create a completely new painting.

"If I'm not pleased with a painting, I'm prepared to wipe down the surface to the bare canvas," Godfrey confesses. "If I'm not completely satisfied but think there might still be hope, I'll set the painting aside for four or five months and then determine how to save it."

RIGHT: Michael Godfrey, *Teton Morning,* 2014, oil on canvas, 48 × 36 inches (121.9 × 91.4 cm). Private collection.

OPPOSITE, TOP: Michael Godfrey, *On the Lewis River,* 2013, oil on panel, 6 × 6 inches (15.2 × 15.2 cm). Collection the artist.

OPPOSITE, BOTTOM: Michael Godfrey, *Evening's Gift,* 2013, oil on linen, 24 × 18 inches (61 × 45.7 cm). Courtesy of McBride Gallery, Annapolis, Maryland.

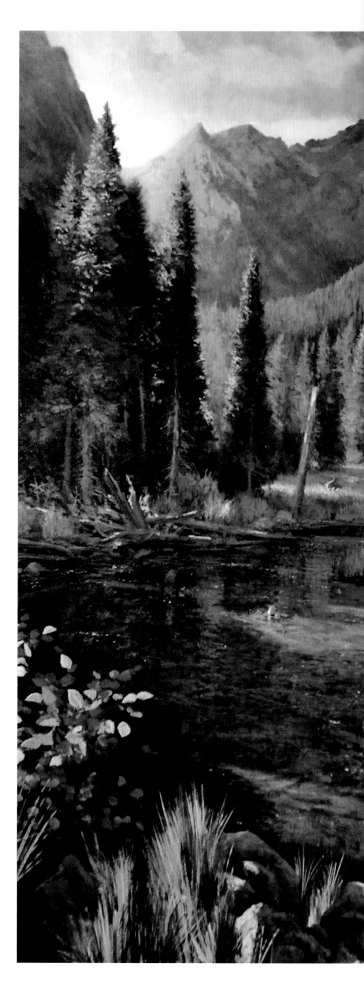

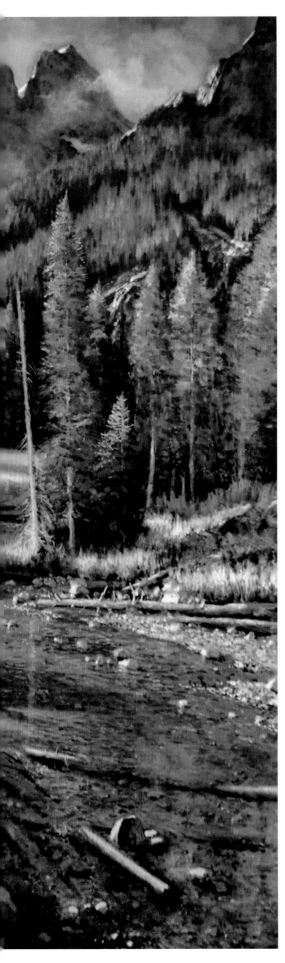

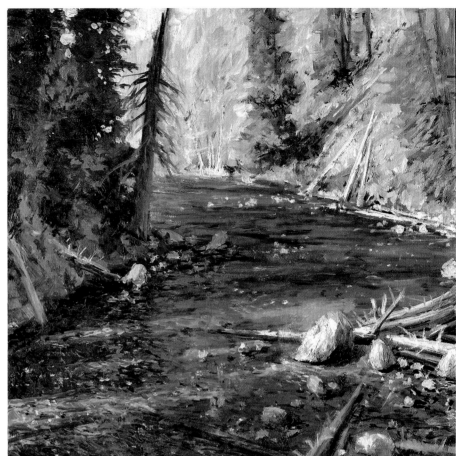

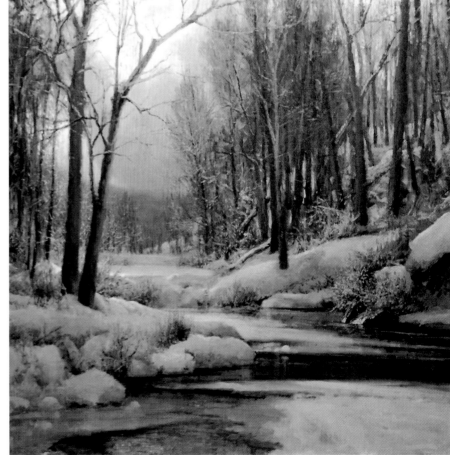

CHAPTER 6

TECHNIQUES

To learn to paint effectively outdoors, people usually take workshops, read books, subscribe to magazines, watch demonstrations, and talk with others who have more experience. The benefit of that research is that the aspiring plein air painter learns about a wide range of painting techniques. The downside of acquiring all that information is that the artist may find it overwhelming, conflicting, or hard to apply.

The best way to deal with all these varied techniques is to focus on a few that seem most likely to help you create the kinds of paintings you like best. If, for example, you appreciate big, bold paintings that verge on abstraction, you might choose to work on large canvases, to extend your arm when stroking with a big bristle brush, and to stop when you've achieved just the suggestion of a landscape. If, on the other hand, you respond to misty, atmospheric landscapes with subtle color transitions, you might want to work with pastels or watercolors on small sheets of paper so that you can build up layers of transparent colors that are close to each other in value. As long as the techniques you use respect the natural characteristics of the paints, the only "right" way for you to work is to employ procedures that yield a work of art that captures your thoughts and emotions.

OPPOSITE: Brienne M. Brown, *Hodge Farm*, 2015, watercolor on paper, 10 × 14 inches (25.4 × 35.6 cm). Collection of the artist.

USING A VIEWFINDER

A viewfinder is a device you hold in front of your eyes to frame potential painting compositions. It can be as simple as the thumb and forefinger of both your hands held to establish an adjustable rectangular space in front of your eyes or two L-shaped pieces of mat board held together by paper clips. Commercially made viewfinders have measurement marks along all four sides of the window; sometimes, the window is covered with transparent red plastic to eliminate colors and emphasize values. With any viewfinder, you can move the rectangular viewing space to the left or right, elongate or shorten it, and hold it closer to or farther from your eyes to expand or contract the space being framed.

ABOVE: A commercially made viewfinder held in an artist's hand.

A viewfinder allows you to quickly determine whether a scene is worth painting, which elements might be eliminated or emphasized, and how the arrangement of values defines the subject.

Creating Visual Interest

When painting in the early morning on the banks of the South River in Waynesboro, Virginia (shown in the photo), I decided to focus on the structure of the old bridge support so that the painting would have a strong focal point and an implied story—two things that could create interest in the completed painting.

RIGHT: The scene along the South River.

FAR RIGHT: M. Stephen Doherty, *Sunrise along the South River*, 2016, oil on panel, 12 × 12 inches (30.5 × 30.5 cm). Collection of the artist.

MAKING PREPARATORY SKETCHES AND COLOR STUDIES

What can a small ballpoint-pen sketch reveal about the painting an artist is about to create? According to Californian Paul Kratter, just about everything needed for a well-designed expression of the total experience in nature. According to Kratter, a thumbnail can be a very small, quickly gestured ink sketch with rapid outlines of the major shapes and hatched lines suggesting the half-tone values. "The most important part of the process may be the few minutes I spend observing the subject and thinking about how to use that information," he explains. "Then I start to turn my thoughts and mental images into a concrete set of lines on a piece of paper. At that point, I can decide if the two-dimensional black-and-white gestured image really captures what I saw and felt about the location.

"That simple drawing won't mean much to anyone else," Kratter says. "But it helps me figure out if I have the best movement and balance of shapes, an effective set of spatial relationships, and a meaningful expression of what I feel. Simply put, it's a way of making decisions before I put a paintbrush in my hand.

"It's not absolutely necessary to make a sketch any more than it is necessary to think about what I'm going to say before I open my mouth," Kratter says with a chuckle. "But thinking first is one way of not saying something stupid, and making a sketch is a way of improving the odds that a painting will be successful. I tell my students that if they look at their completed paintings and realize there was

something they should have done differently right from the start, then they have proved to themselves how valuable it is to make a thumbnail sketch."

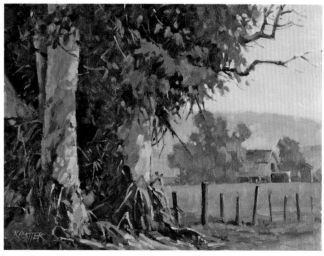

TOP: Paul Kratter made this preliminary graphite sketch before starting his plein air painting *In Good Company*.

BOTTOM: Paul Kratter, *In Good Company*, 2015, oil on panel, 12 × 16 inches (30.5 × 40.6 cm). Private collection.

Jack Beal's Composition Tips

For more than four decades, Jack Beal (1931–2013) lectured on pictorial composition at colleges, universities, convention centers, and workshops. Before his death, he wrote extensively on the critical importance of using time-tested techniques, common from the fifteenth through seventeenth centuries, to direct viewers' attention. Other art teachers commonly offer some of Beal's advice, but many of his recommendations are not generally understood or consistently applied. Here are some tips Beal offered his students.

1. *Don't put the center of interest in the middle of a painting.* It's hard to engage viewers if they are focused on what's happening in the middle, or the "dead center," as it is appropriately called. Primarily used with sacred subject matter, it can create a bull's eye or a dull fried-egg visual experience. Don't divide the canvas in half with a horizon line or place important objects evenly spaced from each other. Principles such as the "golden mean" can be used to create diversity and maintain unity of your shapes.

2. *Use diagonals to welcome the viewer into the painting and create tension.* That diagonal shape can be a road, pathway, fence, or shrub in the foreground of a landscape, a fork lying on the edge of a table in a still life, or a shaft of light coming from over the viewer's shoulder into the space. Horizontals and verticals give a painting strength and structure while diagonals create dynamic movement and energy. Once an artist persuades a viewer to enter a painting, the observer can be led through the space and out again.

3. *Leave some areas of the painting open.* Artists who paint from photographs often fail to adjust for the fact that the camera has a limited depth of field and will document what happens within a narrow space. Those artists often fill their paintings with a crowded pattern of shapes and colors. It's better to leave open portions

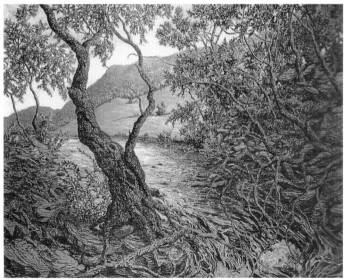

TOP: Jack Beal, *The Farm*, 1979–1980, oil on canvas, 84 × 96 inches (213.4 × 243.8 cm). Collection of the Fralin Museum of Art, University of Virginia, Charlottesville.

BOTTOM: Jack Beal, *The Dark Pool*, 1980, pastel on gray paper, 48 × 60 inches (121.9 × 152.4 cm). Private collection.

of the sky, ocean, field, tablecloth, or room as a balance to the elaborated portions of the painting. If you choose to paint from photographs, it helps to take a number of shots of a potential painting subject—details, overall shots, various exposure settings, and so on—so that you have enough information with which to create a more engaging view of the subject.

4. *Repeat colors, shapes, and patterns to create interest throughout the painting.* If there is only one red building in a landscape painting, that intense color may overwhelm the rest of the picture. It's better to repeat colors, shapes, and patterns to create visual rhythms and echoes to keep viewers' eyes moving around and through the picture.

5. *Look at your paintings objectively by turning them upside down or looking at them in a mirror.* We all become so completely engaged in our drawings and paintings that we can't judge them objectively. It helps to turn the image upside down, put it away for a while, or look at it in a mirror so that you see it differently and can therefore recognize how to improve it.

6. *Consider the rational and emotional aspects of the painting process.* Artists have long recognized that there are two complementary approaches to representing the human experience. One emphasizes reason and rational thought and is often identified as Apollonian (referring to the god Apollo). The other approach is associated with wine, ecstasy, and heightened emotions and is labeled as Dionysian (referring to the god Dionysus). The Apollonian artist prefers to create order from chaos with clarity and logic, or closed form. The Dionysian artist tends to expand visually beyond the confines of the canvas and embrace ambiguity, or open form. Each of us is usually some mixture of both types. Discovering which aspect is dominant in you can help you make more personally satisfying art.

TOP: Jack Beal, *Landscape with Barn and Trees*, 1978, pen and ink wash on paper, 18 × 21½ inches (45.7 × 54.6 cm). Private collection.

BOTTOM: Jack Beal, *Anne Wilfer Drawing*, 1982–1983, oil on canvas, 54 × 50 inches (137.1 × 127 cm). Private collection.

TONING A SURFACE

It is not uncommon for artists to apply a thin wash of color to a canvas, especially when they intend to work outdoors under bright sunlight that will bounce off a white surface and distort the perception of values. Pastel painters often dissolve their initial applications of color with denatured alcohol to establish the big shapes of a design and to lay down an underlying color that will peek through the subsequent strokes of pastel. Portrait painters will sometimes block in the shadow areas of a face with a complementary green color before they apply the reddish flesh colors on top. Be cautious, however, if you're working in oils but doing the initial underpainting in acrylic: the acrylic wash has to be thin enough that it doesn't cause a problem of adhesion when the oil colors are brushed on top.

ABOVE: First stage of *View from Buck's Elbow Mountain.*

WARM-TONED SURFACES

Over the years, I have found it useful to start a plein air painting by wiping a thin layer of a warm-toned color across the entire canvas and then wiping out portions of that tone using paper towels. This process allows me to quickly establish a pattern of light and shadow before the scene changes completely, and it predisposes me to develop a predominantly warm-colored painting.

For a painting showing the view from the top of Buck's Elbow Mountain in Crozet, Virginia, I applied a thin wash of transparent earth red over the entire canvas, painted the cloud pattern, and then developed the land. The advantage of resolving the sky before painting the mountain was that each section of the relatively large 16 × 20 canvas could be painted quickly and the strokes of oil color blended so that the softer edges suggest atmosphere and distance.

ABOVE: M. Stephen Doherty, *View from Buck's Elbow Mountain*, 2016, oil on canvas, 16 × 20 inches (40.6 × 50.8 cm). Private collection.

Warm-toned colors are appealing to viewers because they are more inviting and satisfying than cool ones. That's especially true when painting a landscape in early spring—a time of year when there are few bright colors to build interest. For a painting of a cattle farm along a stream in Virginia, I pushed the overall tone in a decidedly warm direction by blocking in the major shapes with thin washes of yellow ocher and transparent red oxide.

STEP 1

After covering the entire surface of a 12 × 24 stretched canvas with a thin wash of yellow ocher (mixed with Galkyd medium to speed up the drying), I used a paper towel to wipe out the light-value shapes in the sky and the horizontal bands across the middle and bottom.

STEP 2

After first blocking in the mountain shape with a wash of transparent red oxide, I added local colors to the buildings, foreground stream, and bridge. Note that I painted the overcast gray-blue color of the sky and lightened the color along the horizon.

STEP 3

After I'd spent three hours on the painting, rain and a chilly temperature chased me away from the site. I returned the next day when the light was similar but there were billowing clouds in the sky that were more dramatic.

STEP 4

I adjusted the light within the scene, added definition to the bridge and embankment, and refined the buildings. I also added trees to the foreground area.

M. Stephen Doherty, *Cattle Farm by a Stream in Virginia*, 2015, oil on canvas, 12 x 24 inches (30.5 x 61cm). Collection of the artist.

BRIGHT-TONED SURFACES

Wisconsin artist Shelby Keefe creates plein air paintings on canvases toned with brightly colored, fast-drying acrylics. As a result, her finished paintings have a heightened energy, excitement, and unity. "My painting teacher encouraged students to get rid of the white surface on which they intended to draw or paint, so we always found a way to accomplish that, whether it was to apply a collage of tissue paper, spray paint it with several colors, or just brush out the white of the gesso with contrasting colors," says Keefe. "When I left the graphic design field to become a full-time fine art painter in 2005, I continued my practice of 'getting rid of the white surface' before I started a painting."

While it may seem unusual for a plein air painter to prepare a painting's surface with strong colors that are complements to the predominant scene he or she intends to paint, it is not unprecedented. It actually makes a lot of sense to apply a wash of colors that is the complement of the one that will be painted on top. The interaction of the two colors that are opposite each other on the color wheel can add depth and richness. So, one might apply orange acrylic when intending to paint a blue sky or seascape, reds and purples when the subject is a mass of green trees. Similarly, one could paint blues and greens before painting the oranges and browns in a fall scene or brick building. As Keefe says, "The approach can be distracting at first, and some people who try the technique have trouble gauging the right hue and value when they paint such a strong complementary color. But after they become comfortable with the process they find it adds energy, excitement, and unity to their paintings."

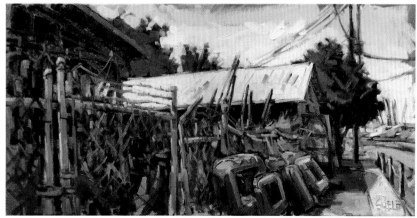

TOP: Shelby Keefe first applied washes of bright warm and cool oil colors according to the general arrangement of color temperatures in the scene she was painting.

BOTTOM: Shelby Keefe, *Artifacts of the Forgotten Coast*, 2014, oil on canvas, 12 × 24 inches (30.5 × 61 cm). Private collection.

"I start painting by applying a light wash of transparent watercolor over most of the surface of a 140-pound rough watercolor paper so there is very little pure white left," Brienne M. Brown explains. "Once those washes dry, I can add mid-range values or jump straight to the darkest tones, depending on the subject. During the first wash, I only use three or four colors, usually some variation of the primaries." Brown, a former toxicologist, is a signature member of both the Utah Watercolor Society and the Pennsylvania Watercolor Society. She currently lives in Julian, Pennsylvania.

"I normally proceed by adding mid-range valued colors, but sometimes I paint the dark values so I have the full range marked by the two extremes," she says. "After the initial washes of 'fun colors,' I shift gears and mix colors to the exact value and opacity I want for the finished painting. I like being bold and letting paint flow and drip, but I don't want to be so tentative about the brushstrokes that I wind up having to apply layer after layer of color and have a dull surface. Watercolor always looks best when an artist confidently mixes the colors and applies them with one active stroke."

Brown's palette is quite extensive and includes colors made by Daniel Smith, Winsor & Newton, and Holbein. The palette includes ultramarine blue, cobalt blue, cerulean blue, cobalt turquoise, alizarin crimson, transparent red oxide, transparent yellow oxide, aureolin, cadmium red, cobalt turquoise, vermilion, sap green, horizon blue, cobalt teal blue, and lavender, as well as a tube of white gouache. She owns tubes of a few earth colors but seldom uses them, and she never uses all these colors in one painting—only about eight to ten.

STEP 1

After planning the composition of values with a quick value sketch, Brown redrew the key lines lightly on watercolor paper. She was careful to get angles and proportions correct as well as a pleasing composition.

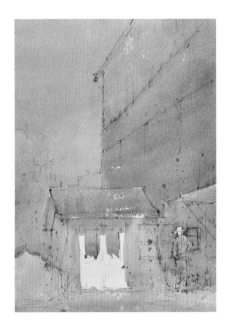

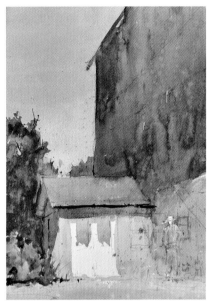

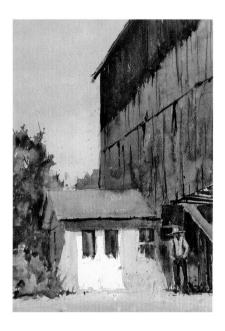

STEP 2

Holding the paper at a 30- to 50-degree angle to the table, the artist applied the first wash of color on the paper and allowed it to freely flow. The colors in this initial wash are not necessarily the local colors because the only important consideration at this point is whether they are warm or cool. By covering most of the paper and using a limited palette, Brown unified the painting from the start.

STEP 3

After the first wash dried completely, Brown started adding mid-tones and connected shapes so there would be both hard and soft edges. She didn't want the shapes to get too neat and perfect, so she splattered some opaque colors to add texture and break up lines. At this point, all that was left to paint were the details. The finished painting is at right.

Brienne M. Brown, *Hodge Farm*, 2015, watercolor on paper, 10 × 14 inches (25.4 × 35.6 cm). Collection of the artist.

BLOCKING IN BIG SHAPES

Many plein air artists focus primarily on value relationships and pay little attention to the dynamic integration of shapes or masses. That's in part because contemporary artists are predisposed toward symmetrical balance and the shallow pictorial space of photographs and Modernist paintings rather than asymmetrical compositions and deep space championed in the Renaissance. Most of us learned to understand the visual world through photographs rather than drawings. I spent years listening to the distinguished artists Jack Beal and Sondra Freckelton urge painters to return to the Renaissance and Baroque ideas about pictorial space, and the demonstration opposite owes a debt to their influence.

ALLA PRIMA PAINTING

Alla prima painting is a process of painting continuously without stopping to allow the paints to dry. The term *alla prima* is Italian in origin and means "on the first [try]"; the technique is sometimes called the wet on wet method.

Wisconsin artist Daniel F. Gerhartz, a master of *alla prima*, often draws the outlines of the major shapes in a landscape or figurative composition and then paints outward from the center of interest. For example, he will paint his model's face and then her hair, clothing, and background, going from one to the other without moving around the canvas to bring each area up to the same level of completion.

When he offers instruction to students, Gerhartz focuses on the importance of distance and squinting. "Squinting is huge," he explains. "It is the best way to glean the essential information needed to build form. Through the twenty-five years I have been painting, there is one recurrent problem that hinders my efforts to produce an effective representation

ABOVE: Daniel F. Gerhartz using a continuous *alla prima* method to paint figures posed outside his Wisconsin studio.

DEMONSTRATION: BLOCKING IN SHAPES

In developing this 16 × 20 plein air painting, I used the shape of the pond as a theme I could repeat so that the composition would gain a greater sense of movement and depth and the natural forms would be integrated.

STEP 1
I first brushed a wash of yellow ocher across the entire canvas and then wiped out the light-value shapes with paper towel.

STEP 2
Continuing with thin mixtures of oil color, I blocked in shapes using lighter and bluer colors to indicate the distant trees and dark greens to mark the stand of evergreens on the left-hand side.

STEP 3
I worked colors that were lighter and more yellow across the open field and introduced the evergreens to add drama to the scene. I brightened the reflection in the pond with thick strokes of light blue.

STEP 4
To finish the painting, I added dark accents and bright highlights and softened edges in the background to further imply a deep space. I painted the clouds in a direction that counterbalanced the diagonal thrust of the shapes across the land. The finished painting is pictured.

M. Stephen Doherty, *New Pond at Polyface Farm*, 2016, oil on canvas, 16× 20 inches (40.64 × 50.8 cm). Private collection.

of what I am seeing. That problem is not properly squinting at the subject to simplify the information enough to solidify the masses and amplify the essentials. I have signs saying 'Squint' up all around my studio, because even after years of doing this, I still want to open wide to see every little thing.

"By gently closing my eyes about halfway, the forms are simplified and the variety between hard and soft becomes more visibly evident," Gerhartz says. "This contrast between the hard and soft is critical to capture and is a powerful tool we must utilize. Squinting forces me to see the value shifts more clearly, reducing the distractions of the reflected lights and darks and color changes. As I am squinting, the question going through my mind is, Is it *value* or *color* that is creating a sense of light coursing its way across a rounded form? If when I

am squinting I see no visible value shift, then I must open my eyes to see the color transitions within the simple shape to describe the turning of form."

The need to get some distance on the work in progress is related to the idea of squinting. It helps you see overall forms instead of individual details. As Gerhartz works, whether outdoors or in the studio, he constantly walks back about ten yards from the canvas to see the evolving image and the live subject—far enough back that both appear to be about the same size. One might call this a sight-size method (see page 144), although Gerhartz is not rigid about making sure that the painting and subject are exactly the same when viewed from a measured distance away from the easel. His approach is less like the one used by artists in classically oriented ateliers and more like the one John Singer Sargent used. It is said that Sargent walked across the Oriental rugs in his studio so often that he wore holes in the valuable floor coverings. "I've been known to make a cowpath through the grass as I walk back and forth trying to determine the appropriateness of each new stroke of paint I will apply to a canvas," Gerhartz says with a laugh. "By making the key decisions away from the surface of the canvas rather than when I'm standing next to it, I'm more likely to make a few bold, accurate strokes rather than a lot of tentative, small marks with my brush."

TOP LEFT: Daniel F. Gerhartz, *Moment of Reminiscence*, 2010, oil on linen, 36 × 48 inches (91.4 × 121.9 cm). Private collection.

BOTTOM LEFT: Gerhartz painting on location in winter.

OPPOSITE: Daniel F. Gerhartz, *A Good Start*, 2005, oil on canvas, 60 × 48 inches (152.4 × 121.9 cm). Private collection.

Adjusting Colors and Values by Mark Boedges

The most basic axiom we representational painters abide by is to paint what we see. It's a solid rule to live by as an artist and not, in my opinion, something to be forsaken lightly. However, in some cases, if executed literally this axiom can yield unsatisfactory results, for a number of reasons. Let's discuss two of these.

I paint on a lot of overcast days and the light is generally cool in these situations. I've learned over the years to mix my colors a little cooler than what I am actually seeing on location—which is to say, I try to make the colors a little bluer than reality. Consider standing outside an overcast day in winter with snow on the ground. In this case the snow really will look like shades of straight gray. If you paint that snow a literal gray and then bring your painting into the studio, it will look far too warm and gray; it will look dead. Imagine looking at the same overcast day from inside your house. You will quickly see that the entire scene outside has a very bluish cast to it. The problem is that when we are standing outside, our canvas and our palette are all in the same cool light, and so what looks right in that cool light is very different from what looks right in normal indoor lighting. We have to take matters into our hands and mix colors slightly cooler than we see them so the painting has the right feel when inside. Don't go crazy. I only ever push this color shift a little bit because if I change the colors too much it's hard to keep them looking right.

When painting outside, mix all your values two shades lighter than what you are seeing. Some form of this advice has been around a while and I think it is good advice in a lot of cases. I often struggle with this one myself. The thing is that when the sun is shining nature is really, really bright and full of color. The Impressionists understood this well and sacrificed some of the deep values in their shadows to achieve a vibrant canvas. One trick I've found that helps is to start with the lights and work down slowly to the darks. I

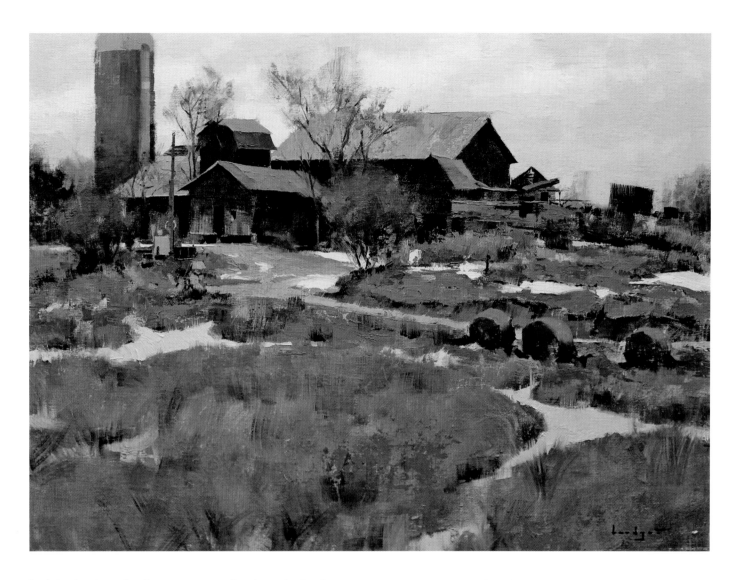

find the brightest bright in a scene and make it the brightest mixture I can—usually white with a fleck of another color, like yellow or blue. Then I pick out the next-brightest values in the scene and carefully mix them right next to my brightest bright on the palette. Make sure the difference in value is small, perhaps even less than you think it should be, but still enough to be a distinct value. Keep working down the next handful of values in the scene this way. With practice you can get a whole set of distinct values in the upper range that will help to keep your painting bright.

OPPOSITE, TOP: Mark Boedges painting.

OPPOSITE, BOTTOM: Mark Boedges, *Niagara Escarpment,* 2013, oil on canvas, 20 × 14 inches (50.8 × 35.6 cm). Private collection.

ABOVE: Mark Boedges, *Spring Thaw,* 2012, oil on canvas, 16 × 20 inches (40.6 × 50.8 cm). Private collection.

INDIRECT PAINTING

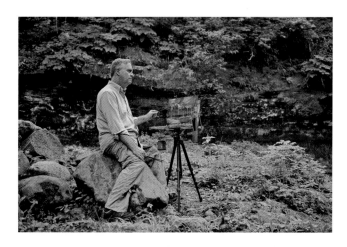

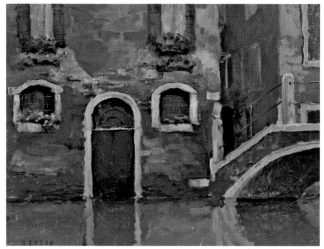

There are two basic kinds of painting processes: direct and indirect. In the direct process, the painter quickly applies thick brushstrokes of local colors; in the indirect method, the artist builds up layers of transparent color that in the aggregate will match the local color. The direct approach is bold and spontaneous, while the indirect approach is slow and carefully planned. In fact, some indirect painters call their style of working "slow painting" to distinguish it from a style characterized by quick strokes of paint.

Minnesota artist Bob Upton has found a way to exercise greater control over the drying properties of oil colors so that he can work indirectly on location and complete small, well-composed, carefully articulated landscapes in three to four hours. In the end, he achieves the depth, brilliance, and clarity that are the hallmarks of indirect painting. "The goal of early indirect painters was to achieve a gemlike quality in which one can't tell how the painting was created," he explains. "The uncertainty usually indicates that glazes and scumbles were used."

The key to Upton's technique is that he first paints the major shapes of the composition using umber oil colors thinned with fast drying Gamblin Alkyd Gel medium but no turpentine. He doesn't do any preliminary compositional sketches or value studies because he has spent years painting and working as a graphic designer and is therefore able to quickly analyze a subject in terms of the value shapes.

When Upton is ready to layer transparent colors over the initial warm tone on the panel, he first paints the dark shadow shapes thinly. It is important that he delay using white to tint the colors: "If I start using white to lighten colors too early in the development of a painting, it will become more difficult to darken values and maintain transparency in the later stages of the process. The paintings may look way too dark when I'm not adding white to the colors, but it's important to wait until I am ready to add the lighter values with thicker paint."

In the next step in the process, Upton paints the sky, now using white to establish a light blue background and the suggestion of clouds. He explains: "I follow the procedure of painting from the background to the foreground, in part because the light sky establishes the full range of values from dark to light, and in part because I need to paint

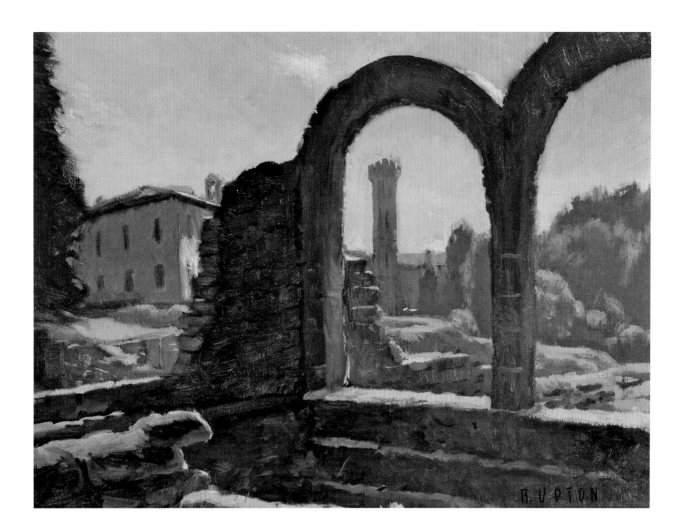

middle-ground and foreground shapes over those distant forms, so the sooner I block them in, the sooner they will dry enough to accept additional brushwork. Moreover, the atmosphere of a landscape is most evident in the distant spaces." Quoting nineteenth-century American landscape painter Sanford Gifford, Upton says, "Gifford said, 'You need to attend to the color of the air at the horizon of the sky, which is the keynote of the picture.' He called it 'air-painting.' Moreover, the atmosphere of a landscape is most evident in the distant spaces, so painting those early helps me convey the look and feel of the moment in time."

Upton says that while the steps he describes happen relatively slowly as he develops a fairly detailed representation of a scene, the final step of establishing the light effect happens quickly during the last half hour of painting. "I normally spend about three hours on a plein air piece, with the final thirty minutes reserved for adding the dark and light accents. However, I have a tendency to keep working and could probably stand at my easel for another hour or two if I didn't tell myself to stop," he confesses.

OPPOSITE, TOP: Bob Upton using an indirect painting method on location.

OPPOSITE, BOTTOM: Bob Upton, *Green Water, Venice*, 2012, oil on panel, 11 × 14 inches (27.9 × 35.6 cm). Collection of the artist.

ABOVE: Bob Upton, *Roman Baths, Fiesole*, 2012 oil on panel, 11 × 14 inches (27.9 × 35.6 cm). Private collection.

SIGHT-SIZING

Marc Dalessio, who will often spend several days working on a very large canvas, adapts classic studio procedures for painting outside. Among these techniques are sight-size drawing.

Dalessio uses the sight-size method for drawing and laying in the big shapes of a landscape composition. This method, once commonly taught in art schools, involves making decisions about scale, placement, and detail from a measured distance away from the painting surface. Dalessio marks a spot—about ten feet away from his easel—from which the painting and the subject appear to be exactly the same. Each time he needs to draw a line or block in a painted shape, he walks back from the canvas to the marked position and stands there to evaluate how to proceed. It's a great way to ensure a direct correspondence between the subject and the finished painting.

"I'm not a slave to sight-size, but I depend on the procedure at the beginning of the painting process when I am establishing the scale, perspective, and essential relationships between the major shapes within the landscape," Dalessio says. "Some situations make it impossible to get ten or twenty feet away from the easel, as when I am standing on the top of my Land Rover to get a view over the tops of the olive trees. My Land Rover can come in handy when I need to block the direct sunlight and I can't get under a tree or into the shadow of a building."

Some of the same painting materials Dalessio uses in his studio go with him into the field. These include his lead-primed linen canvases, his brushes, and a palette of oil colors consisting of three blues, two reds, two yellows, an orange, and titanium white. He also takes along a medium known as *antichi maestri*—a version of the medium that teacher Charles H. Cecil developed after discovering a seventeenth-century manuscript on painting techniques by Théodore de Mayerne. The medium is made from a combination of Canada balsam, sun-thickened linseed oil, and turpentine. "It is excellent for mixing with oil colors both outdoors and in the studio," Dalessio explains. "It has a wonderful aroma owing to the balsam, and it leaves a nice glossy finish. I thin it with turpentine during the initial stages of painting process, and I use it undiluted as the painting progresses. The medium averages the drying time of the various pigments, and it fuses together the layers of paint."

ABOVE: Marc Dalessio using the sight-size method while doing a painting of his wife.

OPPOSITE: Marc Dalessio, Tina Reading under an Olive Tree, 2013, oil on canvas, 43 × 35½ inches (109.2 × 90.2 cm). Private collection.

PAINTING URBAN LANDSCAPES

California artist Bryan Mark Taylor paints a wide range of subjects, but it is his urban landscapes that have earned him international recognition. He creates many of these paintings in downtown San Francisco.

Taylor divides his time equally between studio work and outdoor painting, always striving for a solid abstract compositional structure in his paintings. "Although I am a dedicated representational painter, I recognize the need to consider the organization of shapes and value, the manner in which the paint is applied, and the importance of having an abstract pattern of brush mark coalesce into a recognizable image," he says. "I learn from looking at the work of Wayne Thiebaud and Richard Diebenkorn as well as Sargent, Zorn, Wendt, and Payne. They all dealt with many of the same issues of pictorial illusion and expression even though the results were quite different.

"Every plein air painter has to determine how to edit what he or she sees and feels, and I try to respond to the spiritual and temporal aspects of the process without my paintings becoming too sweet, too juicy, too detailed, or too fantastical," Taylor says. "It's a balancing act every painter performs, and the equilibrium we strive for has to reflect our individual personalities and objectives."

Taylor is willing to take risks in striving for that equilibrium, as he did when painting images observed from a plane. "I'm always interested in

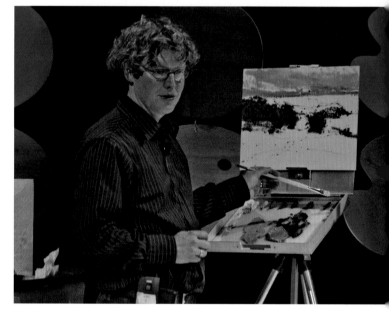

creating a sense of deep space and in emphasizing the geometry of the landscape, and it occurred to me that painting an aerial view of the land near my home in the San Francisco Bay area would present another way of dealing with those aspects of painting," he explains. "A friend offered to take me up in his small plane, but I knew it would be impossible to do any meaningful painting or to take photographs that accurately recorded what I might want

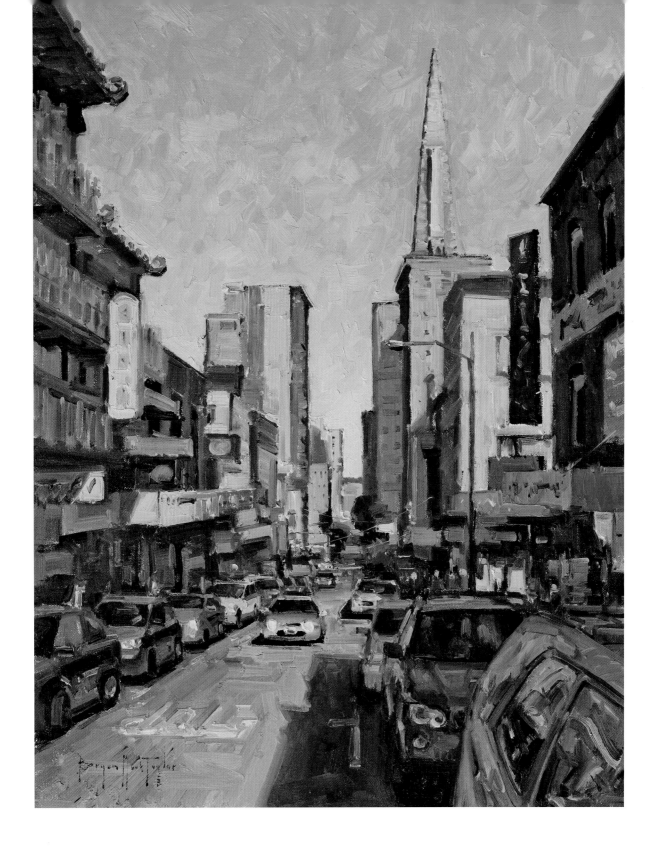

to convey in my paintings. I decided to just make mental notations about the forms, colors, and values that would convey the idea of looking down on the land from the sky, and as soon landed I started making paintings based on those mental notes."

OPPOSITE, TOP: Bryan Mark Taylor painting during a quick draw competition.

OPPOSITE, BOTTOM: Taylor's Strada easel set up for painting.

ABOVE: Bryan Mark Taylor, *Driving through Chinatown,* 2010, oil on canvas, 24 × 18 inches (61 × 45.7 cm). Private collection.

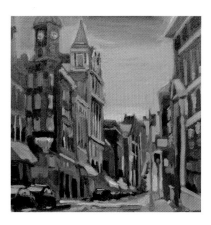

The three big challenges to address when painting street scenes are the dull colors of the urban landscape, the linear perspective, and the number of details. The colors of most urban buildings are muted shades of gray, blue, and deep red, which can result in a dull painting. All the shapes progress into the distance according on the principles of linear perspective, and any viewer will immediately notice the mistake if they are out of alignment. And the buildings often have dozens of windows and doors in perfect alignment that have to be painted with controlled brushwork.

I had to paint the scene in downtown Staunton, Virginia (above), within the two hours of a quick draw competition. To handle the challenges, I blocked in thin washes of color, wiped out lines and edges with sheets of paper towels, and exaggerated the sunlight and the colors.

STEP 1

First, I applied a thin wash of red iron oxide to the entire 12 × 12 canvas and immediately wiped out a general indication of the buildings with paper towels. I then washed in a thin mixture of light blue (titanium white + French ultramarine blue) between the building shapes.

STEP 2

I continued adding patches of color with a flat bristle brush that made it easier to make lines and hard edges. I also wiped paint off the canvas to establish light-value lines and patches. Still using a flat bristle brush, I add warm gray paint to awnings, window frames, and the street, and I used mixtures of purple, blue, and deep red to build up middle- and dark-value shapes. I finished the painting by roughly indicating cars along the street, signage hanging from the buildings, and windows. The finished painting is pictured.

M. Stephen Doherty, *Beverley Street, Staunton, Virginia*, 2016, oil on canvas, 12 × 12 inches (30.5 × 30.5 cm). Private collection.

Two Artists Discuss Nocturnes

A nocturne is a painting depicting a scene in darkness at the beginning or end of a day, or in the middle of the night. Something quite magical happens when an otherwise boring scene comes to life when street lamps, headlights, signage, traffic signals, security spotlights, and interior lights define it. Moreover, there is a certain mystery about structures illuminated directly or by reflected light because it can be hard to define where one building begins and another ends. The challenge in painting these scenes is that just as the subject is bathed in darkness, so, too, are the painting surface and the palette of colors. Without some kind of light shining on them, it is difficult to judge colors and values. That's why nocturne painters work near street lamps, attach battery-powered lights to their easels, or wear miner's lights on their heads. Here, two artists who specialize in nighttime scenes discuss their approaches to this challenging subject.

Thomas Van Stein

"Depending upon the complexity of the subject matter and the size of my intended painting, I am likely to begin a nocturnal painting by drawing the composition prior to sunset," says California artist Thomas Van Stein, perhaps one of the best-known artists of the night. "That saves time and money for the batteries in the Mighty Bright book lights I keep focused on the canvas or board. My headlamp illuminates the palette, and I'm experienced enough to know what I can expect in terms of the distortion of colors and values. In general, the pigments and values will look brighter and lighter when I illuminate them with my headlamp, so the day after I complete a painting on location I look it over in my studio and make adjustments based on my memory of the scene."

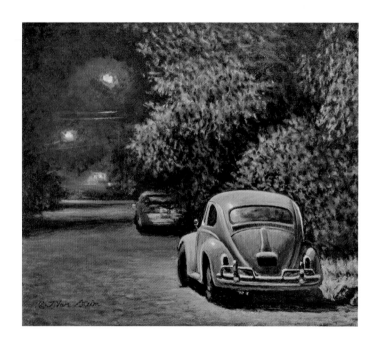

ABOVE: Thomas Van Stein, *Cocha Loma Nocturne*, 2014, oil on canvas, 18 × 20 inches (45.7 × 50.8 cm). Collection of the artist.

Van Stein goes on, "I work on surfaces that vary in tone, depending upon what highlights I wish to have 'pop.' Urban nocturnes will have a different tone than moonlit nocturnes because I am more interested in contrasts in color temperature as well as in value when working at a downtown location. I choose to work on a tone that is anywhere between a value 6 to a value 8 [dark values], and my wide palette of colors gives me a full arsenal at the ready in case something unpredictable color-wise appears before me.

"Unlike daytime painters, I don't use much titanium white. My preferred palette for moonlit nocturnes is ultramarine blue, cobalt blue, phthalo green, burnt umber, alizarin crimson, cadmium red light, cadmium yellow orange, cadmium yellow medium, yellow ocher, and Naples yellow. My preferred color palette for urban nocturnes is ultramarine blue, cobalt blue, phthalo blue, phthalo green, burnt umber, burnt sienna, cadmium yellow, cadmium orange, cadmium yellow medium, cadmium red light, and alizarin crimson."

Hiu Lai Chong

Maryland artist Hiu Lai Chong, who has won awards for her nocturne paintings, describes her approach this way: "I love the idea of combining the artificial lights on buildings, the traffic lights, illuminated signs, and the light of the natural world. It helps to evaluate a potential painting location during the day and at night, so I can determine what will become interesting and how the lights play against the structures. However, sometimes the most magical night scenes are totally uninteresting during the day, and that can make it hard to plan a nocturnal painting. In those situations, it is better to just feel my way through the painting process without worrying about the accuracy of the drawing.

"One of the advantages of working at night is that the scenes seldom change in appearance until the morning. I can paint without feeling the same pressure I do during the day, when the light is rapidly changing. I can spend all night on a painting. I sometimes use two overhead lights on my painting and palette, of which one is tied to a pole and the other attached to a headband. The headband can give me headaches after about two hours, so I have to take it off to get some relief, and then I put it back on and continue painting. I have worked all night until the sunrise on some paintings, but I do get concerned about my safety."

OPPOSITE: Hiu Lai Chong, *Summer Night,* 2013, oil on panel, 15 × 15 inches (38.1 × 38.1 cm). Collection of the artist.

ABSTRACTING FROM REALITY

Many plein air painters strive to capture the essence and emotional context of the landscape and not just its details. To them, these abstract qualities can have greater impact than the tiny elements painted with a #00 brush. "It would be much easier to paint everything I see in the landscape exactly as it appears than it is to only paint the essential elements," says Maryland artist Nancy Tankersley. "My paintings are more likely to reflect who I am as an artist as well as the actual response viewers have to the subjects I paint if I simplify and focus those paintings."

Tankersley points out that none of us see every leaf, blade of grass, or building window when we gaze at a landscape; nor do we focus on every petal on a flower or hair on a person's head. And the fact that we remember what we have seen has more to do with the way we felt when we saw it than with the specific details. We might remember a great meal, lots of laughter, and good friends who joined us for dinner but forget the name of the restaurant or its address. Our recollections are selective, so it makes perfect sense that Tankersley would paint a selective impression of a scene as well as her feelings about the painting's subject.

As Tankersley explains, striving to paint the essential aspects of a visual image is no simple task. It requires the skill and understanding that come from years of drawing and painting. "In getting at the essence of a subject, I might add things that weren't actually part of the landscape I observed," she says. "I

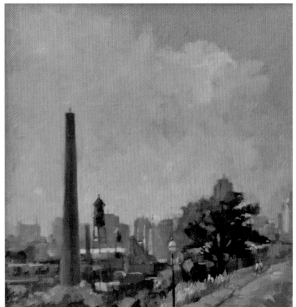

remember hearing someone complain that another painter added boats to a coastal scene that he made up from his imagination. The complaining artist suggested that adding those boats was wrong. To me, if the painting was improved by adding boats it was perfectly acceptable for the painter to add what she remembered, sketched somewhere else, or adapted from other boats docked along the shoreline."

TOP: Nancy Tankersley painting on location.

ABOVE: Nancy Tankersley, *Golden Haze,* 2013, oil on panel, 16 × 16 inches (40.6 × 40.6 cm). Private collection.

OPPOSITE: Nancy Tankersley, *Crab Fest,* 2013, oil on panel, 14 × 11 inches (35.6 × 27.9 cm). Private collection.

USING PHOTOGRAPHS

Painting primarily from photographs is at odds with plein air painting, but many outdoor painters do take photographs while they are working to keep records of where they worked or to preserve visual information they can reference in the studio when adding enriching details to a larger exploration of a scene previously painted *en plein air*.

"I do my best work when I feel something specific about a subject and I see it under conditions that convey a sense of atmosphere and light," says Utah artist Douglas Braithwaite. "The challenge of creating a good painting can force me to become more creative and to think outside the normal box. I do about half my work in the studio these days, relying on my plein air sketches and ten or fifteen photographs I take while painting on location. The sketches are jumping-off points for a new exploration of a subject, not enlargements of what I've already painted."

OPPOSITE: Douglas Braithwaite, *Alley Parking*, 2009, oil on canvas, 36 × 32 inches (91.4 × 81.3 cm). Private collection.

ABOVE: Douglas Braithwaite, *Rush Hour in Ward*, 2013, oil on panel, 8 × 10 inches (20.3 × 25.4 cm). Private collection.

MARK BOEDGES

"The more experience I gain, the more selective I am about the subjects I paint," says Vermont artist Mark Boedges. "I've come to know the kinds of pictorial elements I can use to create a successful painting, and what range of subjects might work well for the prevailing weather conditions. For example, I have recently been painting industrial subjects, and those look best on overcast days rather than bright, sunny ones. I've found that a cool light unifies the complex arrangement of shapes and accentuates the rich colors in these scenes. That ultimately resonates with my emotional response to the subject. Conversely, sunlight is indispensable when painting a snowscape, as it provides patterns and depth where there might not otherwise be any."

Most important for Boedges is having the idea for a painting in the first place: "I start thinking about what I will paint well before I head outdoors or travel to a plein air event. When I go to an event in another part of the country, I first look to paint the kinds of subjects not commonly available in northern Vermont—shorelines, industrial complexes, urban buildings. I don't need to travel to paint barns, for example, and I like the idea of pushing my artistic boundaries when I travel. But there is a balance to be struck, and I may also gravitate toward the same kinds of lush, dense, green locations like the ones around my home. Ultimately it depends on the ideas I wish to express and the amount of time I have available to paint. And the efficient use of time is always on an artist's mind. When my wife and I lived in Boulder, Colorado, for example, painting excursions into the mountains took a lot of time, whereas Vermont and other locales around New England offer an abundance of inspiring subjects nearby."

Once he finds a good scene to paint, Boedges sets up to work for four to five hours on one painting. "I spend the first two to three hours getting down the essential elements of the scene, focusing my effort on the center of interest and making sure to nail down the specific character of the light and any important drawing elements," he explains. "When I'm confident in the compositional structure of the image, I focus on the textures within the painting. At that point I spend more time looking at the painting than the scene. I normally use a palette knife to apply thick strokes of oil color and pull those colors in ways that will emphasize the topography, surface texture, or atmosphere of the scene."

Boedges works on panels covered with oil-primed linen made by either Wind River Arts or New Traditions Art Panels, or he buys Claessens linen and glues it to Gator Board to make lightweight painting panels. When he first started doing outdoor painting, he worked on small panels (8 x 10 or 6 x 8). Now the panels he

OPPOSITE, TOP: Mark Boedges, *Spear Street Farm*, 2012, oil on canvas, 16 × 24 inches (40.6 × 61 cm). Private collection.

OPPOSITE, BOTTOM: Mark Boedges, *First Thing*, 2012, oil on canvas, 16 × 20 inches (40.6 × 50.8 cm). Private collection.

uses are a minimum of 12 x 16 and as large as 18 x 24. "I tried painting on canvases as large as 24 x 36, but the only way I could cover that much canvas was to just paint the center of interest on location and complete the painting in my studio," Boedges explains.

Boedges has experimented with applying thin transparent washes of paint directly into thick passages applied with a bristle brush or palette knife, or vice versa. "Things start to happen—drips, mounds, gobs, puddles—that wouldn't otherwise occur, and the surprising result is how well these 'accidents' can begin to mimic elements of reality. I also admire some of the contemporary and historic paintings in which the artist has left some areas of the canvas loosely sketched," he says. "Richard Schmid does that in many of his paintings and I really like the contrast between the sharply defined center of interest and the open brush-strokes in the peripheral areas. I was strongly influenced by his book *Alla Prima* and initially based my selection of tube colors on his palette. I have since added some transparent colors (Indian yellow, transparent orange, and perylene red), which act as transparent analogs of cadmium colors. This gives me a much greater range of color and temperature in the thin, transparent passages of my paintings.

"In an age when visual media are easily produced and propagated, a well-crafted painting has one clear advantage: it has a real, tactile surface," Boedges wrote on his website. "Depth is not just an illusion of pixels but a concrete quality of pigments layered, manipulated, and blended on a canvas. For that reason, I attempt to let the paint do what it does best: look like paint. The only question is how painterly to make the marks on each painting. The answer is dictated by the subject and by the vision I have about it. And since I work primarily outdoors, the unalterable forces of nature shape a great part of what I do and how I do it.

"I'm a nuts and bolts kind of guy, and I adhere strongly to the 90/10 rule: 90 percent of what I attempt to do is hard, focused, disciplined work and 10 percent is something we usually call talent, or God-given ability. I spend considerable time focusing on (and fretting over) the many technical aspects of a painting. But ultimately there is a vision, a reason why I wanted to paint something in the first place; and it is my hope to remain true to that vision with each painting, and to convey it to viewers as clearly and as beautifully as I can."

OPPOSITE: Mark Boedges, *Seven Falls*, 2012, oil on canvas, 16 × 20 inches (40.6 × 50.8 cm). Private collection.

CHAPTER 7

PLEIN AIR EVENTS

Among the driving forces behind the growth of interest in plein air painting are the numerous outdoor painting festivals now being held across North America. Typically, artists paint in designated areas during weekdays of an event and then submit their completed works for an exhibition and sale over the weekend. Such events help identify new talent; offer opportunities to learn about materials, equipment, and techniques; encourage collectors to buy plein air paintings; and celebrate the idea of painting at specific locations. They are win-win opportunities for artists, organizers, patrons, and the cities and towns that sponsor the events.

One of the great appeals of plein air festivals for people who attend and support the events is the opportunity to watch the creation of artwork based on local scenes. Many of those people are confused by the contemporary art they see in galleries and museums, especially conceptual work made with nontraditional materials. In contrast, they feel no confusion about paintings of local landmarks, historic sites, shorelines, and downtown stores that are created with traditional painting media. And they appreciate seeing how outdoor painters bring their own personal interpretation to both familiar and unfamiliar locations.

A collector who attends a festival and buys a painting isn't just acquiring art. The collector is also learning stories about the artist, the event, and the painting itself that can be shared with friends and family. Those stories will come to mind years after the purchase, because the painting will help the collector recall details of what happened. The plein air painting might not have the investment potential of a Picasso, Monet, or Warhol, but it will reward the buyer over and over again.

OPPOSITE: Oregon artist Brenda Boylan working with pastels during a plein air festival.

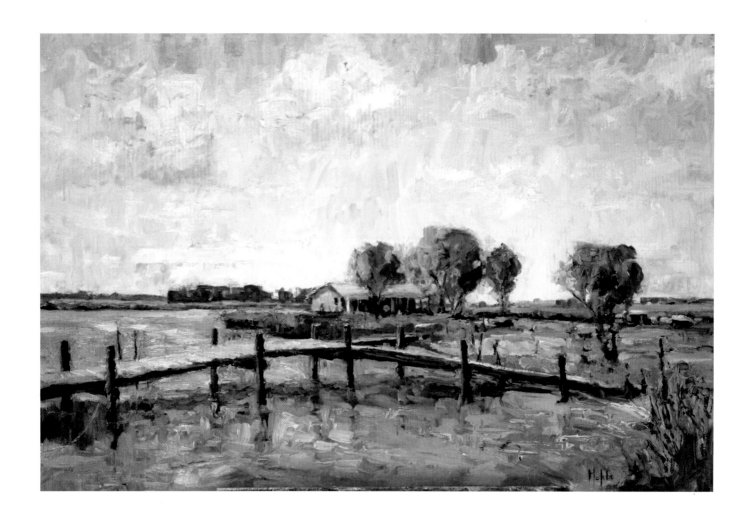

OPEN EVENTS WITH LAST-MINUTE SIGN-UPS

The easiest events to participate in are those that don't require advance registration and are open to anyone who shows up and pays a nominal fee. These community-oriented events are often fundraisers, and the artists sometimes donate all or a large percentage of the money they receive from selling their paintings. The quality of the artwork may not be as great and prices tend to be lower, but the events do offer artists an opportunity to test their level of interest in timed plein air events.

ABOVE: Lynn Mehta, *Fishing Shack on the Chesapeake*, 2014, oil on linen, 24 × 36 inches (61 × 91.4 cm). Private collection. ❱❱ Lynn Mehta has participated in Paint Snow Hill, an annual event on Maryland's Eastern Shore that is open to any artist who registers and pays the entry fee.

MEMBER AND INVITATIONAL EVENTS

Member events can be as casual as a "paint out" for artists who belong to a plein air group and just pick a location and date; invitationals can be as high-powered as the Laguna Beach Plein Air Painting Invitational in southern California. Members of the organization are automatically eligible to participate, and others are invited to paint, compete, exhibit, and sell their work. Some invitationals are organized by art schools, commercial galleries, and civic groups that want to hand-pick the participating artists. Most of the participants are connected to the host organization, but others apply by submitting examples of their work. One of the largest of these invitationals is the Door County Plein Air Festival in Fish Creek, Wisconsin, which according to its bylaws must invite a number of artists who did not participate in the previous year's festival.

TOP: Michael Alten painting during the Laguna Beach (California) Plein Air Painting Invitational, which is open to members and invited guests.

MIDDLE: At some invitational events, artists display their completed paintings on outdoor panels. Here, Bryan Mark Taylor stands by his display during the annual Sonoma Plein Air Festival in Sonoma, California.

BOTTOM: Several of the painting events that take place during the Door County Plein Air Festival in Fish Creek, Wisconsin, are set up to give the public an opportunity to watch and learn—and a chance to buy the artwork.

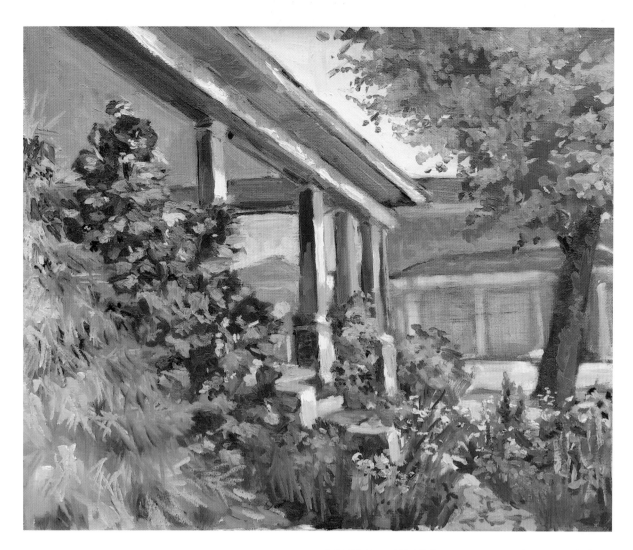

JURIED SHOWS

The most common type of plein air festival is the juried show. For juried shows, organizers put out a call for applications; applicants are asked to submit a number (often three) digital images of their work through an online system. (There is almost always an application fee.) Then a juror or jurors—usually professional plein air painters—select the artists who will attend. If you apply to such a show, make sure to enter paintings that will catch a juror's eye and that are easy to understand and appreciate in a split second.

TOP: M. Stephen Doherty, *Front Porch, Easton, Maryland,* 2015, oil on canvas, 16 × 20 inches (40.6 × 50.8 cm). **»** This painting, created during Plein Air Easton, won the festival's award for Best Composition.

BOTTOM: One of the most competitive festivals takes place every year in Easton, Maryland. It includes a major juried exhibition and quick draw competitions for professionals and for young artists. Here, young artists are shown receiving their awards at the 2011 festival.

Organizers' Expectations

Plein air events are almost always fund-raisers for the host organization or some designated charity such as a school, art center, or foundation. Commercial galleries also host events as a way to make money, bring attention to their regular stable of artists, or attract collectors who might become clients of the gallery.

Because there is almost always a profit motive, these events are managed to maximize sales. A good event organizer usually has the kinds of connections needed to raise prize money, get publicity, pull in the support of civic-minded residents, and appeal to a large number of art buyers. They also have the social connections needed to persuade residents to host artists and open up their homes for social gatherings.

TOP: Frank M. Costantino helped launch Plein Air Vermont to bring attention to towns in the southern part of the state.

BOTTOM: Massachusetts artist John Caggiano participates in a number of plein air festivals organized by galleries, tourism boards, art centers, and foundations and aimed at bringing attention and revenue to the host organizations.

PUBLICITY EVENTS: QUICK DRAWS, NOCTURNES, LANDMARKS

One of the best ways to build an audience for a plein air event is to schedule a timed competition at a specific location—a specific town or historic district or near a notable landmark. This makes it easy for people to observe a group of artists working on location, and such events provide perfect material for a local newspaper to feature. Some artists find events like this to be annoying publicity stunts, but two-hour quick draws and nocturnal painting competitions do help to bring attention to unknown artists, and they offer participants the opportunity to sell paintings.

If you decide to participate in one of these events, remember that your painting time will be very limited, either by the rules of the quick draw contest or, if it's a nocturne competition, by the disappearing light at dusk. Restrict yourself to a small panel and quickly block in the overall pattern of light and shadows. For nocturne competitions, it helps to identify a good location in advance. A day or two beforehand, check out the location while the sun is setting so you know where the interior and exterior lights are and can figure out how they might work well in a nocturne.

ABOVE, LEFT: Virginia artist Ron Boehmer works quickly to create a landscape painting during the 2012 Mountain Maryland quick draw competition. After a two-hour quick draw ends, patrons can buy the work put on display on the artists' easels.

ABOVE, RIGHT: Award winners and a crowd of potential buyers gather around quick draw paintings created during the Mountain Maryland Plein Air event in Cumberland, Maryland, in 2012.

OPPOSITE: The Beverley Street Studio School in Staunton, Virginia, invited members to paint Natural Bridge, a natural landmark once owned by Thomas Jefferson, as part of an effort to support a conservation group. Here I am, participating.

SELLING PLEIN AIR PAINTINGS

If plein air artists could figure out exactly who is likely to get seriously interested in our paintings and what might motivate them to actually pay the asking price, we could all make a lot more money at plein air festivals. That's not likely to happen, because for every theory about what does and doesn't work, there are twenty paintings that match that theory and still don't sell. Buying art is a very personal decision that is influenced by a person's individual taste, interest in the subject, ability to pay the asking price, and even by the energy level during an exhibition.

The staff of Plein Air Easton, on Maryland's Eastern Shore, conducted research to determine just who was spending $3,000 or more buying paintings at their annual event, and the results were surprising. The big buyers weren't people at the top of the economic scale. Yes, the majority of the event's supporters were people of above-average income, but their economic status was well below that of the top 1 percent of wealthy Americans. Many of these folks were as interested in learning how to paint on location as they were in building a collection of plein air paintings. In particular, men and women who were getting ready to retire came to the event to explore the idea of becoming visual artists themselves after concluding their professional careers. The festival provided the perfect opportunity to see paintings develop from start to finish, ask questions of the artists—and then buy paintings that would remind them of the lessons the painters offered. One conclusion to be drawn from this research is artists can increase interest in their paintings through education. There are other ways of attracting potential buyers' interest, as the sidebar opposite explains.

During my tenure as editor *American Artist* magazine I had the opportunity to spend time with artists who were financially successful in the extreme. Not all were people I admired or enjoyed being around. In fact, most were so focused on themselves and so boastful about their accomplishments that it was difficult to carry on a normal conversation with them. Nevertheless, I found myself curious about what it was about their artwork, personalities, and marketing efforts that resulted in such success.

The conclusions I came to after years of observing artists like Thomas Kinkade, Mort Kunstler, and Bob Ross were (1) that financial success starts with an ability to treat artwork as a product like any other consumer product, (2) that the product must have a consistent identity from one piece to another, (3) that the artist has to be objective in measuring people's response to that product, and (4) that when marketing the product you need to use words and concepts associated with museum-quality artwork. If you're unsatisfied with your paintings' sales or the number of awards they're winning, it's worth asking yourself how much time and effort you're willing to spend to shape and market your artwork to increase the number of people who'll buy it and select it for awards.

How to Be a Better Salesperson

ABOVE: Douglas Morgan, *Senior Citizens*, 2012, oil on panel, 11 × 14 inches (27.9 × 35.6 cm). Private collection.

Californian Douglas Morgan brings his previous experience as a commercial real estate salesperson to his successful career as a plein air artist. "I make a point of finding subjects that incorporate well-known scenes or iconic American symbols," Morgan says. "It's a fact that collectors prefer to buy paintings of places they know and love, which is why it's hard to sell paintings of the desert in New England or scenes of New York City in the South. Knowing that, it makes sense to find subjects that can be identified by local

buyers. And—getting back to the idea of having conversations with potential clients—most people are interested in knowing what you found to be inspiring about their hometown. If they are visiting as tourists, taking paintings home is a way of remembering a great vacation.

"It helps to keep in mind that most of the people walking around a plein air event didn't get up that morning with the intention of buying artwork," Morgan adds. "It's up to artists to talk to them about how much they enjoy painting their town and how the buyer will experience the same joy that previous buyers have discovered when living with plein air paintings.

"The point is to get people thinking about the benefits of collecting artwork. Talk about the school, community center, or arts organization benefiting from the event because that is also a great way to engage people. You can tell them that a portion of the sale will support that local organization. Most people don't know that the charitable groups have worthwhile programs for children, senior citizens, actors, or musicians, or that sales will help preserve an important local landmark. Talking about local organizations will encourage people to buy artwork because a portion of the money they spend will go back into the community.

"Once people know it's permissible to talk to you, they can ask questions about your painting, your career, etc.," Morgan points out. "I know from experience that if I engage people in my art and the event, they are much more likely to buy one of my paintings, and if I meet up with them again at another plein air event they will ask for an update on my artistic endeavors. At that point they begin to feel they are following my career and supporting me as an artist. What could be better than that?"

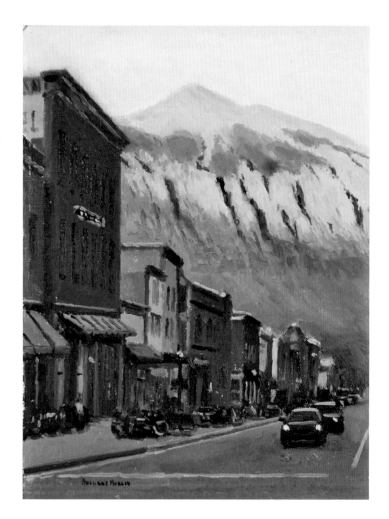

ABOVE: Douglas Morgan, *Mountain Magic*, 2013, oil on panel, 16 × 12 inches (40.6 × 50.8 cm). Private collection.

DRAWBACKS OF PLEIN AIR EVENTS

A hard reality of competitive plein air events is that applications from many top artists are routinely rejected by jurors simply because of the number of applicants. Only about a quarter to a third of the paintings created will actually sell, and just three or four of the participating artists will generate a disproportionately high percentage of total sales and revenue. Another hard reality is that only 5 to 20 percent of the artists will win awards. That means it is likely that even the most talented and accomplished artist can expect rejections, poor sales, and no awards.

Numbers provided by The Avalon Foundation, which runs Plein Air Easton, tell the story. Between 2009 and 2014, the number of paintings sold during the festival ranged from a low of 124 to a high of 201; the average selling price ranged from $1,066 to $1,519; the median selling price landed between $795 and $1,200; and the highest price paid ranged from $3,500 to $7,100. Roughly 60 individuals participate in the yearly event, creating a total of about 600 paintings. A quick review of the numbers shows that only about a third of the paintings sell during the event; two-thirds go home with the artists.

Despite these drawbacks, hundreds of artists still pay entry fees and hope for acceptance into plein air festivals. Is it wise for them to continue doing so indefinitely, or should they consider plein air festivals a short-term means to a long-range goal? The answer may be found in the long careers of the best-known painters. Most stop participating in plein air festivals once their prices reach a certain level, and they keep all their sketches to use in the studio. Some admit that they no longer have fun hanging out with large groups of outdoor painters.

Plein air festivals can be very stressful for competing artists. The only guaranteed benefits are learning about your own and others' work and developing new friendships. But while those may be worthy rewards, they can be achieved under less stressful circumstances. That's why many professional artists come to a point at which they greatly reduce the number of plein air festivals they join or stop altogether. Hopefully, the events make them better known to collectors and more visible within the art community and position them to have greater success selling through galleries or websites.

Of course, a one-day paint-out or five-day plein air festival is not just a business venture to be evaluated in terms of expenses, time, and revenue. The best reasons to join an organized painting event are to improve your ability, to let you enjoy being in nature, and to help you make friends with others who share your interests. Maryland artist Tim Kelly expressed that sentiment very well when he posted a statement on Facebook saying that he "never had an easier time making friends than I have within the plein air artist community. Once you paint alongside somebody and learn their name, you seem to have a friend for life . . . or at least an acquaintance."

RESOURCES

Those of us on a journey to learn more about painting outdoors are fortunate to be living in the so-called Information Age. The Internet allows us to access information from a wide variety of sources. That information can be especially helpful when we want to look at work by plein air masters, watch instructional videos, read blogs about materials and techniques, or just review recent paintings by others who share our passion. And, of course, print books and magazines will always be around for our instruction and enjoyment.

BLOGS

Mitchell Albala
Mitchell Albala Landscape Painter / Instructor / Author
blog.mitchalbala.com

Brenda Boylan
B. Boylan
brendaboylan.blogspot.com

Marc Dalessio
Marc Dalessio—Recent Paintings and General / Musings on Art
marcdalessio.com

Larry Groff
Painting Perceptions
paintingperceptions.com

James Gurney
Gurney Journey
gurneyjourney.blogspot.com

Michael Chesley Johnson
Oil & Pastel Landscapes of Downeast Maine, the Canadian Maritimes & American Southwest
mchesleyjohnson.blogspot.com

John Pototschnik
John's Blog
pototschnik.com/blog

Ed Terpening
Life Plein Air: The Artistic Adventures of Ed Terpening
edterpening.com/blog2/wordpress

Christopher Volpe
One Artist/Art Historian's Random Take on the World's Great Paintings
christophervolpe.blogspot.com

BOOKS

Mitchell Albala, *Landscape Painting: Essential Concepts and Techniques for Plein Air and Studio Practice* (New York: Watson-Guptill, 2009)

Michael Chesley Johnson, *Backpacker Painting: Outdoors with Oil & Pastel* (CreateSpace, 2013)

Michael Chesley Johnson, *Outdoor Study to Studio: Take Your Plein Air Paintings to the Next Level* (CreateSpace, 2015)

Gary Pendleton, *100 Plein Air Painters of the Mid-Atlantic* (Atglen, Pa.: Schiffer Publishing Ltd., 2014)

Richard Schmid, *Alla Prima II: Everything I Know about Painting—And More* (Brattleboro, Vt.: Stove Prairie Press, 2013)

FACEBOOK COMMUNITY PAGES

"En Plein Air" Paintings and Painters

Plein Air Painters

MAGAZINES (PRINT AND DIGITAL)

The Artist's Magazine
artistsnetwork.com

International Artist
internationalartist.com

PleinAir Magazine
pleinairmagazine.com

Southwest Art
southwestart.com

WEBSITES AND SOCIAL MEDIA
(ARTISTS AND CONTRIBUTORS)

Michael Alten
michaelalten.fineaw.com

Lauren Andreach
laurenandreach.com

Clyde Aspevig
clydeaspevig.com

Marla Baggetta
marlabaggetta.com

Cindy Baron
cindybaron.com

Jack Beal
georgeadamsgallery.com

Mark Boedges
markboedges.com

Ron Boehmer
ronboehmer.com

Brenda Boylan
brendaboylan.com

Douglas Braithwaite
dougbraithwaite.com

Brienne M. Brown
briennembrown.com

Ryan S. Brown
ryansbrown.com

Marcia Burtt
marciaburtt.com/art

John Caggiano
johncaggiano.com

Hiu Lai Chong
hiulaichong.com

John D. Cogan
johncogan.com

John Cosby
cosbystudio.com

Frank Costantino
fmcostantino.com

Brent Cotton
cottonfinearts.com

Marc Dalessio
marcdalessio.com

Ken DeWaard
kendewaard.com

Gil Dellinger
gildellinger.com

Daniel F. Gerhartz
danielgerhartz.com

Stephen Giannini
stephangiannini.com

Ulrich Gleiter
ulrichgleiter.com

Michael Godfrey
michaelgodfrey.com

Daniel Grant
twitter.com/
dangrantwriter

Steve Griffin
stevegriffinart.com

James Gurney
jamesgurney.com

Mark Kelvin Horton
hortonhayes.com

Charlie Hunter
hunter-studio.com

L. Diane Johnson
ldianejohnson.com

Becky Joy
beckyjoy.com

Ken Karlic
kenkarlic.com

Shelby Keefe
studioshelby.com

Tim Kelly
tkellybal.com

Raleigh Kinney
kinneywatercolors.com

Thomas Jefferson Kitts
thomaskitts.com

Erik Koeppel
erikkoeppel.com

Paul Kratter
paulkratter.com

John P. Lasater IV
lasaterart.com

Jack Irwin Liberman
jacklstudio.com

André Lucero
andrelucero.com

Jeff Markowsky
jeffmarkowsky.com

Joseph McGurl
josephmcgurl.com

Lynn Mehta
lynnmehta.com

Larry Moore
larrymoorestudios.com

Douglas Morgan
douglaspmorganart.com

Stephen Quiller
quillergallery.com

Ron Rencher
ronrencher.com

James Richards
jrichardsstudio.com

Peggi Kroll Roberts
krollroberts.com

William Rogers
williamrogersart.com

Jeremy Sams
jeremysams.com

Loriann Signori
loriannsignori.com

Hodges Soileau
hodgessoileau.com

Kathryn Stats
kathrynstats.com

Lisa K. Stauffer
lisastauffer.com

Carol Swinney
carolswinney.com

Nancy Tankersley
nancytankersley.com

David S. Tanner
davidtannerfineart.com

Bryan Mark Taylor
bryanmarktaylor.com

Clive R. Tyler
insightgallery.com/
Clive-R-Tyler.php

Bob Upton
bobuptonstudio.com

Thomas Van Stein
thomasvanstein.net

Dirk Walker
dirkawalker.com

Stewart White
stewartwhitestudios.
com

Dawn Whitelaw
dawnwhitelaw.com

J. D. Wissler
lancastergalleries.com

WEBSITES
(ORGANIZATIONS)

American Impressionist
Society
aisi.wildapricot.org

International Plein Air
Painters
ipap.homestead.com

Missouri Valley
Impressionist Society
missourivalleyimpres-
sionistsociety
.com/other1

Pacific Northwest
Plein Air
pleinairhoodriver.
blogspot.com

Plein Air Painters of
America
p-a-p-a.com

Plein Air Painters of the
Southeast
pap-se.com

Southern California
Plein Air
Painters Association
socalpapa.com

INDEX

Page numbers in *italics* indicate illustrations

A

acrylics, 23, 55, 95, 110-113, 114
additive mediums, 111-113
aerial view, 146-147
alkyd medium, 63
Alla Prima (Schmid), 158
alla prima painting, 136
Allison, Steve, 15
American Prairie Reserve, 48
Andreach, Lauren, 98, 99
antichi maestri, 144
Apollonian artist, 129
Art Instinct, The (Dutton), 47
Arts Without Boundaries, 48
Aspevic, Clyde, 47-48
 Boulder River, 50-51
 Junkyard Pump, 47
 Sargent Point, 48, 49
 Snow Capture, 48
Avalon Foundation, 171

B

Baggetta, Marla, *82*
Barbizon School, 18-19, 40
Baron, Cindy, 102-104
Beal, Jack, *128*, 128-129, *129*, 136
Beverley Street Studio School, Virginia, 166, *167*
Bierstadt, Albert, 36, 37
Bishop, Isabel, 44
blocking in shapes, 136-138
blogs, 172
Boedges, Mark, 140-141, 156, 158
 First Thing, *157*
 Niagara Escarpment, *140*
 Seven Falls, *159*
 Spear St., *157*
 Spring Thaw, *141*
book resources, 172
Boylan, Brenda, 108, *109*, 160
Braithwaite, Douglas, *154*, *155*, 155
bright-toned surfaces, 133
Brown, Brienne M., *124*, *125*, 134-135, *135*
brushes, 63, 72, 83, 101, 102, 110, *114*, 114, 115, 117
Buechner, Thomas S., 68, 79, 82
Burtt, Marcia, *110*, *111*

C

canvas (cotton/linen), 90, 158
Cassatt, Mary, 40
Cecil, Charles H., 144
center of interest, 128, 158
Chase, William Merritt, *44*, 44
Church, Frederic Edwin, 36-37, 63
 Great Basin, Mount Katahdin, Maine, *38*
 Niagara, 36, *37*
Cogan, John D., 110, *112*

Cole, Thomas, 37
 Catskill Creek (study), *36*, 36
color mixing, 134-135, 140-141
color palette, 134
 acrylics, 110
 binder in, 95
 grays, 84
 greens, 97
 limited, 28, 55, 98-99, 121
 nocturnal scenes, 150
 pastels, 105, 106, 108
 portability of, 83, 95
 prismatic, 98
 properties of, 53, 55
 transparent, 158
 urban scenes, 148
 watercolor, 101, 102
composition, 128-129
 sketches, 86
Constable, John, 31, 33-34
 The Hay Wain, 33, *34*
 Study of Trunk of Elm Tree, *34*
Corot, Jean Baptiste-Camille, 31, 35
 The Arch of Constantine and the Forum, Rome, *35*
Cosby, John, 98-99, *99*
Cotton, Brent, 59, *60*, *61*
Cramer, Bill, *83*, 83
 Morning Salute, *83*
Cropsey, Jasper Francis, 36

D

Dalessio, Marc, 144, *145*
Daubigny, Charles-François, 40
demonstrations, 57
Desavary, Charles, 35
diagonal shapes, 128
Dibond panels, 94
Dionysian artist, 129
direct painting process, 142
distance colors, 98
Doherty, M. Stephen, 9, *14*, *17*, *19*, *43*, *52*, *54*, *56*, *58*, *66*, *69*, *72*, *75*, *81*, *97*, *113*, *126*, *130*-*131*, *132*, *137*, *148*, *164*
Door County Plein Air Festival, Wisconsin, 18, 163
drawings/sketches, preliminary, 18-19, 32, 34, 39, 82, 86, 102, 127
drying time, 23, 112
Dumond, Frank Vincent, 98
Durand, Asher B., *39*, 39
Dutton, Denis, 47

E

easels, 110
 French, 119
 Gloucester, *120*, 120
 metal/plastic, 120
 portable, 118

Easels in Frederick festival, Maryland, 19
editing process, 12, 146
equipment. *See* materials and tools
exhibitions, 16

F

festivals/events
 appeal of, 161
 drawbacks of, 171
 eligibility requirements for, 15
 as fund raisers, 165
 invitational/member, 163
 juried shows, 15, 16, 18, 164
 location selection in, 16, 71, 72
 nocturnes, 166
 open, 162
 sales at, 71, 168-170, 171
 timed sessions, 16, 166
figures in plein air landscapes, 20
focal point, 126
foreground colors, 98
Freckelton, Sandra, 136
French easels, 119
frisket, 24

G

Gerhartz, Daniel F., 136, *136*, *138*, *139*
Gifford, Sanford, 143
Gleiter, Ulrich, *78*-*79*, 79
gloss gel, 110
Gloucester easel, *120*, 120
Godfrey, Michael, 122
 Evening's Gift, *123*
 On the Lewis River, *123*
 Teton Morning, *122*-*123*
Goerschner, Ted, 84
grays, 84
greens, 97
Gurney, James, *115*, 115

H

Haseltine, William Stanley, 36
Heilman box, 106
Hiu Lai Chong, 150, *151*
Horton, Mark Kelvin, *74*, 74
Hudson River School, 36-38

I

Impressionists
 American, 44-46
 colors and values of, 140
 influence on contemporary painters, 43
 as plein air painters, 19, 33, 40-42
indirect painting process, 142-143
industrial scenes, 156

J

Johnson, L. Diane, *12*
Joy, Becky, *117*, 117
juried shows, 15, 16, 18, 164

K

Kanuga Watermedia Workshops, 57
Keefe, Shelby, *133*, 133
Kelly, Tim, *73*, 171
Kincade, Thomas, 158
Kingman, Doug, *46*, 46
Kinney, Raleigh, 100, 100-101, *101*
Kitts, Thomas Jefferson, *121*, 121
Koeppel, Erik, 96
Kratter, Paul, *127*, 127

L

Laguna Beach Plein Air Painting Invitational,
 163
landscape painting, naturalistic, 31
Lane, Fritz Henry, 63
Lasater, John P., IV, *18*, 22
learning process
 color palette, 53, 55
 demonstrations, 57
 light and shadow, 54
 observation in, 11-12, 53
 outlining shapes/forms, 56
 personal style in, 59-60
 washes, 58
 workshops, 55-58
Leffel, David A., 60
Levitan, Daniel, 47
Liberman, Jack I., 98
light
 changing, 76-77, 82
 quality and direction, 68, 69
 and shadow, 14, 54, 141
 and style, 60
 values, 83, 84
limited palette, 28, 55, 98-99
linear perspective, 148
linseed oil, 63, 69
locations
 carrying supplies to, 83
 choosing, 67-70
 favorite spots, 74-75
 at festivals, 16, 71, 72
 multiple paintings at, 76-77
 physical limitations of, 79
 scouting, 13, 15, 73, 156
Lorrain, Claude, 31, 34
 Artist Studying from Nature, *32*
Lucero, André, 76-77, *77*

M

Macchiaioli artists, 19
magazine resources, 172
Manet, Édouard, *Monet in His Studio Boat*,
 41
Mason, Frank, 98

materials and tools
 brushes, 63, 72, 83, 101, 102, 110, *114*, 114,
 115, 117

compact/portable, 25, 83, 89, 106
 Heilman box, 106
 linseed oil, 63, 69
 palette, 101, 110
 palette knife, 60, 63, 75, 83, 101, *114*, 114,
 116, 117
 pochade boxes, 108, 118
 spray bottle, 102, 110
 in travel abroad, 121
 viewfinder, 100, 126
 See also color palette; easels; mediums;
 surfaces
Mayerne, Theodore de, 144
McGurl, Joseph, 63-65, 82
 Drifting Clouds, *64-65*
 Late Summer, *62-63*
mediums
 acrylics, 23, 55, 95, 110-113, 114
 additive, 111-113
 antichi maestri, 144
 oils, 23, 55, 63, 95-99
 pastels, 25, 26, 28, 55, 93, 105-109
 watercolor, 23, 24-25, 93, 100-104, 114
metal panels, 94
Metcalf, Willard, 40
Millet, Jean-François, 40
Monet, Claude, 40
 Water Lillies and Japanese Bridge, *40*
Moore, Larry, 20
Moran, Thomas, 36
 Upper Falls, Yellowstone, *38*
Morgan, Douglas, *169*, 169-170, *170*
music and art, 48

N

nocturnal competitions, 166
nocturnal scenes, 149-151

O

observation process, 11-12, 53
Oil Painting (Goerschner), 84
oils, 23, 55, 63, 95-99
outlining shapes/forms, 28, 56, 102

P

paints. *See* color palette
palette knife, 60, 63, 75, 83, 101, *114*, 114, 116, 117
palettes, 101, 110
 See also color palette
panels
 hardboard, 92, 156, 158
 metal, 94
paper
 pastel, 106, 108
 watercolor, 93, 100, 102, 106, 112
pastels, 25, 26, 28, 55, 93, 105-109
personal style, developing, 59-60
photographs
 influence on plein air painting, 64, 136
 in painting process, 15, 86, 128-129, 154-155
 vs plein air painting, 13, 68
Pissarro, Camille, 40
plein air, defined, 12
Plein Air Easton, Maryland, 22, 168, 171

plein air masters
 Aspevic, Clyde, 47-51
 Boedges, Mark, 140-141, 156-159
 Godfrey, Michael, 122-123
 McGurl, Joseph, 62-65
 Stats, Kathryn, 84-87
 Tyler, Clive R., 26-29
plein air painting
 benefits of, 11-15
 defined, 15-16
 figures within, 20
 impressionist look in, 43
 vs photography, 13, 68
 resources for, 172-173
 sketches/studies for, 18-19, 32, 34, 39, 82,
 102
 See also festivals/events; learning
 process; locations; materials and
 tools; subjects; techniques
plein air painting, history of, 31-33
 American Impressionists, 44
 Barbizon School, 18-19, 40
 Constable, John, 31, 33-34
 Corot, Jean Baptiste-Camille, 31, 35
 Hudson River School, 36-38
 Impressionists, 19, 33, 40-42
 postwar, 44-46
 sketches/studies, 39
pochade boxes, 108, 118

Porter, Fairfield, 44
 Island Farmhouse, *2*, 45
Potter, Ken, *46*, 46
Poussin, Nicolas, 31
pre-mixed colors, 98-99
preparatory sketches, 127
preservation of paintings, 90
prismatic palette, 98
Przewodek, Camille, 98-99

Q

quick draw competitions (timed session),
 16, 166

R

Renoir, Auguste, 40
repainting, in studio, 17
resources, 172-173
retarder, 112
Roberts, Peggy Kroll, 20
Rogers, William, 24
Rose, Guy, 44
Ross, Bob, 168
Rousseau, Théodore, 18-19, 40
Rungius, Carl, 37
rural scenes, 21

S

sable brushes, 115
sales, at plein air events, 71, 168-170, 171
Sams, Jeremy, 23
Sargent, John Singer, 31, 40, 138
 Bridge of Sighs, *42*
 *Claude Monet Painting at the Edge of a
 Wood*, *41*

Spanish Fountain, 30
savanna hypothesis, 47
Schmid, Richard, 158
shadow, light and, 14, 54, 131
sight-sizing, 68, 138, 144
Signori, Lorinn, 25
simplification of subjects, 80-82
sketches, preliminary, 18-19, 32, 34, 39, 82, 86, 127
Soltek easel, *120*, 120
spray bottle, 102, 110
Stats, Kathryn, 84, 86
 Changing Seasons, 87
 Time Travel, 87
 Zion Shadows, 84-85
Stauffer, Lisa, *105*, 106, *107*
Steele, T.C., 44
Strada easel, 120
style, developing, 59-60
subjects
 changing scene, 14
 industrial scenes, 156
 in limited settings, 71, 72
 nocturnal scenes, 149-151
 rural scenes, 21
 simplification of, 80-82
 unpretty, 71
 urban scenes, 21-22, 146-148, 155
 See also locations
supplies. *See* materials and tools
surfaces
 canvas (cotton/linen), 84, 90, 158
 hardboard panels, 92, 156, 158
 metal panels, 94
 paper, pastel, 106, 108
 paper, watercolor, 93, 100, 102
 plastic fabric, 94
 toning, 130-133

Swinney, Carol, 116

T

Tankersley, Nancy, 152, *153*
Taos Society of Artists, 44
Taylor, Bryan Mark, 120, 146-147, *147*
techniques, 125
 alla prima painting, 136
 blocking in shapes, 136-138
 color mixing, 134-135, 140-141
 composition, 128-129
 editing process, 12, 146
 focal point, 126
 indirect painting, 142-143
 lean to fat painting, 86
 nocturnal scenes, 149-151
 outlining shapes/forms, 28, 56, 102
 photographs, using, 15, 86, 128-129, 154-155
 pre-mixed colors, 98-99
 preparatory sketches, 127
 selective impressions, 152
 sight-sizing, 68, 138, 144
 toning a surface, 84, 130-133
 underpainting, 108
 urban landscapes, 146, 148
 washes, 24, 28, 58, 72, 106, 108, 134, 158
This Is Your Brain on Music (Levitan), 47
timed painting sessions, 16, 166
toning a surface, 84, 130-133
Tonkovich, Jennifer, 33
tools. *See* materials and tools
Tyler, Clive R., 26, 28
 Autumn, 26
 Fall Poudre, 27
 Winter Fall, 29

U

underpainting, 108
Upton, Bob, *142*, 142-143, *143*
urban scenes, 21-22, 146-148, 150

V

Valenciennes, Pierre-Henri de, 31
 Study of Clouds over the Roman Campagna, 32
value-pools, premixed, 98-99
values
 in color mixing, 83, 84, 134, 140-141
 nocturnal scene, 149
Van Stein, Thomas, *149*, 149-150
viewfinder, 100, 126
Visual Music (Aspevig), 48

W

Walker, Dirk, *91*
warm-toned surface, 131, 132
washes, 24, 28, 58, 72, 106, 108, 158
watercolor, 23, 24-25, 93, 100-104, 114
watercolor paper, 93, 100, 102, 106, 112
websites, 173
Weir, J. Alden, 44
Wendel, Theodore, 40
Whitelaw, Dawn, 96
whites, reserving, 24, 101
White, Stewart, 80
Wilcox, Jim, 120
Wissler, J.D., 93
Wyeth, Andrew, 44

PUBLICATION CREDITS

Portions of this book were previously published in somewhat different form in articles by M. Stephen Doherty in *PleinAir Magazine*, a division of Streamline Publishing. Used by permission.

The opening section of chapter 2 originally appeared in somewhat different form in The Huffington Post (huffingtonpost.com) on July 29, 2012, under the title "The Morgan Library's Plein Air Collection Comes as a Nice Surprise," by Daniel Grant. Used by permission of the author.

The sidebar "Corot: An Early Outdoor Painter," on page 35, originally appeared in somewhat different form on May 24, 2011, on Christopher Volpe's blog, christophervolpe.blogspot.com, under the title "Corot's palette revealed! & notes on the ethereal colors of spring." Used by permission.

The sidebar "Traveling to Paint," on page 121, originally appeared in different form as "Travel Light When Painting Abroad," by Thomas Jefferson Kitts, in *PleinAir Magazine*, February–March 2013. Used by permission.

The sidebar "Adjusting Colors and Values," on pages 140–141, is excerpted from the article "Mark Boedges: Learning from Others While Establishing One's Own Voice," in *PleinAir Magazine*, October–November 2013. Used by permission.